SPELLBOUND
BY MARCEL

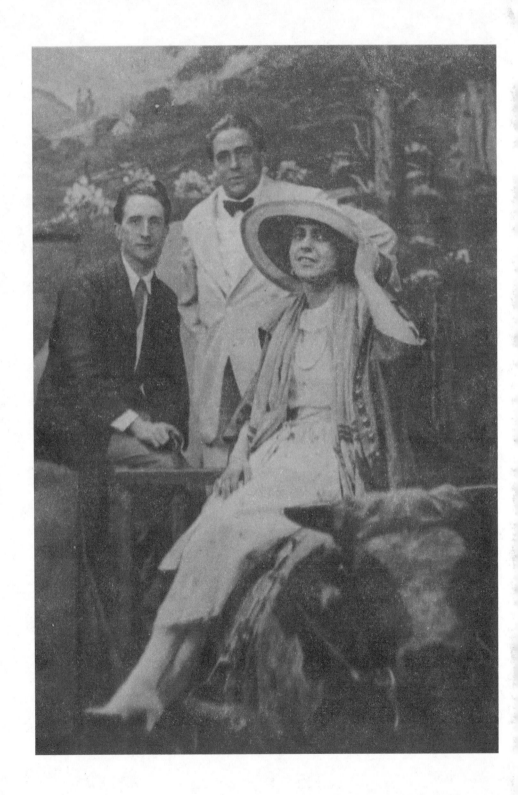

SPELLBOUND BY MARCEL

Duchamp, Love, and Art

RUTH BRANDON

PEGASUS BOOKS
NEW YORK LONDON

SPELLBOUND BY MARCEL

Pegasus Books, Ltd.
148 West 37th Street, 13th Floor
New York, NY 10018

First Pegasus Books cloth edition March 2022

Interior design by Maria Fernandez

Frontispiece: Marcel, Picabia, and Beatrice, Coney Island, June 1917.

ISBN: 978-1-64313-861-9

10 9 8 7 6 5 4 3 2 1

Printed in the United States of America
Distributed by Simon & Schuster
www.pegasusbooks.com

To Phil, who first introduced me to Duchamp's strange world

CONTENTS

CHIEF DRAMATIS PERSONAE

Marcel Duchamp: French artist, the originator of conceptual art
Beatrice Wood: American would-be artist, later a successful ceramicist
Henri-Pierre Roché, aka Pierre: French artistic hanger-on and compulsive womanizer, later the author of *Jules et Jim*
Walter Arensberg: Collector of modern art
Louise Arensberg: His wife

Marcel's Brothers and Sisters
Gaston, aka Jacques Villon: Painter and cartoonist
Raymond, aka Raymond Duchamp-Villon: Sculptor
Suzanne: Artist
Yvonne
Madeleine

Marcel's Paris Friends
Guillaume Apollinaire: Poet
Francis Picabia: Playboy, artist
Gabrièle Picabia: His wife

Beatrice's New York Friends
Beth Reynolds, later Hapgood: School friend, Russian linguist
Norman Hapgood: Magazine editor
Charles Coburn: Theatrical impresario
Ivah Coburn: His wife, theatrical producer
Alissa Franc: Journalist
Madame Yorska: Director, French American Theater

The Arensberg Circle: Americans

Walter Pach: Artist, organizer of the Armory Show
Allen Norton: Poet, editor of *Rogue* magazine
Louise Norton: His wife, later the wife of Edgard Varèse
Joseph Stella: Italian doctor, New York artist
William Carlos Williams: Doctor, poet
Mina Loy: Poet
Arthur Cravan: Poetic beefcake
Man Ray: Photographer

The Arensberg Circle, French

Francis Picabia
Gabrièle Picabia
Edgard Varèse: Composer
Jean Crotti: Ex-husband of Yvonne Chastel, later husband of Suzanne Duchamp
Henri-Pierre Roché

Marcel's Wealthy Middle-Aged Lady Friends

Ettie Stettheimer
Florine Stettheimer: Painter
Carrie Stettheimer
Katherine Dreier

In Canada

Paul Ranson: Bigamous "husband" to Beatrice

Marcel's Women, Buenos Aires and Paris

Yvonne Chastel: His lover in Buenos Aires and Paris
Mary Reynolds: His longtime lover, Paris
Lydie Sarazin Levassor: His first wife, Paris
Maria Martins: Brazilian sculptor and diplomatic hostess, with whom he falls blindly in love
Teeny Matisse: His second wife

INTRODUCTION

This is a story about war, love, memory, fame, art, and the endless conflict between those who want to shape the future and those who would prefer to keep it at bay. The action takes place in New York and Paris: the New York of the Arensberg salon, and the American Paris of Gertrude Stein, Janet Flanner, and Man Ray. The pivotal moment was World War I, which both destroyed an old way of life and opened the doors to a new one, in which people felt free to follow their inclinations untrammeled by social conventions they now perceived as useless.

In 1915–16 a group of French artists fled war-torn Europe for New York. In the few months between their arrival and America's entry into the war in April 1917, they pushed back the boundaries of the possible, in both life and art. The hub of this transformation was the apartment at 33 West 67th Street owned by Walter and Louise Arensberg, where artists and poets from both sides of the Atlantic met nightly to talk, eat, drink, discuss each other's work, play chess, plan balls, organize magazines and exhibitions, and fall in and out of love. None of the participants ever again experienced so thrilling a moment.

At the center of all this activity stood the mysterious figure of Marcel Duchamp, always approachable, always unreadable. Many people, of both sexes, were in love with him, but although he was blithely friendly to them all, his own feelings, if any, remained opaque. Decades later, when Duchamp became famous for the second time and was reincarnated as the twentieth century's most influential artist, anyone still living who had been present during those all-consuming months was avidly sought out. Most of their accounts, however, were more a study of memory's vagaries than an accurate record of what actually happened.

Henri-Pierre Roché and Beatrice Wood were both in love with Duchamp, and briefly, and (for her) life-changingly, with each other. Both kept daily diaries, which along with other contemporary writings give a picture of events very different from what they later remembered. Or rather two pictures—for the views they offer, including of their own love affair, are stunningly divergent.

Roché's reminiscences of the Arensberg years are contained in a novel *Victor*, unpublished because it was still unfinished when he died in 1959; Beatrice's form part of a memoir, *I Shock Myself*, published in 1985 when she was ninety-two. When put side by side with the contemporary accounts it becomes clear that both these books often misrepresent both the sequence of events and how people felt at the time. What they do reveal is how the writers prefer to remember what happened. So in *Victor* the Beatrice character is called Patricia, which was the name of her dog—a detail that says quite a lot about Roché's post-hoc diminution of her importance to him; while Beatrice, in her memoir, says she met Duchamp *after* Roché, and that he (Duchamp) was in love with her, when in fact she was madly in love with Duchamp, who introduced her to Roché in hopes that she might find another object for her romantic yearnings. In *I Shock Myself* this is rendered thus: "Marcel knew I was in love with his good friend Roché and did not approach me amorously. Secretly I wished he would. My love for Roché could not keep me from being a little in love with Marcel."

Duchamp, too, left a contemporary record of his life in the shape of the artworks he produced. They obviously reflect the frame of mind in which he made them, but as they are also, like their maker, open to infinite interpretation, he remains an enigma. He never wrote any autobiographical account of any aspect of his life, and often said different things to different people. The principle he applied to all his works, however, was that any and every interpretation was correct. And if, as Roché remarked to François Truffaut,[*] Duchamp's greatest work was his life—a verdict with which Duchamp himself heartily agreed—all his accounts should perhaps be taken as correct. Truth takes many forms, and Duchampian truth embraces most of them.

[*] Truffaut, introduction to Roché, *Carnets, les années Jules et Jim*.

Part One

PREWAR

1

THE ARMORY SHOW, 1913

I n 1912 Walter and Lou Arensberg bought Shady Hill, the enormous house in Cambridge, Massachusetts, that had previously belonged to Charles Eliot Norton, America's leading man of letters.

The Arensbergs were in their early thirties. They had been married five years, and were living in Pittsburgh, where Walter's father was president and part owner of a crucible steel company. Lou, née Stevens, the sister of one of Walter's Harvard classmates, was even wealthier: her family owned one of the largest and oldest-established textile mills in Massachusetts.

Neither Walter nor Lou wanted to stay in Pittsburgh. Lou missed her family, while Walter was still much involved with his alma mater and the East Coast's intellectual life. He published poems and translations in *Harvard Monthly*, which he had once edited, and described himself to the *Cambridge Tribune*, which carried an article on the Shady Hill sale, as "a journalist and writer and a student of Dante." Buying Shady Hill must have felt a little like buying into Harvard; perhaps he hoped he might channel the august spirit of its previous owner.

Apart from installing electric light, the Arensbergs kept the house much as it had been. But it must have echoed with the absence of everything that had filled it previously: children (Norton had six; the Arensbergs, none) and purpose. A comfortable but aimless life stretched endlessly ahead of them.

A little less than a year after they moved in, Walter received a call from an artist called Walter Pach, an old friend from his bachelor stint as an occasional journalist in New York. Pach wanted the Arensbergs

to visit, before it closed, a show he had helped organize: the International Exhibition of Modern Art, put on by the American Association of Painters and Sculptors at the 69th Regiment Armory on New York's Lexington Avenue.

The phone rings. Everything else follows.

The Armory Show opened on February 17, 1913. It had two aims: to break down "the stifling and smug condition of local art affairs as applied to the ambition of American painters and sculptors,"[*] and to exhibit the kind of new European art of which most Americans knew little or nothing. Among the exhibitors were Picasso, Matisse, Kandinsky, Brancusi, Kirchner, Cézanne, Braque, Gris, Picabia—and Marcel Duchamp.

Walter Pach had spent some years in Paris, knew all the artists there, and was deeply familiar with the European art scene. He had helped select the European artworks, had arranged the logistics of getting the vast stash of paintings and sculptures onto a ship, and had then boarded a faster ship in order to greet them in New York. There followed a fortnight's terrified wait during which the Atlantic was beset with storms, the ship carrying the artworks did not arrive, and everyone feared she had sunk. Finally, however, she berthed. The pictures were hung, the sculptures placed, the critics invited.

The show received plenty of notice, but for the first two weeks hardly anyone came. And then, on the second Saturday, "the storm broke . . . Old friends argued and separated, never to speak again. Indignation meetings were going on in all the clubs. Academic painters came every day and left regularly, spitting fire and brimstone—but they came—everybody came."[**]

The Armory Show wasn't the only artistic event to arouse violent antagonisms that year. 1913 also saw the riot that greeted the opening performance, in Paris, of Stravinsky's *Sacre du Printemps*. That was so

* Kuhn, *The Story of the Armory Show*, 4

** Kuhn, 17

unlike any music the audience had ever heard before, and created such new difficulties for the orchestra, that the musicians broke down several times, and various factions in the audience took the opportunity to vent other furies, not least with Diaghilev, the impresario who had commissioned the work. By contrast, the Armory Show controversy had comparatively little to do with the art. Rather, it was about politics. For those few weeks the battlefront in America's perpetual war, begun when the fundamentalist descendants of the Plymouth colony confronted the secularizing Founding Fathers and still ongoing, was an art show. Conservatives detested it: former president Theodore Roosevelt, reviewing the show for *The Outlook* as "a layman," declared these works "not Art!" And even if they were art, a vociferous faction thought them unacceptable. When, in April, the show moved to Chicago, the Illinois legislature's white slave commission and Lieutenant Governor Barratt O'Hara ordered an immediate inquiry. "We will not condemn the international exhibit without an impartial investigation," the lieutenant governor impartially declared. But although the investigator found a number of the pictures "immoral and suggestive," he was unable to unearth any connection to white slavery. One unforeseen consequence of his activities was an enormous increase in attendance. As Maurice Girodias, the publisher of upmarket pornography, cheerfully observed, "Ban a book and everyone wants to read it."*

In particular, Marcel Duchamp's *Nude Descending a Staircase* became a focus for the show's detractors. Aggressively Cubist, absolutely unpretty, and indefinably subversive—what was that joking title doing, *written on* as though this were some sort of comic book? This was art, or supposedly so, and everyone knew what nudes did in art. They reclined gracefully, and they were not made of squares! It might have been (and as we shall see, perhaps had been) designed to aggravate. If so, it triumphantly succeeded in its aim. Famously dismissed by a *New York Times* critic as "an explosion in a shingle factory," it was the subject of derisive cartoons in almost every American newspaper.

The modernists, for their part, also recognized its urgent relevance. The doctor-poet William Carlos Williams wrote of the Armory Show:

* In Hulten, *Paris-New York.*

"There had been a break somewhere, we were streaming through . . . I had never in my life before felt that way. I was tremendously stirred." And of the *Nude*, "I laughed out loud when I first saw it, happily, with relief."*

·:⫶:·

Some facts about the Arensbergs in 1913:

Walter was thirty-five. He had hamster cheeks, close-set eyes behind rimless glasses, thin lank hair that constantly fell into his eyes, and drank too much. His wife, Mary Louise, always known as Lou, was a year younger. She was extremely shy, and although she was an accomplished pianist and singer, and enjoyed playing the piano for close friends, she could never have brought herself to perform in public. A photo shows her arranged on a chaise longue: she has full lips and a dreamy expression. She was not, however, a beautiful woman. In the words of her lifelong friend Beatrice Wood, "Her nose was short and upturned, with lines on either side that ran down to her chin like streams trying to find a river, and her brown and curly hair was not flattering to her face. But she was direct and sincere, and it gave her great charm." Walter "was also charming, but he was not quite so sincere. His cordiality lit up for callers . . . Men liked his intellect, while women responded to his warmth like moths to light."**

Walter was brilliantly clever, but wanted above all to be a poet, a calling in which even the brightest intellect cannot guarantee success. His verse was accomplished, but (unlike that of his Harvard contemporary Wallace Stevens) derivative and unremarkable. He spent a year in Europe, returned to Harvard for graduate studies, which he did not complete, then plunged into cryptography and the Bacon-wrote-Shakespeare controversy. An avid Baconian, this would occupy the rest of his life.

Walter was a liberal; Lou, a conservative. They liked to joke that their votes canceled each other out.

·:⫶:·

* Williams, *Autobiography*.

** Wood, *I Shock Myself*, 27.

The Arensbergs were so wealthy that Walter did not need to work. But work gives life a framework. When everything is possible and nothing compulsory, where to begin? Walter—extremely intelligent, compulsively active, relentlessly well-informed—pursued his cryptography. For Lou, children would have provided a focus, but they didn't arrive, and she did not particularly enjoy social life. Nor was love a consolation—what Lou mostly recalled of their wedding night was that she had felt cold and Walter had refused to shut the windows.* Admittedly, this memory surfaced at a moment when her marriage was at a low ebb, but even so, it hardly suggests passionate transports. And everyone knew Walter chased other women. But he and Lou got on well enough. And given the endless time at their disposal, and since Pach was so insistent, why not visit the Armory Show and see what all the fuss was about?

The Arensbergs knew nothing about modern art. They owned some early American pieces that came from Lou's family and had bought one or two pictures, including a Whistler. The Armory Show was a revelation, especially for Walter. At long last, he knew what he had been born to do. He would become America's leading collector of avant-garde art.

The piece he really wanted to buy was, predictably, the most controversial: Marcel Duchamp's *Nude Descending a Staircase*. Unfortunately for Walter, it had been bought on the day the show opened, by a San Francisco lawyer called Frederick C. Torrey.** Instead, he bought a Vuillard print, and later, a painting by Duchamp's brother Gaston, who painted under the name Jacques Villon: first steps in what would become a spectacular collecting career.

It was clear that if Walter was serious about his new calling, the Arensbergs couldn't stay in Cambridge. The modern art scene, insofar as such a thing existed in America, was all in New York. In 1914, therefore, they sold up (Shady Hill was bought by a school) and moved to Manhattan, where modern people congregated.

* Roché, *Carnets*, September 17, 1918.

** Arensberg commissioned a replica from Duchamp "(No. 3)" now at Philadelphia Museum of Art.

At the turn of the nineteenth and twentieth centuries, studio buildings were all the New York rage. Completed in 1905, The Atelier, at 33 West 67th Street, was one of the most luxurious. Although *l'atelier* means "the studio," the building's residents, then as now, were more the artistically inclined wealthy than actual artists. It suited the Arensbergs perfectly.

The Atelier is now part of New York's Artists' Colony Historic District, and is little altered since the Arensbergs' day. Its thirty-four units range from single studio rooms with a sleeping alcove to luxurious three- and four-bedroom duplexes whose double-height reception-room/studios have huge windows two stories high. The Arensbergs' apartment was one of the three-bedroom units. Decoratively, the effect was somewhat random: the double-height walls showcased an expanding gallery of modern art (years later, Walter told an interviewer that he and Lou had disagreed over only two purchases,* which might mean that their taste was in perfect accord, or simply that she was usually happy to go along with him); the floors were covered with oriental rugs on which stood small sculptures, some of them African, some by Brancusi; and the furniture was a mix of Lou's dark, sparse Shaker pieces, her piano, and scattered armchairs and sofas.

Once they were settled in, and since Walter was a poet and a friend of poets, he began to finance, wholly or partly, two poetry magazines. *Others* published work by, among others, Wallace Stevens, Alfred Kreymborg, and William Carlos Williams; *Rogue* ("Advertise in *Rogue*, it doesn't pay") was edited by a young poet called Allen Norton. The poets and their friends routinely met downtown in Greenwich Village.

The Arensbergs' beautiful new apartment, their growing collection, and all these interesting friends made the next step obvious. They would collect not just art, but the people who made it. They instituted a nightly open house for friends, acquaintances, and the friends of friends, at which guests could be sure of food, drink, chess, music, and congenial company. "The Walter Arensbergs are at home a great deal, and . . . they are seldom

* For this section I have largely relied on Francis Naumann's article "Walter Conrad Arensberg: Poet, Patron and Participant in the New York Avant-Garde 1915–20," *Philadelphia Museum of Art Bulletin* 76 (Spring 1980), and Robert Buttel, *The Making of Harmonium*, Princeton, 1967.

at home alone," remarked art critic Henry McBride. "People seem to like to come to see them. In particular the new poets and the newest artists flock to the studio. In addition to the pleasure that young people evince in merely being together there is always the further excitation that comes from a consciousness of being in the van of the movement."*

For the poets and artists, who like all poets and artists were mostly broke, there was the added incentive of a good feed. And for the Arensbergs, instead of long, solitary evenings à deux, or where Walter chased company in the city while Lou lingered at home, there was the constant pleasure of filling not only the walls of their apartment with great artworks, but the void in their marriage, with the best company in New York.

* Henry McBride, "The Walter Arensbergs," *Dial*, July 1920.

2

MARCEL, 1912

Marcel Duchamp was born in Normandy in 1887, the third of six children of a notary. His brothers, Gaston and Raymond, were, respectively, twelve and eleven years his senior. A sister, Suzanne, two years his junior, was his special friend; there were also two much younger sisters, Magdeleine and Yvonne. Marcel had red hair; a long, straight Norman nose; a thin, wide mouth; and an overwhelmingly abstract mind. His chief interests were art, chess, and puns, visual and verbal.

The mother of this brood, a talented pianist, had become profoundly deaf and withdrawn. All four elder children found her cold and distant, and disliked her;* it may or may not be coincidental that none of the six chose to have a child of his or her own. Relations with their father, by contrast, were cordial.

Marcel was, in a small way, financially independent. The Duchamps were well-off, and as the children reached adulthood their father, in an act of unusual generosity, gave each of them the option of a small income, to be set against their share of what they would otherwise inherit after their parents died.

All four elder Duchamp children were artists. Gaston, who had taken the nom de guerre Jacques Villon, and Raymond, who sculpted as Raymond Duchamp-Villon, both lived in Paris, starting out in Montmartre, and then, when they married, moving out to the then-leafy and

* According to a local librarian who knew the family, in conversation with biographer Alice Goldfarb Marquis.

respectable suburb of Puteaux. The Section d'Or group, of which they were leading members, met there, and was also known as the Puteaux group. Marcel, who had joined them in Montmartre as soon as he was old enough to leave home, and who in 1908 also moved to Puteaux, was a member of the group, but by default rather than with active enthusiasm. He did not find groups congenial.

In 1912 the group decided to mount an exhibition. Marcel, who was interested in conveying movement on canvas, and whose picture was much influenced by the serial photographic experiments of Etienne-Jules Marey and Eadweard Muybridge, entered his *Nude Descending a Staircase* (one of Muybridge's photograph series was, in fact, of a nude girl descending a staircase). It was a Cubist painting but also reflected the fascination with machines and movement that Marcel shared with his inseparable friend Francis Picabia. With Picabia, one of life's great dilettantes, this enthusiasm manifested largely as a taste for fast cars and visual puns. Marcel, however, was more interested in how to express it graphically. He had been experimenting with them for some time, and his *Nude* was the latest in a series of canvases that tackled it.*

The painting was rejected by the organizers, ostensibly because they were uneasy about the title, which he had inscribed in the bottom left-hand corner, though probably because its teasing satire of that quasi-sacred artistic concept, The Nude, made them uncomfortable. They felt that the title spelled out not just the picture's subject but Marcel's lack of sympathy with the group's serious aims, and wanted him to paint it out. His brothers were deputed to convey the unwelcome news, which they did dressed in undertakers' black. Marcel, however, refused to participate in this funereal melodrama. "The general idea was to have me change something to make it possible to show it because they didn't want to reject it completely," he remembered. But he had no desire to change anything. "I said nothing. I said all right, all right, and I took a taxi to the show and got my painting and took it away."**

* The Italian futurists were also, at this time, tackling this same problem in a very similar way. But the globe was not yet a village, and Duchamp knew nothing of what was going on in Italy.

** Cabanne, *Dialogues with Marcel Duchamp*, 81–83.

Could he really have been as unaffected as he appeared? It is perfectly possible. The world's approval was always somewhere near the bottom of his list of priorities. And if he had written in the title because he knew it would annoy, he had triumphantly succeeded. This was the first public display of his particular talent; namely, his unerring ability to slide needles under the art world's fingernails. His capacity to disturb (and, along the way, to intrigue) was, and would remain, world class.

The rejection of his picture was just the first of the seismic events 1912 held in store for Marcel. The second took place in June, when, with his friends Francis and Gaby Picabia and the poet and cultural impresario Guillaume Apollinaire, he attended a performance of Raymond Roussel's extraordinary theatrical work *Impressions d'Afrique.*

Apollinaire, Picabia, and Duchamp were the three wittiest and most iconoclastic players on the Paris art scene. They had recently become inseparable friends, linked in a sort of four-way love affair whose center was Picabia's remarkable wife, Gabriële Buffet (generally known as Gaby). Unusually, this was a marriage of equal talents. Gaby, the clever and articulate daughter of a prominent intellectual family, was a gifted musician, a pupil of Vincent d'Indy at the Schola Cantorum, while Picabia, half-Cuban, half-French, was a painter of such facility that from the age of twenty he had made a living, and a name, painting Impressionist-style pictures. In 1909, however, he had abandoned Impressionism and joined the Puteaux group, where he had met the Duchamp brothers. He and Gaby married that same year. Picabia's teeming brilliance so enchanted her that she willingly gave up her career to be with him.

The Picabias, who by 1912 had two children, became a sort of second family for Marcel, who was eight years Francis's junior (and six years younger than Gaby). "Marcel was much less liberated than one imagines," Gaby said years later. "He had remained a provincial young man, very attached to his family and his brothers, for whom he had great respect, while at the same time he was a revolutionary at heart. Clearly he felt that with us he could be himself, which was impossible for him when he was with his brothers. Francis' influence on him was extraordinary,

and mine too, given the customs of the time: a woman who dared to have her own ideas . . . I believe that it was I who extracted Marcel from his family."*

Roussel, one of literature's more bizarre figures, had chosen to devote his strictly abstract mind (like Marcel he was a gifted chess player, and also composed music) to the distinctly un-abstract business of making books and plays. He explained his methods in a booklet entitled *Comme j'ai écrit certains de mes livres*. He would begin by selecting two almost identical words—the examples he gave were *billard* (a billiard table) and *pillard* (an African chieftain). He then constructed two sentences in which all the words except the near homonyms were the same, but in which all the meanings were different:

1. Les lettres du blanc sur les bandes du vieux billard . . .
2. Les lettres du blanc sur les bandes du vieux pillard . . .

In the first sentence, *lettres* means "typographical signs," *blanc* is white chalk, and *bandes*, edges. So the sentence means, "The white letters chalked on the edges of the old billiard table." In the second, *lettres* means "missives," *blanc* is a white man, and *bandes* are armies. This sentence means, "The white man's letters about the African chief's armies." The next stage, Roussel explained, was to write a story beginning with the first phrase and ending with the second. This was the basis for *Impressions d'Afrique*, whose action begins with "a stormy night in equatorial Africa" and ends with "the fête given by the members of the Club des Incomparables, with its sideshows: the wind clock from the Land of Cockayne, Monsieur Bex's thermo-mechanical orchestra, the earthworm which plays the zither . . ." Roussel paid for the play to be put on (the title can also be read as a pun: *à fric* means "at his own expense").

Marcel was enchanted. "It was tremendous," he remembered. "On the stage there was a model and a snake that moved slightly—it was absolutely the madness of the unexpected. I don't remember much of the

* Interview with Jennifer Gough-Cooper and Jacques Caumont, "Ephemerides," in
 Hulten, *Marcel Duchamp*.

text. One didn't really listen."* Roussel's work excited him in a way that painting never had. The notion that abstract complexities and elaborate jokes might become artistic tools struck an immediate chord with his own complicated and joke-inclined intellect. The fact that the audience had to work out for themselves what was going on also appealed to him. In the artistic philosophy he would develop over the coming years, the artist provided only what he described as "raw art," a sort of artistic molasses which it was then the spectator's job to refine into sugar." His art, like Roussel's, was about ideas, and as ideas are infinitely open to discussion, the viewer was no mere spectator but played an active part in the creation of the artwork.

It was perhaps inevitable that Marcel would fall in love with Gaby. The Picabias were his ideal couple, and as well as being kind and welcoming (he now spent much of his life in the Picabias' apartment), she was the cleverest woman he knew, and very attractive. Shortly after the Roussel adventure, he telephoned her to confess his feelings.

Gaby's great-granddaughters, in their biography of her, suggest that she returned his affection. Indeed, it's not unlikely. Although the Picabias had been married only three years, and Gaby was and would remain in love with her fascinating husband, it is perfectly possible to love two people at the same time. Marcel was the Picabias' closest friend: witty, talented, and (at that time) disarmingly beautiful. Who would not love such a person? However, she did not encourage him. Unlike Picabia, Gaby took marriage very seriously; not only was she determined to remain faithful to her husband, she was even prepared to discount his multitudinous infidelities, of which she was only too well aware. She felt sure that whatever the body's vacillations, they would remain united in spirit. And in any case, she disliked what she called "these clandestine things."***

Marcel decided to go away to Munich, where an acquaintance had offered him a quiet place to live. He asked to meet Gaby before he left,

* Cabanne, *Dialogues with Marcel Duchamp*, 33.

** "Raw art," in Lebel, *Sur Marcel Duchamp*, 77–78.

*** This and her other comments on this event from an interview with Jennifer Gough-Cooper and Jacques Caumont, quoted Tomkins, *Duchamp*, 111–12.

but she refused. She agreed, however, that he might write to her in Kent, where she proposed to spend some weeks with her two young children.

Marcel left Paris for Munich on June 21. He spoke no German, and all he said about his stay was that "Munich had a lot of style in those days. I never met a soul and had a great time." The important thing about Munich, however, was not its style, but that it freed him from the distractions of Paris and gave him time to collect his thoughts. The Section d'Or's rejection of his picture had crystalized his dislike for artistic groups in which, unless one was a big name, one lived precariously from sale to sale, thus reducing art to product for the market. Hence his otherwise inexplicably unperturbed reaction to the refusal of his *Nude*.

Not that he meant to give up art. But from now on he would work entirely to please himself. Released by his inability to speak German from the temptations of social life, he began to sketch out some new ideas. Unsurprisingly, given recent developments in his love life, they involved an unattainable woman and male desire. He made a drawing with the legend "Première recherche pour: La mariée mise à nu par ses célibataires," two drawings entitled *Virgin*, and a small painting, *The Passage from the Virgin to the Bride*.* The intellectual and artistic journey of which these were the first intimations would find its expression in *La Mariée mise à nu par ses célibataires même* (The Bride Stripped Bare By Her Bachelors, Even). This work, also known as *The Large Glass*, would occupy him, on and off, for the next decade. If a thought could be formulated, he reasoned, then it should be possible to give that thought solid form. The thoughts themselves were noted down as they arose. Marcel was creating a new world—one where, in Gaby Picabia's words, "machine organisms have extremely human adventures"**—and it needed a user's manual.

Unlike the headlong Picabia, who was also fascinated by the world of useless machines, but who favored quite simple visual puns—thus *La Nourrice Américaine* was a drawing of a lightbulb with a nipple-shaped protrusion—Marcel's machines were part of a complex and subtle

* For a full discussion of this period, see Richard Hamilton, "The Large Glass," in *Marcel Duchamp*, ed. d'Harnoncourt and McShine.

** Buffet-Picabia, *Rencontres*, 93.

intellectual exploration. He proposed, he said, "To strain the laws of physics . . . My approach to the machine was completely ironic. I made only the hood. It was a symbolic way of explaining. What went on under the hood, how it really worked, did not interest me. I had my own system quite tight as a system, but not organised logically."* It included chance, different perspectives, the fourth dimension (a quasi-mystical idea then fashionable, and distantly related to a physics that has since acquired many dimensions), all with overtones of lubricious double entendre. In Henri-Pierre Roché's unfinished novel about Duchamp, *Victor*, Marcel/Victor explains that his work is an "epic of desire, a fairy-tale and a mechanical ballet."

From Munich, Marcel wrote Gaby two letters that she found very moving. He said he badly wanted to see her alone, and compared their situation to that described in André Gide's very Protestant novel, *La Porte étroite*, a study of sexual frustration that had been published to great acclaim in 1909. In the novel, two sisters are in love with the same boy, who loves only the elder of the two. The sister he isn't in love with sadly marries another; the elder sister perversely withholds herself, turns to religion, and fades away into an early death.

It would be hard to imagine anything less like the uproariously anti-conventional Francis/Marcel/Gaby threesome than Gide's religiose drama of pointless self-sacrifice, but it was clear enough what he meant. Gaby replied from her mother's house in the Jura, where she and the children had by this time moved on from Kent. She told him she proposed making a brief trip to Paris. There would be an hour or so between trains at a station called Andelot, where the branch line from her mother's village met the Paris main line. If Marcel wished, he could meet her there.

Munich is seven hundred kilometers from Andelot: a ridiculously long way to come for such a brief meeting. But to Gaby's astonishment, when she arrived at Andelot Marcel was waiting for her on the platform. He had been traveling forty-eight hours, from Munich to the border at Lake Constance, through Austria and Switzerland, and finally to Lake Geneva

* Interview with Francis Roberts, quoted in Penelope Haralambidou, *Marcel Duchamp and the Architecture of Desire*, 37.

and the French border. "It was utter madness to travel from Munich to Andelot just to spend a few hours with me."

They spent the night in the station, talking on a wooden bench. The Paris train left at two in the morning, but Gaby didn't take it, waiting instead for another that came later. Although visibly consumed with desire, Marcel didn't touch her. "It was somehow slightly inhuman, to be sitting beside a man who you know desires you that much, and yet not touch each other . . . I thought, I must be very careful with everything I say to him because he understands things in quite an alarming way, in an absolute way." But her answer remained No.

It was Marcel's third great rejection. Maternal love had failed him; painting had failed him; now romantic love had proved as treacherous as the rest—though one can't help wondering if he would have risked such self-exposure if he had thought he would be required to act on it. However much he loved Gaby, he was and remained devoted to Picabia, whose unbridled mind and hedonistic lifestyle of fast cars, opium, and drink he envied and admired. Always interested in entering other skins, perhaps his courting of Gaby was really a way of trying out another life possibility: that of being Picabia.

He returned to Paris, moved into a studio in the rue Saint Hippolyte, installed a bicycle wheel on its fork that when he turned it reminded him of the flickering open fires he loved at home in Normandy, and took a job at the Bibliothèque Ste-Geneviève, a post obtained for him through Picabia, whose uncle was the library's director. His hours were 10:00–12:00 and 1:30–3:00, and he was paid five francs a day. In his copious free time he made the most of the library's collections, including such rarities as *La perspective curieuse, ou magie artificielle des effets merveilleux*, published in 1638 by Jean-François Niceron, in which Niceron demonstrates various mathematically exact but wonderfully unsettling perspective effects.* He also began work on the layout of what would become his *The Large Glass*, on the perspective of the Bride,

* For a discussion of Niceron's influence on Duchamp, see Stephen Jay Gould and Rhonda Shearer, "Drawing the Maxim from the Minim: The Unrecognised Source of Niceron's Influence upon Duchamp," *Tout-Fait: The Marcel Duchamp Studies Online Journal* 1, no. 3 (December 2000).

hovering on top, and the quite different perspective of the eight Bachelors beneath—one that would fit them all into the frame (so comfortably, in the event, that he went on to add a ninth).

He would not risk love again for thirty years. Henceforth, he would be "antimarriage, but not antiwomen. Quite the contrary, I was exceedingly normal."* By which he meant heterosexual: *normal* was not a word anyone would otherwise use to describe Marcel Duchamp.

* "Antimarriage . . ." Cabanne, *Dialogues with Marcel Duchamp*, 33.

Part Two

WARTIME

1
MARCEL, 1915

When war broke out in 1914, Marcel, to his relief, was rejected for military service on account of a heart murmur. However, one can hardly wear a notice reading HEART MURMUR, REJECTED on one's chest: what people saw was a young man, in apparent good health, who had somehow evaded the fate of all other French young men and was not in the trenches. Women waved white feathers at him; Gaston's wife, whose husband was at the front, thought him a coward. He found it unbearable. Paris, he said, felt "like a deserted mansion. Her lights are out. One's friends are all away at the front. Or else they have been already killed. I hadn't anyone to talk to and was frightfully lonely."*

Go to America, advised the Picabias. They had visited New York for the Armory Show and had been enchanted—by the jazz, whose syncopations Gaby adored (she was especially excited by tap dancing), and which Francis tried to reproduce on canvas; by the nightlife; by the lovely girls with their long, long legs and thoroughbreds' ankles; by the womens' elegant clothes; by cars with self-starters . . . Francis, also anxious to escape the draft, had got himself commissioned by the French government to go to Cuba, where he would use his family connections to procure a supply of sugar. After that, he planned to revisit New York. Perhaps they would meet up there. In the meantime, he would help Marcel with the fare.

* "Paris is like a deserted mansion . . ." *New York Tribune*, October 24, 1915.

⁘

Marcel began by sounding out Walter Pach, the only person he knew in New York. The Pachs had just had a baby son, whom they had called Raymond after Marcel's elder brother, Raymond Duchamp-Villon.

Bibliothèque Ste-Geneviève, January 19, 1915[*]

My dear friend,

First of all, many congratulations on becoming a father, do give Madame Pach all our best wishes for young Raymond—you must be so happy.

Jacques Villon should have written to you, he's still near Amiens, though for the past fortnight he's been on furlough 20 kilometres behind the lines. Nothing's changed—it's a bloodbath, I can't bear to talk about it.

Raymond's still at St Germain, from time to time he seems to be on the point of leaving, but nothing's happened so far. Yvonne is still at the hospital, she loves being a nurse, I spend every evening with them.

Life in Paris continues annoying. Yesterday they announced that all lights are forbidden because of the Zeppelins ...

I haven't seen any artists for ages. I don't know if Brancusi is still in Paris. I don't think so. I'll go and see one day.

I'm writing to you from the Bibliothèque, where life is even more relaxed than in peacetime. There's hardly anything to do.

We're delighted to hear of the sale of the watercolour and the prints, your efforts haven't been in vain, my dear Pach.

No exhibitions here, I need hardly say. The only colour in town is flags. There are some Sunday concerts, but obviously no German music.

Best wishes to Madame Pach, lots of kisses to little Raymond, and a thousand friendly regards to you—Marcel Duchamp.

Nothing much changed in the next couple of months. Marcel's brother Raymond was stationed just outside Paris at Saint-Germain-en-Laye as a

[*] All translations from the French, here and throughout, are my own.

behind-the-scenes medic, while his brother Jacques Villon continued in the trenches. Marcel meanwhile remained awkwardly in Paris.

St–Hippolyte, Friday, March 12

My dear friend,

I read the letter you sent Raymond. And I've also seen the reproduction of my painting in the newspaper.

Here the war goes on and on. Excellent news of Villon, his morale's good, he's almost cheerful. We're all bowled over by his spirit. Everyone's talking about a big spring push, which is supposed to be decisive, but I remember the same confidence last August . . .

I've been doing a lot of work on my bits of glass, I'm getting started on the top of my picture . . .

Raymond's happy in St Germain, we play poker and the war seems a long way away . . .

But of course the war was not a long way away, it was very near— Amiens is only seventy-two miles from Paris. And Marcel was beginning to find the situation unbearable.

Friday, April 2

My dear friend,

There's something I particularly need to say. I've decided to leave France. And as I told you last November, I'd very much like to try life in New York. But only if I can earn a living. So, firstly, how easy might it be to find a job as a librarian, or something similar, that would leave me enough time to work? (I don't speak English, though I did it at university level (don't laugh!!) but I've spent two years learning librarianship at the Bibliothèque Ste Geneviève.) Secondly, I won't leave here before the end of May at the earliest. Do you think that would be a good time to come, or should I leave it till September?

I haven't spoken to anyone about this, so please don't say anything about it in a family letter, my brothers mustn't know anything before it's all arranged.

April 27, Café-restaurant L. Mollard, rue St–Lazare, Paris

My dear friend,

Your letter arrived this morning. I feel you're trying to discourage me! You miss Paris. I can understand that, because when you were here you led the free life of an artist, with all its ups and downs that are such fun to remember. But my stay in New York is a very different matter. I'm not going there to look for something I can't find in Paris. All I'm expecting to find there are people. I'm not going to New York, I'm leaving Paris. It's a very different thing.

In fact I was fed up with the artistic life long before the war. It's not the kind of life I want at all. I went to the Bibliothèque to try and get away from artists. Then when the war came I felt even more out of place. All I want is to get out, and the only place I can think of is New York, where I know you, and where I hope to avoid the artistic life by doing a job that will fill my time.

I asked you to keep this secret from my brothers because they'll be very upset, as will my father and sisters.

But if you really don't think New York would be possible, I'll have to try elsewhere.

I must have a job, though, because my father's already helped me more than enough. I'm very happy that you've sold my canvases, I can't thank you enough. But I'd hate to find myself obliged to sell pictures in order to live, that is, to be an artist.

Please thank Madame Pach for finding out about possible jobs at Brenta-no's. But don't forget I don't know a word of English, that's the most annoying part of this whole thing.

Paris, May 21, 1915

My dear friend,

I've received your letter of May 7. I can understand your uncertainty. The only way is to take things as calmly as possible, and keep hoping.

I saw Raymond at St Germain and told him I was leaving. He thought it a good idea but hates that it's so soon. He thinks I should wait. As I expected, there's a great deal of family emotion, which I share. But I've weighed it all up, I can't change my plans now.

There's no boat on May 29, but the Rochambeau leaves on June 5, and I'll almost certainly leave with her.

I also spoke to him about Arensberg's magazine. Mercereau might do an article, and so might Gleizes. I'll try and contact friends who might come up with some poems or prose pieces. We need to find someone who would undertake to correspond regularly with Arensberg. When I leave on the 5th I'll try and bring something with me for the magazine. (The problem is, they're all away at the war.)

When it comes to my stay over there, I've decided to take any job, and if it doesn't leave me time for my own work, too bad. I hate causing you all this trouble, but not for long, I hope.

2

MARCEL, NEW YORK, 1915

The New York papers kept a sharp eye on the passenger lists of incoming vessels, and anyone of the slightest celebrity was usually greeted by massed journalists shouting questions. The Picabias, when they came over in 1913 to see the Armory Show, had been greeted from the pilot's boat as their ship prepared to dock—"What do you think of American women, Mrs. Picaybia?"—after which the press pack had followed them to their hotel, the Brevoort, a favorite haunt of visiting French, where they spent the whole of their first day answering the phone.* They were astonished. How could avant-garde art have made them into celebrities? But Picabia's *Dances at the Source* had been hung next to Marcel's *Nude Descending a Staircase*, which it somewhat resembled, and had shared its celebrity, selling, like the *Nude*, on the first day. And insofar as this was an art world fight, Picabia also shared the lack of gravity that had made Marcel's *Nude* suspect in the solemn French art world. In America, by contrast, levity was welcomed by both sides of the fight: for the modernists it represented a finger in the face of tradition; for traditionalists, a focus of attack as the embodiment of everything which made them nervous and angry.

An astonished Marcel, arriving two years later, received the same treatment. Of course he knew that the pictures he had sent to the Armory Show had sold, and sold, what was more, for what seemed like improbable amounts of money. But nothing had prepared him for the crowd of

* All Gaby Picabia's observations in this section are taken from Buffet-Picabia, "Un peu d'histoire," in *Paris–New York*.

shouting journalists, eager for quotes from the maker of the scandalous *Nude Descending a Staircase*, who besieged him as soon as he set foot in New York. He soon escaped them, however, and after an initial stay at the Arensbergs' apartment while they were out of town for the summer, Walter Pach found him lodgings at Beekman Place, where getting to his room involved what Gaby Picabia described as "a long, terrifying walk at the end of which it was necessary to brave a narrow, swaying footbridge."* What this "footbridge" actually consisted of, she did not say; perhaps she meant that one approached his room via one of those alarmingly rickety fire escapes that zigzag up the back of New York apartment buildings. After a few months he would move back to the bourgeois solidity of The Atelier, this time in a small studio apartment of his own, his rental paid by Walter Arensberg, to be set against any works Marcel might produce in the future.

For Arensberg, Marcel's arrival was a dream come true. Here, wafted three thousand miles across the Atlantic from Paris, was the embodiment of everything that had changed his life—had given it a direction, moved him from Shady Hill to New York, made him a collector, inspired him to open a salon. Happily, the two of them hit it off at once, for Walter's chief interests, chess and ciphers, were also Marcel's. Walter wanted to buy everything Marcel had ever made, and he and Lou unquestioningly followed his advice on what other artworks to acquire. Marcel at once suggested Constantin Brancusi's sculpted portrait of Mademoiselle Pogany, which was also, unmistakably, a giant erect penis. Walter bought it, and salon habitués watched, astonished, as Lou, whose family was very correct, explained it to uncertain visiting Bostonians, pointing out the nose, the eyes, the shoulders, and seemingly quite oblivious of the work's other anatomical significance.

The Arensberg salon was transformed. From being slightly provincial—as the Picabias observed, the avant-garde scene in America, while interesting, was very small—New York became, as more and more Paris refugees arrived, an international hot spot. Avant-garde painters like Joe Stella, Charles Sheeler, Charles Demuth, Walter's cousin John Covert, the photographer and gallerist Alfred Stieglitz, and poets like

* In Gough-Cooper and Caumont, "Ephemerides."

William Carlos Williams now mingled with expats like Picabia and Albert Gleizes (who in 1912 had declined to hang the picture Marcel referred to as *cette demoiselle*), and their various wives and girlfriends. Every night was party night, with Marcel the magnetic center around whom everything revolved, speaking a slow and highly idiosyncratic English and occasionally producing, with appropriate flourish, a triumphantly grammatical sentence. It was hard, said Gaby, to believe this was the same shy, retiring person, abstemious and awkward around women, whom they'd known in Paris. America had transformed him into someone completely different, relaxed, lighthearted, partial to a drink, and infinitely seductive.

Marcel loved New York. People, he liked to say, knew his picture but not him: when he got tired of being feted at the Arensbergs', all he had to do was step into the street, and (unlike in Paris, where everyone knew everyone) anonymity was his. He spent happy hours playing chess in Washington Square, took a part-time job at the Pierpont Morgan Library, and gave French lessons at $2 an hour. Two or three lessons a day provided quite enough to live on. "It is $1.50 a person if there is more than one—$2.00 for single lessons," his devoted pupil Katherine Dreier told her sister. "We are reading a very amusing French story which I am afraid will shock you, so you must be prepared . . . It is very humorous, but quite French in a naughty way."* "Love lessons for Americans," Picabia called these lessons, and Miss Dreier was indeed in love, though as she was ten years older than Marcel and rather large, her feelings were not requited.

Allen Norton's estranged wife, Louise, was more successful, both in French and in love. Tall and slinky, with a head of unruly curls, a red, red mouth (lipstick, which until not many years earlier no decent woman would have worn, had become a badge of female emancipation), and wispy froufrou dresses that left little to the imagination, she was the

* "$1.50 a person . . ." Katherine Dreier to Mary Dreier, January 13, 1918, quoted in Tomkins, *Duchamp*, 201.

toast of the Greenwich Village poets who published in *Rogue*, the little
magazine financed by Walter Arensberg and edited by Allen. She had
written a play, *The Wax Candle*, about art and love, whose set, all mist
gray and mother-of-pearl, with a Whistler on the wall, green orchids and
a bed with a mirrored headboard, was the epitome of decadence, then all
the rage. (The three sonnets that formed "A Portrait of Louise Norton"
in *Sonnets from the Patagonian*, a collection published by Donald Evans,
another member of the Greenwich Village set, were suitably entitled
Buveuse d'Absinthe, *The Jade Vase*, and *Extreme Unction*.)

The truth was that Louise was busy making up for lost fun. A sentence
in the short biography appended to her papers by her alma mater, Smith
College, tells the too-familiar story: *She attended Smith College (class of
1912), leaving in the fall of 1911 to marry Allen Norton. A son, Michael, was
born in 1912.* Fortunately for her, however, she was rich—for Louise, like
Walter Arensberg, came from Pittsburgh, and like him was the happy
recipient of steel money, which gave her a freedom of action denied to
most women, not least in the shape of a townhouse on 88th Street owned
by her mother, of which she had the use.

Since young Michael seems never in any way to have interfered with
her bachelor-girl life, she was presumably able to consign him to the care
of a nurse, and when *Rogue* began publication in the summer of 1915,
embarked on a journalistic career as Dame Rogue. Dame Rogue's column
was entitled *Philosophic Fashions*, but it had little if anything to do with
philosophy. Rather, it set out its author's design for the ideal life, a dream
of leisure and sensuality in the greenery-yallery setting she favored. The
Dame's motto was "Beauty for the eye, satire for the mind, depravity for
the senses," and it is clear that Louise's ideal life, a dream of child-free,
servanted luxury, was as far from a young mother's as could be imagined:

> *She returns, Seraphita, your maid; she spreads a soft mat in front
> of the fire and on it she places your tub. We must each of us choose
> the tub of our heart's desire, and I cannot tell whether yours would
> be of bronze or Limoges, tin, marble, silver or Russian enamel,
> but as for me, having seen Claudine's tub by Roubille, I could be
> satisfied with nothing more or less lovely than a tub of wood . . . It*

*must be quite delicious to lie in salted and scented water or chilled
milk (if there are guests) . . .*

Louise recounted, feelingly, the story of an Irish chieftain
who, the day after his wife had given birth, sent her out to
lead his armies while he himself took to the childbed—
*"The first man on record to have unquestionably demonstrated the
superiority of woman."* As so often, however, real life fell sadly
short if the ideal. *Now that houses are built around bathrooms
with the unique ideal of cleanliness, bathing has lost its sensuous
appeal and become a commonplace domestic fact, like sleeping
with one's husband . . .*

Alas poor Allen, reduced to a commonplace domestic fact! Evidently
the seductive figure of college days had not lived up to his early promise.
Was it a coincidence that in the same issue in which Dame Rogue pub-
lished her bathtub meditations his poem "Amy" wistfully traced the tra-
jectory of a love affair from rapturous beginnings—"Amy, when we first
met / In the painted heather, / Birds were all a blossom, / And ships were
like the Spring"—until "Amy, when we last met / In the Paris heather,
/ Nothing old was over / And nothing old was new; / There was there
the darkness / That had no wind for weather, / And Amy when we last
met—*Tu* was *vous!*" (*Tu* being the intimate form of address one would
use with a lover, while *vous* is more formal.)

Louise met Marcel at the Arensbergs' soon after his arrival in New
York, and they soon became great friends. By 1916 she had abandoned
Allen and was living alone on the ground floor of the 88th Street house,
where she leased two of the floors to the Picabias and the Gleizes,
and where, presumably now securely in possession of birth control
equipment, she and Marcel enjoyed delightful sex quite devoid of
encumbering romance. He introduced her to modern art in the shape
of Stieglitz, "a great photographer and the John the Baptist in the
American desert of modern art," and also gave her French lessons. "My
education continued in Marcel's studio, not verbally but by osmosis . . .
Marcel was only didactic about the French language and taught me
all the expressions no lady needs to know, which made Albert Gleizes

warn me: 'Madame Norton, if you speak like that all the doors of Paris will be closed to you!'"*

The only 88th Street inhabitant not to enjoy herself was Gaby Picabia. In 1913 New York had seemed like heaven, and she had looked forward to joining her husband there when his Cuban business was finished. When she arrived, however, she found that he had been in New York all along, any thought of Cuban sugar quite vanished from his mind. Horrified at the possible consequences of this disdain for wartime orders, she forced him reluctantly onward to Cuba. But when they returned, Picabia's eye, always inclined to rove, was seriously caught by Isadora Duncan. Gaby had always felt their relationship was strong enough to rise above mere sexual infidelities, but it was hard not to be upset at his persistent absences. Was it for this life of constant infidelities that she had abandoned her children to a Swiss pension? But Picabia was restless and easily bored, and if you wanted to be with him, which Gaby did, you had to be prepared to travel light.

* All these quotes from Louise Varèse, "Marcel Duchamp at Play," in *Marcel Duchamp*, ed. d'Harnoncourt and McShine.

3

BEATRICE, 1916

On what would turn out to be the most important day of her life, September 27, 1916, Beatrice Wood noted in her diary that she lunched, as she did most days, with her friend Beth Reynolds. Beth was caught up in the excitement of planning for married life and wanted to show off the apartment she and her fiancé, Norman Hapgood, had just taken. In the afternoon, however, they parted, and Beatrice set off for St. Vincent's Hospital to visit a young French composer, Edgard Varèse, who was trapped there with a broken leg.

Like Marcel and Varèse, Beatrice was in New York because of the war. She had spent the previous two years in Paris, studying acting and painting and perfecting her French while her mother went shopping and gossiped with other American expat wives. She had loved it, not least because her mother, with whom her relations were, to put it mildly, ambivalent, had returned to New York after a year, leaving her lodged with a family doubtless quite as conventional as her own, but whose company Beatrice enjoyed because the demands it made were social and not emotional.

Monsieur and Madame de Nieuport had had two sons. They had been keen pilots and had both died in plane crashes; the Nieuports hoped a young lodger might brighten their sad lives. Beatrice loved them, and they loved her back. They introduced her to the aristocratic salons of the Faubourg Saint-Germain, which though doubtless as excruciatingly dull as New York bourgeois drawing rooms, were dusted with the glamour of foreign titles. Every morning Madame de Nieuport would adjust

Beatrice's veil and straighten her outfit before sending her off to walk the Nieuports's little dog in the Bois de Boulogne; when she went riding there (sidesaddle, naturally), she was often escorted by a count who gallantly helped her off her horse. Was he about to propose? Almost certainly not—but the war intervened before she could find out.

In August 1914, Beatrice was at the seaside in Normandy. Despite the war, she would have given anything to stay in France and help tend the wounded. But that was deemed impossible. Instead she was shipped back, raging, to the family home on the Upper East Side, where her parents conducted their very own war.

Beatrice stares out from her photographs, wide-eyed, ingenuous, and topped off by a variety of absurd hats. In 1916 she was twenty-three years old, outgoing, adventurous, trusting, and on the lookout for all the things twenty-three-year-olds commonly desire: love, independence, fame. She had never experienced the first, had had fleeting glimpses of the second, and would eventually, but not for another half-century, attain the third.

Easily elated and as easily cast down, she was bent on making some form of artistic name for herself, only to have her excursions into the artistic life constantly quelled by her mother. Mrs. Wood (whose given name, improbably, was Carrara) played with allowing Beatrice her freedom, but whenever her independence seemed to be getting too marked, the leash was abruptly shortened. The pattern was always the same. Mrs. Wood would give Beatrice her head, then be seized with terror and pull her, fuming, back to heel. She gave permission for Beatrice, duenna in tow, to study art in Monet's Giverny, then rushed to haul her back to Paris when she gave her duenna the slip and took, on her own account, a suitably artistic attic room; agreed to let her study theater design with Gordon Craig in Florence, then, hearing of Craig's reputation as a womanizer, canceled her ticket at the last minute; agreed to let her act in New York, but insisted a maid accompany her to the dressing room. If compliance was not immediate, Mrs. Wood would fall ill or threaten divorce. In old age, Beatrice looked back sadly on this fraught relationship. "She loved me so much and believed I was a special, talented person who had to be protected. The last thing I wanted was her protection. Yet it was difficult for me to completely defy her for I truly

loved her . . . We both suffered terribly, but perhaps my mother more, for she suffered the anguish only a mother can feel. She was a beautiful and generous woman, with great charm and style. Her friends loved her, and thought me some sort of monster, which in a way I was. The real monster was the generation gap."*

Fortunately for Mrs. Wood, a framework had been laid down for New York mothers wishing to find their daughters a wealthy husband. In the absence of a landed aristocracy, the ineffable Ward McAllister, whose aim was to conjure up social class and snobbery where none had previously existed, had created New York's own ironclad system of social exclusion. The condition of entry was money—the further back its dark origins, the more acceptable. Hopeful mothers pined for entry, and Mrs. Wood, having achieved an invitation to a debutantes' ball, insisted that Beatrice, in pale blue satin and a pearl-net Juliet cap, attend it.

Beatrice's best friend, Beth Reynolds, was also making her debut, and supplied helpful hints on how to make conversation with dull young men one didn't know. Pick any topic at random, Beth said. Their watch, their tie, the color of their shoes. You'll be amazed. Beatrice duly tried this, and to her astonishment it worked. The trainee stockbrokers and entry-level bankers who were her partners were delighted to talk about their watch, more or less ad infinitum—its provenance, its jewels, the family watch history—an experience that confirmed her determination not to spend her life in their company. But in that case, what other avenues were open to her?

One possibility was to marry someone who was not a boring stockbroker. This, as it happens, was what Beth Reynolds would soon do.

Like Beatrice, Beth was ambitious, and like her, had spent the two years preceding World War I in Paris. Unlike Beatrice, however, Beth had spent little time shopping. Very clever and focused, she had studied Russian at the Ecole spéciale nationale des langues orientales vivantes, which provided training for the diplomatic service. After completing a nominally three-year course in two years she returned to New York, where at the age of twenty-one she was appointed head of the newly created Russian Department at Columbia University. However, she only

* Wood, *I Shock Myself*, 33.

stayed in the job a year, for in 1916 she got engaged to the journalist and diplomat Norman Hapgood.

Hapgood was quite a catch. When Beth met him, he was the editor of *Harper's Weekly* and a close friend of President Woodrow Wilson (who would soon send him to Denmark, where he was, briefly, American ambassador). Previously, he had edited *Collier's*, where he had encouraged the movement that came to be known as muckraking journalism, employing such well-known names as Jack London, Upton Sinclair, Ida Tarbell, and Ray Stannard Baker, and where he ran powerful and successful campaigns on slum clearance, the reform of child labor laws, votes for women, and food hygiene. Hapgood was also active in the arts scene. He was one of the small group that met at Stieglitz's gallery at 291 Fifth Avenue, which showed modern art alongside pioneering photography, and was also an influential drama critic; his first wife, Emilie Bigelow Hapgood, was a well-known theatrical producer. They had divorced in 1915; two years later, he married Beth.

Hapgood came at a price: he was twenty-seven years older than his bride, and had never been good-looking. "When he was not smiling," said Beatrice, "his features resembled a hillside that had been neglected, but he had one of those appealing homely faces that held charm and beauty in its bony structure."* Homely or not, no comparable prospect presented himself to her.

How, then, to achieve independence? For a respectable unmarried woman like Beatrice, the choice was not wide. She could become a factory worker, a teacher, a shop assistant, a nurse (but not, unless she was altogether exceptional, a doctor). There were a few women journalists, no women politicians, and, other than small shopkeepers, very few businesswomen. (Helena Rubinstein, the first self-made female millionaire, opened her first New York salon in 1915. The beauty business was not one that men took seriously, as cosmetics were considered out of bounds to decent women. That quickly changed when they saw how much money Rubinstein was making.)

Any woman, however, if she was talented enough, might become an artist. Women worked in the theater, both onstage and behind the scenes

* Wood, 15

as producers. Women were singers and dancers. In Paris, a few women were recognized painters. And since Beatrice was good at drawing and liked acting, the artistic life seemed the obvious one to try. She had a good eye, a charming stage presence, and excellent connections in New York's theatrical circles, as well as a little rented room where she dyed and printed fabrics. Hapgood, who liked ambitious, independent women so much that he married two of them, encouraged her and helped with introductions. She became a friend of Madame Yorska, who ran the American French Theater, and at whose apartment she met such figures as the photographer Arnold Genthe and the impresario Arnold Daly; Beth introduced her to Pavlova's choreographer, Ivan Clustine, who taught her some Russian dances; she took acting lessons with Yvette Guilbert, the toast of the turn-of-the-century French stage. (Guilbert was a bit of a disappointment in person. Her signature outfit had been a tight black dress and long gloves, but the woman Beatrice met wore a plain dark dress and no makeup, and would not teach the naughty songs that had made her famous and that Beatrice longed to learn. Instead, she insisted they study the classics. "Listen, *ma petite*, if you can master Racine, which is like moving big rocks, you will find everything that comes after much easier.")[*] And she was introduced to the actor-manager Charles Coburn and his wife, Ivah, who took a liking to her and who would become her lifelong friends.

The Varèse introduction, however, was not made by any of these connections, but by a journalist friend, Alissa Franc. Miss Franc was a new acquaintance—her name appears for the first time in Beatrice's diary the day before the Varèse visit. Dumpy and jovial, she was a journalist and lived on what she earned in a tiny, frugally furnished apartment that seemed to Beatrice the essence of freedom and sophistication.

Journalism, if you had the necessary pushiness, was another of the possible ways for a young American woman to make a living: not exactly respectable, but acceptable.[**] It was a precarious life, but Beatrice's new friend Alissa showed that it could be done. Alissa belonged to a group

[*] Wood, 14–15.

[**] This had been so for some time. Henry James wrote *Portrait of a Lady*, featuring the irrepressible Henrietta Stackpole, in 1880.

of similarly placed young women journalists who made a point of supporting each other in adversity. Henri-Pierre Roché was introduced to this group and was impressed by them. "They were a fine bunch, active like bees, and sometimes stinging too . . . When one of them lost her job, or simply wanted a change, they all helped until several were offered. They said they did not care for men, they would never marry. Most of them," he observed, "did marry soon after."[*]

Alissa was exactly the kind of person Mrs. Wood did not want her daughter to mix with, let alone become. When Beatrice, in the always vain hope that the two sides of her life might be reconciled, invited her to one of her mother's Sunday lunch at-homes (turkey, sweet potatoes, all the trimmings), Mrs. Wood criticized Alissa's shabby tweeds, bad haircut, and common manners. She was not invited again. But the two continued to meet in Alissa's apartment, where they sat in front of the fire and discussed books and world affairs. And it transpired that Mrs. Wood had been quite right. Alissa knew some very interesting, highly unsuitable people.

Unlike Marcel, who loved New York—"I love an active and interesting life. I have found such a life most abundantly in New York. I am very happy here," he told the *New York Tribune*[**]—Beatrice longed for Paris. But now Paris, or some of it, had arrived in New York, and Alissa, presumably through her journalism, had actually met its representatives. She and Beatrice spent the evening of September 26 scouring the town in search of "Marcelle Duchamp" (as Beatrice spelled him in her journal—how the gender-shifting Marcel would have enjoyed that!) They visited his favorite haunts—Les Pierrots, the Prodigal—but to no avail: he wasn't there. So Alissa suggested that Beatrice visit the composer Edgard Varèse, who was also French, and was safely tethered to a hospital bed. And there, as though conjured by desire, was Marcel, smiling his irresistible smile.

* "They were a fine bunch . . ." Roché, "How New York Did Strike Me."

** *New York Tribune*, October 24, 1915.

Varèse was a close friend of Gaby Picabia, who had been one of his fellow students at the conservatoire. They spent a good deal of time together, walking the New York streets and talking about music.

Varèse had been walking alone one day thinking about Berlioz, a fellow French composer with whom he felt a particular affinity, when a car mounted the pavement and broke his foot. He was taken to the nearest hospital, which happened to be St. Vincent's Hospital, and where he was condemned to spend the next eleven weeks marooned among Anglophones. Marcel often visited, and one day suggested that Louise might accompany him. But she was doing something else, so he went alone.

He arrived to find that Varèse already had a visitor: an American girl, fashionably dressed, with dark hair, wide eyes, and a charming, mischievous smile who was making nervous chitchat in excellent French. She and the invalid were not, it seemed, getting on particularly well, her composure not helped by the fact that an extremely masculine hairy leg, sticking out from beneath the sheets, drew attention to Varèse's barely covered nakedness. Varèse, who was very handsome, with thick, unruly dark curls, a cleft chin, and classically beautiful features, had broken many hearts, though Marcel found him heavy going, for he thought only of music and had no sense of humor.* Beatrice, too, found him heavy going. What do you do, he asked her, to which she replied that she was an actress.

As it happened, Varèse had spent seven years married to an actress, the beautiful Suzanne Bing. "You don't look like one," he said.

As Beatrice nervously opened her mouth to reply, a fly that was buzzing about the room flew into it. Unsure what to do—should she spit it out? Root for it with a finger?—she swallowed it. Behind her, someone laughed. She turned, and found herself face to face with a tall, thin young man with "a delicate, chiseled face and penetrating blue eyes that saw all."** Save when he smiled, his face was oddly expressionless. Everyone remarked on this, not least because it was so hard to reconcile with the charm and magnetism everyone also felt. Journalist Morris Lazarus,

* According to Duchamp in Gough-Cooper and Caumont, "Ephemerides," July 1, 1966.

** Wood, *I Shock Myself*, 22.

interviewing him in 1960, tried to analyze how the effect was made. "His face seems to sit there. His lips occasionally are pursed; his eyes will squint for a moment . . . There is almost a mask, which in most persons, you would resent. However, there is such a feeling of amused warmth and life behind the mask that you feel charmed rather than resentful. And why is there this life? It is Duchamp's hands. They are never still—but they are seemingly never in motion. They glide from one arm to the other. They are suddenly clasped together. In a moment he is leaning his face on an outstretched finger. A finger touches his eye, it causes a squint that is sinister. A finger to his lips. A hand on his elbow. I sat there and watched a choreography that almost hypnotized me. One would think this endless motion would be distracting, but on the contrary one feels a fantastic feeling of calm and repose. It is the face, the calm backdrop of the face, which co-ordinates all these motions into the man."[*]

Marcel smiled now, and his face lit up. "Marcel Duchamp smiled. I smiled. Varèse faded away." He at once addressed Beatrice as *tu*, the French familiar mode, normally used only between close friends or family. "At that moment we were lovers."[**]

Marcel and Beatrice left the hospital together and strolled uptown. They got on wonderfully well. Marcel took her phone number and said he'd call.

"Very happy," Beatrice noted in her diary.

For the next year, as if by magic, all Beatrice's dreams would come true. And then, on the stroke of midnight, the golden coach would turn into a pumpkin.

It was some days before Beatrice heard from Marcel again. In the meantime she inspected Beth Reynolds's new apartment, lunched with the happy couple at Henri's (a current favorite, it was where she dined with Alissa prior to their wild-goose Marcel-chase), met up with Yorska

* Gough-Cooper and Caumont, "Ephemerides."

** Wood, "Marcel," in *Marcel Duchamp*, ed. Kuenzli and Naumann.

at the American French Theater, and hopefully paid another visit to Varèse, where Marcel did not appear. And then, the following day, he finally called.

They arranged to meet for dinner at one of the cheap restaurants he favored, the Dutch Oven. Overjoyed, Beatrice had to share her delight or burst—and with whom if not Alissa? Who, not unreasonably, wanted to come too; a request Beatrice could hardly refuse, even had she wanted to. Marcel, being a well-brought-up young man, doubtless made charming and inclusive conversation over that shared first dinner. But it was Beatrice, not Alissa, whom he invited back with him to the Arensbergs afterward.

And so the relations between Alissa and Beatrice were set. On the surface they were friends, but how could dowdy, poor, self-supporting Alissa, still unattached and on the wrong side of thirty, not bitterly envy rich, pretty, well-connected Beatrice? For Alissa, Beatrice could never be a friend, only a rival. Beatrice, however, absorbed in her happiness, could not recognize this.

4

ARTISTIC LIFE, NEW YORK, 1916

What a ripple of interest at 33 West 67th Street when Marcel came in accompanied by a pretty girl nobody knew! *Who was this?* Insofar as he had any female attachment, it was to Louise Norton, whose bed he often visited—though this might not have been generally known, for Louise had been introduced there by Allen, whose wife she still was, while Marcel, who hated the thought of being tied down, was obsessively secretive about his relationships with women in case acknowledgement might be taken to imply commitment.

Since their affair began in 1916, which was the year Allen and Louise agreed to separate, it seems likely that Marcel was the casus belli. From Marcel's point of view, however, one of Louise's many attractions was that she was not looking for commitment. On the contrary. What she wanted at this point was fun: the fancy-free girlhood that had been so abruptly terminated when she became pregnant. And the fact that she was (or had been) married was no barrier to this ambition. Even accidental pregnancy, should it occur (Louise evidently took precautions, for it didn't) would no longer be a social calamity. On 88th Street, she lived the rackety life of her dreams. So, too, did her lodgers. When, in the summer of 1917, Gaby left to be with her children in Switzerland, Varèse moved in with Picabia. They would lie around the apartment more or less naked in the stifling New York summer, not bothering to dress even when they had female guests. Such guests as Isadora Duncan would hardly have

been shocked by mere nudity, but in her memoir Louise recalled how their behavior distressed the housekeeper. "'Mrs Norton,' she said, in a dramatically shocked tone, 'I am an old woman but I have seen such carryings-on as I never dreamed of.'"* Whether she knew about Louise's own carryings-on is not revealed.

Few of the Arensbergs' female habituées would have shared her shock. Gaby Picabia was used to her husband's habits; Mina Loy had escaped to America, leaving her husband and children in Europe; the unashamedly bisexual Clara Tice had had her work confiscated for obscenity when it was exhibited at Polly's restaurant in 1915; the three-times-married baroness Elsa von Freytag-Loringhoven was in her forties and shed her clothes at every opportunity; Carl van Vechten's wife, Fania Marinoff, had been on the stage since she was thirteen. The only virgins were wealthy middle-aged groupies like Katherine Dreier and the three Stettheimer sisters, who though single and visibly in love with Marcel were certainly not girls and entertained no hopes of amorous reciprocation.

Ingénues like Beatrice were another matter; they did not generally frequent the Arensbergs. Improbably, however, the person who most nearly shared her outlook was the salon's hostess. Lou Arensberg was much older than Beatrice and, of course, married, but she and the new-comer shared a certain unfinished quality that perhaps derived (despite Lou's married state) from sexual inexperience, or simply from a particular combination of social aplomb—Lou the wealthy *salonnière*, Beatrice with her bold manner and theatrical connections—with unworldly innocence; exactly the contradictory quality that marked out Henry James's Isabel Archers and Daisy Millers. In France, if you had Beatrice's interests and enthusiasms, it was assumed you were sexually available. And in France, a salonnière like Lou would be a repository of unshockable worldly wisdom, her marriage to Walter an official arrangement that suited them both but in which infidelity would be an equal-opportunity occupation, not just accepted but expected. In fact, Walter was routinely unfaithful. But Lou was not, and the unawakened quality she shared with Beatrice set them apart from the other women in the Arensberg circle and drew them to each other.

* Varèse, *A Looking-Glass Diary*, 131–32.

⁙

On entering the Arensbergs' salon, Beatrice felt that the door to heaven had opened and she had been invited in. She had longed to be among artists, and now here they were, all around her. As was the art they made, for once he had begun buying, Walter had become addicted. Although Beatrice had taken painting lessons in Paris, she had never seen anything like what was before her now. A Picasso supposedly depicted a woman—but where was she? There was a Rousseau of a horrible dwarf, a Brancusi brass that seemed about to take off skyward, and over the fireplace a Matisse (his portrait of Mademoiselle Yvonne Landsberg) with white dagger-like streaks surrounding the subject's body. Beatrice gazed at it. "Willing myself to be open-minded, I almost went into a trance. My eyes locked on its angular lines, until suddenly out of the canvas appeared a creature of wonderous [*sic*] beauty. Matisse had spoken, and I listened."* Marcel, from the comfort of an armchair, smilingly watched her reactions. Lou Arensberg sat at the piano and sang, then at midnight wheeled in a trolley of cakes and hot chocolate to try to mitigate the effects of the whiskey everyone drank in such quantities. Was this really her, here, now?

"Duchamp very lovely," recorded Beatrice in her diary that first day. Later, during her affair with Roché, this was the phrase she used to indicate that they had been making love. But at this point, with Marcel, there would have been no question of that—no question, indeed, of anything more, in physical terms, than the ritual *bise*. It was obvious he really liked her. But that was the whole point. He really *liked* her, and the fact that he had introduced her so publicly into the Arensberg circle was, paradoxically, the clearest possible indication that he had no intention of sparking the kind of embarrassing passion that would lead to the end of their friendship.

Beatrice, of course, could not know this.

⁙

* Wood, *I Shock Myself*, 28.

As though meeting Marcel had somehow pressed some magic button, Beatrice suddenly found herself in artistic demand on all sides. Worlds that had hitherto been all but closed—worlds of which she had had no inkling—suddenly, miraculously, opened to her. She saw Yvette Guilbert at least once a week; Madame Yorska of the American French Theater hinted that Ruben, the French Theater's leading man, was broke and might also be willing to give her lessons, should Beatrice want any; she received a commission to make theatrical props for Lord Dunsany's new play; Isadora Duncan commissioned her to design and make some of the long, floating scarves she loved to wear (one of which would eventually strangle her); and on October 14 the Coburns offered her a small part in their new play, *The Yellow Jacket*.

Charles and Ivah Coburn were important figures in the theatrical world, and they became very fond of Beatrice. Later, when she desperately needed help, they, along with Beth Hapgood, were the friends she could always turn to for support. Beatrice was thrilled to have been cast in her first professional role and found the play "fascinating"—an opinion shared by the rest of the world, for it went on to become a huge hit. That meant rehearsals every day until opening night on November 9.

But the more taken up she became with theatrical and artistic life, the more her mother and Alissa, eaten up, respectively, with possessiveness and envy, did their best to prevent her from enjoying her moments of triumph. Even a visit to Ziegfeld's *Midnight Frolic*, with the Dolly Sisters, which she saw in the wholly respectable company of Beth and Hapgood, was enough to set Mrs. Wood scolding, and Beatrice was as always saddened by her disapproval.

On October 21 she met Marcel again for dinner at the Brevoort. Once again Alissa accompanied them, and the next day began a campaign of needling. She and Beatrice talked about *The Yellow Jacket*, which was set during the Spanish-American War; the costumes, Alissa declared, were all incorrect. But that moment of uncertainty swiftly passed, for two days later Beatrice was with Marcel again, and this time without Alissa. They dined, and Beatrice showed him some of her drawings, which he liked. Indeed, her drawings are delightful, witty, self-deprecating, and with a striking economy of line. She and Marcel had a "charming time"—yet

another of her code phrases, but one that, on this occasion, probably meant little more than that she had all his attention. They were becoming good friends, though Beatrice hoped for more. "Marcel Duchamp is on my mind," she noted.

Her balloon was soon punctured by her mother and Alissa. On November 4, Mrs. Wood scolded her about her "bohemianisation"; "Unhappy," she recorded in her diary. And the following day, Alissa said she was afraid Beatrice was "not sincere." What did that mean? Whatever it was, it hit its target. "Hate myself again," recorded Beatrice, who was also now suffering from constant, small but unpleasant physical symptoms sometimes caused by exhaustion and emotional pressure: a boil on her finger that had to be lanced three times, toothache, a cyst on her face.

No sooner had *The Yellow Jacket* opened than yet another offer materialized: M. Benedict, director of the French Theater, wanted her for his next play. What to do? Beatrice dined with Duchamp, and asked his advice. This torrent of opportunity made her feel "too sophisticated," "as if the greatness of life was lost." She decided in favor of Benedict; Coburn genially agreed to release her as soon as he found a satisfactory replacement. On November 24, Beatrice appeared in *The Yellow Jacket* for the last time, and was soon deep in rehearsals for *Les Precieuses ridicules* and *Patachou*.

On top of all this there was her art. Marcel had shown one of her drawings to Allen Norton, who proposed to publish it in his magazine *Rogue*. Why, Marcel wondered, didn't she concentrate on drawing, at which she was really good, instead of trying to act? Beatrice explained that it was hard for her to draw and paint at home; there wasn't really room and the place was full of valuable antiques that might get damaged. So Marcel, who was now living in comparative luxury at The Atelier, suggested that she might like to come and work in his studio. The only condition was that she must phone ahead, to make sure the coast was clear and he wasn't giving a French lesson.

The first time she took him up on this suggestion, he was out. That was disappointing, for she had been looking forward to seeing him, but he must have left a key, as she still spent the afternoon there. When he was in, he usually sat quietly smoking a pipe while she worked, and at the

end of the session would go through her sketches one by one, dismissing her more heartfelt effusions and picking out, to her surprise, quick little drawings she had dismissed as superficial. "MD on my mind a lot," Beatrice told her diary.

·:·

She was not the only one. Marcel Duchamp was the most glittering conundrum in New York. Henri-Pierre Roché, a habitué of the Paris art scene who had recently arrived in America, had never, in France, noticed the youngest Duchamp. In New York, however, his star quality was overwhelming. Roché was dazzled, and fell instantly and permanently in love. "[Marcel] was open to everything new, spontaneous, audacious. His presence was a grace, a gift, and he didn't realise it even though he was surrounded by a growing crowd of followers . . . Everyone repeated what he said. Everything he did seemed miraculous."*

Marcel's studio, which faced onto a light well, gave the impression, Beatrice remembered, of being "in various stages of undress."** There was a bed, usually unmade, in an alcove, two chairs covered with clothes, and a litter of chocolate bars and half-eaten packets of crackers on the windowsill. Against one wall stood a trestle with a large sheet of glass, while scattered around the room were various unrelated objects: a snow shovel hanging from the ceiling, a coatrack that disturbingly didn't look quite right nailed to the floor, a bicycle wheel in its fork mounted on a box, an advertisement for Sapolin Enamel on the wall. These, as the world now knows, were examples of what Marcel had begun to call "ready-mades," with which he hoped to undermine aspects of the art world he disliked—the premium on handmade originality and unrepeatability, and the way in which artworks were regarded as a form of investment. In a letter written a few weeks later to his sister Suzanne in Paris, he set out his thoughts:

* "Souvenirs sur Marcel Duchamp," in Lebel, *Sur Marcel Duchamp*, 79–84.

** Wood, *I Shock Myself*, 24.

You'll have seen a bicycle wheel and a bottle rack in my studio. I bought them as ready made sculptures. And I've had an idea regarding this bottle rack. Here, in N.Y., I've bought some objects of the same sort and I treat them as "readymade." You know English well enough to understand the sense of "ready made" that I give these objects. I sign them and give them an English inscription. I'll give you some examples: I have for example a large snow shovel upon which I wrote at the bottom: In advance of the broken arm, translation in French: En avance du bras cassé. Don't try to understand this in the Romantic or Impressionist or Cubist sense—that has nothing to do with it. Another "readymade" is called: Emergency in favor of twice, possible translation in French: Danger—(Crise) en faveur de 2 fois. This whole preamble in order to actually say: Take the bottle rack for yourself. I will make it a "Readymade" from a distance. You will have to write at the base and on the inside of the bottom ring in small letters painted with an oil-painting brush, in silver white color, the inscription that I will give you after this, and you will sign it in the same hand as follows: [after] Marcel Duchamp

When Beatrice asked Marcel about these objects, however, he gave no explanation, simply saying they had their purpose, but she shouldn't bother about them. *Cela n'a pas d'importance*, he assured her.

He was also working on his big, long-term project *The Bride Stripped Bare by Her Bachelors, Even*, that had begun in Munich, and that, given the history between Marcel and Gaby, and despite its mechanical dress, was clearly (and paradoxically) deeply felt. Meanwhile, on a more superficial level, its scenario of many Bachelors all lusting after one teasing Bride was echoed in life by a slightly perverse and dehumanizing fashion then current at the Arensberg parties, in which a girl would lie back on a sofa while surrounding men caressed different parts of her, one taking her left forearm, one her neck, etc. William Carlos Williams, describing this scene, was shocked by it, but it was just the kind of thing—erotic yet at the same time impersonal—that appealed to Marcel.

That first day, after painting for a while, Beatrice went to meet Alissa, whom she was beginning to like very much. They had dinner at Henri's, where her description of the new and exciting turn her life had

taken was, predictably, received without enthusiasm. "Disappointed in people," she recorded. However, life was too busy for depression. Next day, after a morning working on *Les Deux sourds*, she rehearsed her Russian dance with an orchestra, for performance at a bazaar. The first performance didn't go too well, but she felt very happy, and the next one went better. An audience member came forward offering to manage her as a dancer. There were rehearsals for *Les Precieuses ridicules*; on the day they started, she also attended the Reynolds-Hapgood wedding. This torrent of activity left her so tired that even her eyes hurt. "Feel so very much more sophisticated than two years ago," she noted on the first day of the new year, 1917.

For a while all went smoothly at the French Theater. Some days were better than others, but Benedict seemed to like her, and she was busy and happy. In a play called *Les Amants* she felt that her performances were indifferent, the only high point being a passionate embrace with the leading man. Beatrice always tended to fall in love with her leading men, and this kiss was so heartfelt that not only did the audience applaud it, one of them wrote anonymously to her parents alerting them to their daughter's public immorality. That didn't stop her, however, and perhaps not coincidentally, the leading man in question, Ruben, renewed his offer of acting lessons. He certainly was hard up—Beatrice was shocked by his rickety, threadbare apartment, and (perhaps naïvely, given those heartfelt kisses) was even more shocked when it became clear he expected to have sex with her. She made a swift exit, but when she complained to Yorska her complaint fell on deaf ears, for it transpired—too late!—that Ruben was Yorska's lover.

Possibly as a result, Benedict suddenly became distant. On January 24, to Beatrice's disgust, he told her the French Theater had no more use for her. In fact, this was not really the end: she went on rehearsing and performing new plays for them—without enthusiasm, however.

It was all very unsettling, and she turned to Marcel for comfort. He obligingly took her out to dinner, tried to console her ("He is so decent!") and four days later found her a new and exciting occupation.

⁘

On 29 January, 29, 1917, Beatrice lunched with Marcel, Walter Arensberg, and Arensberg's cousin John Covert. They had a proposition for her. The group that met at The Atelier was planning an art exhibition. It would be called the Independent Vortices Exhibition (soon slimmed down to the Independents) and would be open to all comers on payment of a $6 fee. There would be no jury and everything entered would be shown. The idea was for the show to open in early April, but that would take a lot of organizing. Would Beatrice like to be one of the organizing committee?

Would she! From then on, she saw the Arensbergs—and Marcel—even more often, for theater outings or dinner or evenings at home "reading dreams," an offshoot of the spiritualist revival sparked by the war that now threatened to involve America. She kept up her theatrical connections—Forbes Robertson read her a sketch, she often saw the Coburns—but the Arensberg circle was fast becoming the focus of her social and emotional universe. And at the center of it stood Marcel.

That Beatrice would fall in love with Marcel had been inevitable from the moment she first saw him, magically materialized at Varèse's bedside. Beautiful, impassive, magnetic, kind, famous, cleverer and more amusing than anyone she had ever met, how could anyone resist him? And this extraordinary person actively sought her company! No other outcome was conceivable.

Nor was it conceivable that he would return her feelings. And yet—the last thing Marcel wanted was to hurt her. It would have been easier if Beatrice had been just another girl, but if she had been just another girl, they would never have become friends. She was so bright, so talented, so enthusiastic, so full of American snap, so devastatingly vulnerable. He liked her so much. "Except for the physical act, we were lovers," was how Beatrice remembered it.[*]

But of course that was a very big exception. And, paradoxically, it was precisely *because* Marcel liked her so much that physical involvement was, for him, unthinkable. For Marcel, now that Gaby had turned him down, sex was purely a means to pleasure, "a physiological function

[*] Wood, 25.

involving two people," as he would later describe it,* quite separate from any emotion, though hopefully involving affection. Both the *Bride Stripped Bare*, on which he had been working for the past several years, and *Étant donnés*, the diorama he began thirty years later—and which occupied the last twenty years of his life—were representations of sex, but not of love.

This separation was essential if Marcel was to maintain his equilibrium. In any situation, whether artistic or emotional, he had to be in absolute control, and control is precisely what love abolishes. The worlds he created, the world of the *Bride Stripped Bare* and of *Étant donnés*, were achieved by immense, painstaking preparation, the position of each mark, each object, laid precisely down. Even when chance was allotted a role, as with the lengths of cord he called the *3 Standard Stoppages*, it was tightly controlled. In the *Notes* that later formed part of this work, he set out the conditions for what he called "canned chance": "A horizontal thread one metre in length falls from a height of one metre onto a horizontal plane while twisting as it pleases and creates a new image of the unit of length." Richard Hamilton describes what then followed: "This process was repeated three times with the thread falling on a canvas painted blue . . . and drops of varnish were gently applied to fix the curve as it lay. Each canvas was cut into a strip, and these were glued individually to long pieces of glass. The three curves were then inscribed on wooden slats so that a profile of the curve could be cut to make three templates, boxed as a set of tools . . ."**

In France, where realism ruled, it was understood that sex need not entail love. In America, by contrast, and despite the fact that in New York bourgeois young women were put on display in a more or less overt marriage market, the myth of romantic love leading to the perfect marriage prevailed. This view had little do with reality—one need only look at Beatrice's parents' unhappy marriage to know that. But it formed the basis of the rose-tinted culture energetically purveyed by

* To Lydie Fischer Sarazin-Levassor, his first wife. See *Un échec matrimonial*, 160.

** In d'Harnoncourt and McShine, *Marcel Duchamp*, 61.

the burgeoning film industry, and for those who, like Beatrice, bought into this myth, a lingering kiss was liable to be taken as a promise of lifelong devotion.

Since Marcel had no wish to hurt his charming American friend, it was time to begin the necessary distancing process. "Am unhappy sentimentally," Beatrice noted on February 26, a month after the lunch that co-opted her onto the Independents committee, and on March 1, the storm broke.

Beatrice had gone, as she often now did, to paint at Marcel's studio. This time he was in; also present was "Duncan"—probably the actor Augustin Duncan, Isadora's brother. Marcel mentioned an upcoming fancy dress ball at the Vanderbilt Hotel; Beatrice naturally hoped this meant he was going to invite her. Far from it, however. It soon became brutally apparent that he had mentioned the ball in order to make it clear he would *not* invite her. For he had already invited someone else: Louise Norton.

The news hit poor Beatrice like a bomb. She had arrived in expectation of a delightful evening in the world's best company—and now—this! Marcel refused to apologize. "Duchamp horrid," she noted. And then, "But I deserve it."

Poor Beatrice! Who could blame her for not discerning the barrier that stood between her beloved and all emotional engagement? Valiantly, she tried to persuade herself that this was only to be expected, that Marcel was within his rights to draw her in then abruptly to snub her, that she had been presumptuous even to imagine he might reciprocate her feelings. "Whole situation with Marcel is normal," she sternly told herself next day. "My emotions are bound to shudder, My spine cold and hot. Marcel like a knife, but he is right."

They went on meeting as before—his plan wasn't to cut off contact, merely to dampen expectations. Thus, a few days later she was painting a poster at his place, and after she'd finished for the day the two of them went down to the Arensbergs', where they played twenty questions. Meanwhile, she filled her life with distractions. A stay in the country and a long talk with her friend Mary Mowbray Clarke made her feel a little better; she took up batik; she attended lectures given by the radical

French theater director Jacques Copeau, founder of Paris's Vieux Colombier (and now, so intertwined was this society, the partner of Varèse's ex-wife Suzanne Bing) who was in New York on the first leg of an American tour. But in spite of this, she continued depressed, in a "beastly Marcel mood."

5
PIERRE, 1917

Beatrice attended all Jacques Copeau's lectures, and at one of them, on March 22, she ran into another of her French acquaintances. This was Henri-Pierre Roché, known to all his friends as Pierre, whom she had met the previous month during a dream-reading session at the Arensbergs'. Now, when the lecture finished, the two of them walked to Marcel's together, where they dined before joining the Arensbergs.

Marcel had already tried, more or less literally, to throw Pierre and Beatrice into each other's arms. It had happened late one snowy night. Pierre was about to go to bed in his basement room when he heard footsteps outside, there was a knock on his door, and in surged Marcel and Francis Picabia, holding a dark, mischievous-looking, and very angry girl securely by the arms. Picabia announced that this was Beatrice, whom they had brought for Pierre to take care of because she insisted on making a scene when they needed to talk privately. And just before they dashed off in Picabia's sports car, Marcel said, "We haven't brought her just on a whim, there are reasons." The reasons, of course, being his hope that Beatrice would transfer her romantic yearnings from himself to Pierre.

Beatrice immediately made herself at home, inspecting the furniture and also the pictures and art objects Pierre kept scattered about, in particular a Marie Laurencin drawing. "I like this crazy room," she concluded, though she thought it could do with some more chairs. In the absence of a sofa she settled herself on (but not in) the large double bed—the expression she used was *Je vais me foutre sur ton lit*, one of the

vulgar idioms Marcel delighted in teaching his pupils. (On another occasion, at the Arensbergs', an elderly Russian professor went down on his knees before Beatrice and begged her not to use the word *merde* anymore, which if Marcel was present must have filled him with glee.) She explained to Pierre that Marcel had invited her out, and that she had hoped, for once, to have him to herself. But then Picabia had arrived, and she'd made a scene to try and drive him away. But he had stayed. So here she was.

The horse, however, declined to drink. The two of them spent the next hours in a strange mix of chastity and intimacy, Pierre in the bed and Beatrice on it. "You didn't even want to kiss me!" she exclaimed, recalling this incident some months later. "But you were very sweet."[*] Mostly they talked about Marcel, how they both loved and admired him, how the whole world seemed to be in love with him. Pierre brought out some refreshments—*fromage frais*, brown bread, and apples, which she exclaimed were just the kind of things she liked to eat—while Beatrice practiced her French slang and described her fraught relationship with her parents. At about five in the morning Marcel and Picabia returned, found them thus chastely ensconced, and whisked Beatrice away to her home.[**]

Following this piece of theater, Beatrice twice sent Pierre notes inviting him to tea, so that they might get acquainted in less extreme circumstances. But he already had many girlfriends, and had no interest in adding another unless there was some prospect of sex, of which he was a voracious connoisseur. So he didn't reply.

Marcel, however, was not about to let his matchmaking drop. He was anxious to sweeten the bitter pill he had just forced on Beatrice; if he couldn't offer her love, he needed to find someone who might. And Pierre perfectly fitted both his and her requirements. From Beatrice's standpoint, he was French, interested in art and the theater, and was even tall and redheaded like Marcel—so like him, indeed, that they

[*] From *Pour Toi*, her extended love letter to Pierre, unpublished MS, Philadelphia Museum of Art.

[**] Roché, *Victor*, 40ff. I was inclined to dismiss this episode as imaginary, since it isn't mentioned in either Pierre's or Beatrice's diary, but Beatrice refers to it in *Pour Toi*.

were sometimes taken for brothers. And from Marcel's, he was a man perpetually interested in both sex and love. The fancy-dress ball, to which Marcel so pointedly had not invited Beatrice, now provided an excuse to push her once more into Pierre's arms. Why not arrange for Pierre to take her? And—even better!—get her to make him a costume?

Later, perhaps because even he, a man who wholly rejected guilt in connection with sexual matters, felt uneasy about what followed, Pierre did all he could to minimize Beatrice's importance in his New York life. In both *Victor*, which was about the events of that spring and summer, and in a memoir he wrote in 1959, he said he went to the ball alone, and implied that Beatrice was not invited. He said she assured him she didn't mind missing the party, but that she turned up after all, unescorted and sub rosa, padded out as a Hottentot Venus. It seems unlikely this was really her costume—why would this clever seamstress, alone of all the girls at the ball, choose such an unflattering getup? But *Victor*, hovering, like all Pierre's novels, between fact and fiction, is among other things an exercise in self-justification.

In fact, as both their diaries show, he agreed to be Beatrice's escort. And in return she agreed to make his costume, which meant taking him to the little rented studio where she did all her work on fabrics. "Happy," she noted that day. "Most interested. Have a nice feeling of independence." She was still too much in love with Marcel to feel in any way attracted to another man—"We must try not to care about others," she told her diary sternly. But insofar as she realized it was still possible, despite everything, to have fun, Marcel's scheme was working.

Pierre, too, enjoyed the day. Forty years later, he still remembered that dilapidated room with its tubs and powders, and in the middle of it all the rubber-aproned sorceress wringing out her fabrics, blocking them, hanging them up to dry, and from time to time swearing one of the French oaths Marcel had taught her. She produced trousers that she had borrowed from her brother and which he tried on chastely in an adjacent cupboard. They were too tight and short in the leg, but she declared them perfect, produced some gold fabric, draped it over him, and marked some lines with tailor's chalk. Taking this over to the table she swiftly cut out the jacket, then laid out the pieces and began drawing designs on them

"with bananas here and there . . . She was a sorceress inspired, splashing color on her bare arms and even her face. Her rubber apron was dripping. She was a native Indian on the war-path . . . The next day she came to see how the coat looked on Pierre. It was a work of art. He told her that."*

So Pierre and Beatrice went to the ball—one of many such events in those not-yet-wartime New York years of 1916 and 1917—with Marcel and Louise.

Pierre had already met Louise at the Brevoort Hotel, whose owner was French and which had become the recognized meeting-place for French expats. He thought her pretty, though pale. But this was the first time Louise and Beatrice had met. In a little sketch Beatrice drew of the evening, Marcel, in a sort of wizard's gown, is seated at a table, while Pierre, in his gaudy jacket, dances with the contentious Louise, of whom Beatrice is so jealous, and who is a slender line full of ease and elegance. "Meet Louise Norton. Do not like," Beatrice noted.

Henri-Pierre Roché had arrived in New York in October 1916. He was thirty-seven years old and, like Marcel, was the product of an unusual maternal relationship. In Pierre's case, however, his mother was not distant but pathologically close. Relentlessly artistic and intellectual, Madame Roché had devoted the years following her husband's early death to devising a system of education for her son—to be instilled by herself.

Madame Roché made sure Pierre spoke excellent English and German, and his first ambition had been to become a diplomat. But his professor at Sciences Po, Paris's school of political science, discouraged this. Did he have a large fortune? Was there any way in which he might more or less legitimately lay claim to connection with a noble or in some way celebrated family? If not, diplomacy was not for him. "Then what should I do?" Pierre asked. "Be an inquirer" (*un curieux*) said the professor.

* "With bananas . . ." Roché, *Victor*, trans. Chris Allen, in *3 New York Dadas*, London, 2013, 46.

"That's not exactly a career!" Pierre retorted, to which the professor replied, "Not yet, maybe, but it will be soon."*

The professor knew his man. Pierre spent his life exactly as recommended, dipping in and out of other people's existences, tasting, enabling, observing; never, however, creating (the three novels he produced at the very end of his life were little more than adjusted versions of his diaries). He had tried to become an artist, enrolling at the Académie Julian, a well-known private art school where some years later Beatrice would also become a student. He was soon forced to recognize he had no talent, but he did have taste, for he and his mother had spent many enthusiastic hours in Europe's galleries as part of her educational program. He therefore allied his curiosity to his excellent eye and the outgoing charm that brought him an ever-increasing network of acquaintances, and began looking out for promising new artists and introducing them to people who might buy their work. It was he who discovered Marie Laurencin, whom he launched on an international career (and welcomed into his bed); it was he who introduced Picasso to Gertrude Stein; he who encouraged Cocteau into the collaboration with Picasso and Erik Satie that eventually produced the ballet *Parade*. Stein, who knew him well, devoted one of her inimitable word portraits to him. *Was this one a complete one*, she wondered, and seemed to conclude he was not. He wasn't very good at actually doing anything—though he *certainly would be doing a very beautiful thing if this one did do that beautiful thing*. Rather, he liked to know what everyone else was doing, and how they did it. He listened rather than talked, which was *a completely pleasant thing*—which might, indeed, be seen as a definition of charm.**

Perhaps, though, Stein's view of creativity was too narrow. Like the diplomat he might have been, Pierre's gift was social.

His first love, shot down in flames by Madame Roché, was an English girl, followed in short order by her sister. His novel about these affairs, *Les deux anglaises et le continent*, was made into a film by François Truffaut, whose *Jules et Jim*, also from a Roché novel, was about yet another

* Editor's introduction to Roché, *Carnets, les années Jules et Jim*, Marseille, 1990.

** *Was this one a complete one* . . . see Stein, "Roché," in *Geography and Plays*.

of these triangular loves, this time featuring two men and one girl. He often visited Germany, and had several girlfriends there as well as many male friends. (The painter Marie Laurencin, whom he discovered and promoted, and who accompanied him on one of these excursions, briefly married one of the latter.) For all of them, one of the most distressing aspects of World War I was that it set them in enemy camps. But these cross-border friendships also provided a revenge opportunity for an abandoned (French) girlfriend. Four days after war was declared, she denounced Pierre to the authorities as a German spy.

He recounted his arrest, and his subsequent fortnight's incarceration in the ancient Conciergerie prison, in a jaunty little booklet, *Deux semaines à la Conciergerie pendant la bataille de la Marne* (Two weeks in the Conciergerie prison during the Battle of the Marne.) In it he makes the whole thing sound like a not too unpleasant social adventure. In reality, however, it was a terrible shock, and Paris no longer seemed a welcoming place. On his release, after being turned down by the military on account of a damaged knee, he took a short-lived job with the General Staff of the French army, where he impressed members of the visiting American Industrial Commission with his linguistic competence. Would he, the Americans wondered, be interested in coming over to New York, to help them liaise with French industry? He would earn hardly anything—the wage for a private soldier was twenty-five cents a day—but there would be plenty of time for journalism on the side. With some relief he took them up on the offer, and in October 1916 became a soldier, second class, with the French High Commission in America, whose aim was to secure America's entry into the war.

Pierre arrived in New York on October 29 with just enough dollars to last him a week.* In Europe, he would have dreaded such a situation. But in New York, "somehow I don't." With his usual gregarious charm he soon made friends with a number of New York journalists, including the drama critic Alexander Woollcott, who sent him to review a new play, *The Yellow Jacket*, in which he must have seen Beatrice perform.

* Just enough dollars and subsequent details of settling into New York life, from Roché, "How New York Did Strike Me."

He settled in a basement at 77 West 12th Street, a big, dark, cheap room, with a clean bed that he called "my cave." It had its own separate entrance, like a private apartment, which was a good thing. On the other hand, you could hear both passing trams and the El trains running nearby. But there were no bugs, and it had a decent bathroom. And the location, in Greenwich Village a couple of blocks from the French-friendly Brevoort, was excellent.

In a rougher room next door lived a large elderly Swede who did carpentry jobs for the neighbourhood and who liked to make a fire of old wooden boxes. "On the first Sunday night we were both at home he invited me to rejoice with him in the view of it." Sometime later, the landlord discovered the Swede entertaining a woman in his room, and despite the fact that she was visibly respectable, not to say almost as old as the Swede, the two, after a short fight between Swede and landlord, were turfed out on the spot, into the snow. It was a dramatic induction into the madness of American sexual puritanism.

Despite this, however, Pierre was enchanted by New York. The modernity! On his first day in the office, he noticed a boy printing out hundreds of addresses "by turning a little wheel." When Pierre marvelled, the boy scoffed: next door, all they had to do was press a button! And the efficient secretaries! And the ubiquitous telephones! And new American foods to sample—sweet corn, a vegetable he had never encountered before (he loved it, as did Marcel, despite the "gymnastic difficulty" involved in attacking it) and avocado pears, which he thought "worthy of being sung by poets." And the lunches! Pierre very much approved of the "quick lunch habit," which didn't interrupt the working day and left the head clear, quite unlike France, where the lunch habit was slow, vinous, and took a large chunk out of the afternoon. Whenever he wasn't being treated to lunch in some acquaintance's private club, he tried a new fast-food joint. He was particularly fond of a chain of restaurants called Child's: in *Victor*, he dines there on veal and peas, pancakes and yogurt. But the phenomenon that really astonished him was the all-you-can-eat self-service cafeteria. "One day I discover a large restaurant full of soups, fishes, meats, cakes, drinks, where they say one can get in, eat all he likes, without control, and pay what he likes, when he leaves, without

control.—I thought I was dreaming." His impression of America was "bigness . . . generosity . . . as if Nature herself was saying 'Come, come in! Work and take! Work and take!'"

But although he spent his working life with American journalists and diplomats, he mainly socialized with the French expat community, most of whom he already knew. And in this city of revelations, the chief revelation was Marcel. How had this dazzling butterfly emerged from a Parisian chrysalis so insignificant as to be unnoticeable (at least by Pierre)? Henceforth, for Pierre, Marcel became Victor (of all he surveyed). Hence the title of his novel; person-to-person the familiar form Totor, or Tor, was the name he, and Marcel himself, always used.

Although he went to bed with countless women, both of Pierre's significant love affairs were with men: the German poet Franz Hessel, who was the model for Jules in his novel *Jules et Jim*, and Marcel Duchamp. And in both cases he expressed his attachment indirectly, by sharing a woman with the male object of his affection. In Hessel's case this was his wife, Helen, and in Marcel's, Louise Norton. The friendship with Hessel lasted for many years—from 1906, when the two first met, until 1933, when Helen, who had by then been Pierre's mistress for thirteen years, finally broke off relations. But with Marcel, although the sexual part of the relationship lasted only a few weeks, their attachment to each other lasted for the rest of Pierre's life. François Truffaut said that when he met Pierre in 1959 to discuss Truffaut's projected film adaptation of *Jules et Jim*, Pierre, "who was very tall and slim, and looked a lot like Duchamp," talked of Duchamp "all the time."* Given the pattern of Pierre's life, it seems somehow fitting that his not-particularly-distinguished novel should nevertheless have been the catalyst for a great work of art.

Unlike his friendships with men, however, Pierre found it hard to maintain relationships with women. And paradoxically, the reason for this was that his main preoccupation, and the activity to which he devoted the best part of his energies, was sex.

* "Talked of Duchamp . . ." Truffaut's introduction to Roché's *Diary* for the *Jules et Jim* years.

The serious pursuit of this interest had begun in 1902 with what was ostensibly a sociological experiment. Pierre was then living, as he would for the rest of her life, with his mother in a spacious apartment on Boulevard Arago in Paris (his father had died when he was a child, leaving them a small income). Just round the corner in rue d'Alésia, however, he and a friend rented a sex room, of which Madame Roché knew nothing. They gathered their partners via small ads; this was how he met Germaine Bonnard, the only woman apart from his mother who remained a constant in his life and whom, after many years and at least two aborted pregnancies, he married. As part of the experiment he kept a diary of these encounters, a habit that persisted for the rest of his life. Every day he recorded whom he had met and where, and minutely detailed, in a sort of code, all his sexual encounters—who with (the names, too, were often encoded), kisses, moods. His aim was always to please: he was particularly expert at oral sex, the occasions of which he noted in his diary with the term KPF. ("kiss petite femme"). If you went to bed with Pierre, you would almost certainly enjoy it. But you fell in love with him at your peril. It was Germaine's fury, when she came across some of these diaries, that finally cornered him into marrying her.

Doubtless Pierre was what today would be called a sex addict. But that did not mean he was a rapist. Quite the contrary; his weapon—one he shared with that beau ideal of seducers, Giacomo Casanova—was not coercion, let alone force, but charm. Like Casanova, he genuinely loved whoever he was trying to bed. And then, once the relationship was safely established and the thrill of conquest exhausted, he moved on and fell in love with somebody else, though always maintaining, as far as was practically possible, relations with previous partners.

Pierre had acquired his first American mistress, whom he christened Nuk, within a week of arriving in New York, and was soon carrying on an energetic affair with her as well as doing his best to seduce the artist and caricaturist Clara Tice, who was notorious for her lesbian erotica, and whose phone number he had acquired from Marcel. Tice, however, proved unconquerable. A few days later, however, when he visited her apartment, he found, to his annoyance, that the upstairs neighbors were paying a prolonged call. Finally they disappeared, and the two were left alone. He

kissed Tice's hands, her hair, her forehead, then made his "declaration." To no avail: her only response was "Have a heart!" "Je no in love mais j'ai affection avec elle," he assured his diary.

Pierre was therefore pretty occupied as far as women went, and agreed to partner Beatrice at the Vanderbilt ball mostly out of friendship for Marcel. When the ball was over, the partying continued in various apartments and bars, ending up at Louise Norton's, where everyone gathered round Marcel in deliciously shocked anticipation. One way and another, Beatrice did not much enjoy the evening. "Feel disgusted over Marcel last night," she noted. "He drunk." What Pierre saw, however, was not drunkenness, or not *only* drunkenness, but star quality. Marcel in America wore an irresistible halo of celebrity "that he's always retained for me."* Remembering that moment years later, Pierre wrote that "he was joie-de-vivre incarnate." The source of this power, he thought, was "beauty and a central, incendiary, negative idea," but whatever its source, its effects were dramatic. From the moment he entered the room, Marcel gathered girls around him "like a big flower made of fresh dresses, constantly renewing itself . . . In his company they really felt that their whole culture was tottering and in need of being reassessed. Pierre could hardly imagine such an unqualified success in London, Berlin or Paris, and he admired these American girls . . . Victor was the touring idol . . . He was euphoric, and tipsy."**

* In Lebel, *Sur Marcel Duchamp*, 79.

** Roché, *Victor*, 52–53.

6

THE BLIND MAN

On March 19, a week before the Vanderbilt ball, Marcel had involved Pierre in a new project: a magazine called *The Blind Man*, to be published as part of the Independents Exhibition, and edited along similar principles (i.e., everything received would be published). A few days later, at the Arensbergs', where he dined with Marcel, Gleizes, and "beaucoup girls," the project was discussed again, and given a name: "the P.E.T." Two of these mysterious initials stood for the editors, Pierre and Totor; *E* might have been another proposed editor, or was possibly just a misprint, for when the magazine was published the initials, which formed part of the masthead, had become P.B.T., the *B* standing for Beatrice. Although the magazine was Marcel's idea, its editors needed to speak and write English. That was one of the reasons he called in Pierre, who not only spoke English fluently but was a professional journalist, and Beatrice, who was American and so could be its official publisher.

Pierre was delighted. As well as the pleasure of working closely with Marcel, *The Blind Man* brought another substantial reward. Previously all his writing had been for other people; now he had his very own publication. On March 29 he recorded: "Publ[ic] Lib[rary] j'écris article pour ma revue"—*his* magazine, for the first time in his life, to do what he liked with. Indeed, in a piece written in 1924 entitled "How New York Did Strike Me," his only reference to the whole affair of Mr. Mutt's *Fountain*, the urinal that would later be voted the twentieth century's most

influential artwork, and of which this was part, concerns not the seminal brouhaha itself, but *The Blind Man*, which he edited and in which, we are to understand, he was the prime mover. Beatrice is referred to solely as "my co-editor"; as for Marcel, he is as absent from the 1924 article as he was from the first issue of the magazine itself. He was nevertheless closely involved. "It was their child," Beatrice remembered, "and I endured endless discussions about its birth, while longing for conversation of a more romantic nature."[*]

Beatrice of course pictured those longed-for conversations as being between herself and Marcel. He, on the contrary, saw *The Blind Man*, among other things of which only he was as yet aware, as a way of pushing P and B together again, an enterprise that was almost exaggeratedly realized when they went to register the magazine at City Hall. They asked a painter who happened to be working in the lobby where the appropriate office was. "He pointed out the door, and they entered and filled out the necessary forms. When they took them to the clerk, however, he wanted to know why both of them had written *The Blind Man* at the top of the form.

"Because that's the name of the magazine."

"What magazine?"

"The one we've come to register."

"But these are marriage licenses!"

The clerk told them where they needed to go. The painter waved his brush as they passed."[**]

Unmarried, they left.

If one was to judge only by this first issue, and was unaware of the various ulterior motives, *The Blind Man* must have seemed more or less pointless. Pierre's contribution, a series of cliché-filled paragraphs on independent art, took up three and a half of the five pages of editorial and showed signs of a desperate search for something to say. "The hour has come," he announced. "The big brotherhood is

[*] "It was their child . . ." Wood, introduction to Marquis, *Eros, c'est la vie*.

[**] Roché, *Victor*, 47.

there, men, who have felt the strange need of expressing a little of their soul and of their time with paint and brushes upon stretched canvases—madmen!" New York would "catch the Indeps fever. It will rush to see what its children are painting, to scold them, laugh at them—and laud them . . . American artists are not inferior to those of other countries. So, why are they not recognized there? Is New York afraid? Does New York not dare to take responsibilities in Art?" He filled in the rest of the space by touting for future contributions. There were "Questions" ("Which is the work you prefer in the Exhibition? And why?"), "Guesses" ("What will be the total number of visitors?"), and "Suggestions" ("Write about the Indeps, or about any special work in the Exhibition. A dramatic story of less than one hundred words. A comic story of less than one hundred words . . .") His English, to judge by his other, less successful excursions into written English, had been doctored by a native, presumably Beatrice. The only other contribution was an overworked piece on The Artist and The Public from Mina Loy.

So far so vacuous. The Arensbergs, Beatrice noted sadly, thought it was rubbish. But Marcel was playing a longer game. The first issue's contents were neither here nor there: the important thing about *The Blind Man* was its existence. Although he could not predict precisely what was going to happen at the Independents Exhibition, he knew his contribution, which he was even then organizing, would, in one way or another, create a sensation. And in that sensation *The Blind Man* would play an essential part. It would be a public mouthpiece ready and waiting to amplify the scandal.

<center>⋰⋱</center>

Here our story divides into two parts. One might be categorized as art history. The other, however, is a quite different matter: a drama of love and jealousy, of *Vénus tout entière à sa proie attachée* and the chaos left in her wake.

Two sets of diary entries record its beginning. One is Beatrice's; the other, Pierre's.

April 4, 1917

Pierre:

Fatigué—lunch Regina Nostra au Ritz—<u>Béa à la library</u>—m'accompagne*
chez l'imprimeur—puis au <u>ferry-boat Staten Island & back.</u>—w.h. [work at
home]

(In Pierre's diary, underlining always indicates love interest.)

Beatrice:

Go about for Independents. Fuss around printer with Rocher [sic]. Go to Staten
Island with him. He is quite nice—Home.

These, of course, are the boniest of bones. But the story was fleshed out
by the extended love letter Beatrice wrote some months later setting out in
detail the course of their affair, and that she called *Pour Toi.*

It was probably Beatrice who suggested the Staten Island Ferry, for it is
a popular tourist ride, and Pierre was an avid tourist. And (like the Public
Library where they met that morning) it had the added advantage of being
free. It was cold on deck, the winter was dragging on, and there was still
snow to come. That day, however, it was sunny, giving a good view of
the famous skyline. Manhattan was already, in 1917, thickly dotted
with skyscrapers and Beatrice, who was wearing the new hat—a blue
turban with a feather, that she'd bought with her mother the previous
week—pointed out the Woolworth Building, the Flatiron Building, the
Statue of Liberty

Pierre was more concerned with the speaker than with what Beatrice
was saying. He started a conversation about love, the subject always upper-
most in his mind. He told her she loved Marcel more than she realized.

In fact, she realized it only too well. She knew she must keep her
distance, but it was very hard. Only the previous day, in yet another failed
attempt to reconcile her two warring lives, she had invited him to one
of her mother's at-homes—for who could fail to be charmed by Marcel?

The answer was Carrara Wood. His deceptively correct comportment,
his effortless good humor, his delightful manners—his *sophistication*—far

* A half-Russian half-Italian woman who did Russian-Italian translations.

from mollifying Mrs. Wood, only reinforced her fears. If Bohemia was so charming, how could Beatrice possibly resist it? No banker or stockbroker would ever compete in the romance stakes with Marcel Duchamp. When he left the apartment, "You're falling in love with that man," she observed.*

This, of course, was hardly news. But the point of the remark was to discourage. And as always, Mrs. Wood's displeasure found its mark. "Am unhappy," Beatrice sadly told her diary.

So perhaps she loved Pierre, after all, she reflected, if only because they both loved Marcel.

She asked Pierre if he'd often been in love. His reply quite simply astounded her: "About once a year."

Once a year! How was that possible? All she could say in reply was that she'd never been in love in her life!**

In her diary, all this is contained in two small words: *Quite Nice.*

For Pierre, the Staten Island Ferry was a welcome break in a manic schedule. The previous day he had worked all morning on articles for *The Blind Man.* This first issue was almost entirely written by himself and Beatrice, and it not only had to be written but edited and printed. That was followed by the opera at five, and a cabaret afterward, and finally a late night at Louise's place with Marcel and Charles Demuth. Then there was his official work, involving endless lunches with various French and American officials as America edged toward declaring war, and he had also been cultivating American journalists who could put extra paid work his way. (Unfortunately, his best contact, Alexander Woollcott, the *New York Times* drama critic, was about to disappear, for Woollcott enlisted on April 7, the day America entered the war.) He also led a brimming cultural life—attended lectures, went professionally to the theater and privately to cabarets, watched Isadora Duncan dance both in public and, which he preferred, in private. Isadora was one of the few women he never tried to bed—an attempt to set him up with her failed, they didn't attract each other, and in any case she was carrying on with Picabia. (One evening she phoned to say she had an artwork to show him. When he arrived she led

* Wood, *I Shock Myself,* 18.

** Wood, *Pour Toi.*

him on tiptoe toward a large cabinet. Opening it, she said, "Here it is!" and revealed Picabia seated upon a box in front of a tiny table, wearing "a Napoleonic expression," and drinking hot chocolate.*) He also spent a good deal of time discussing art and dealing with Marius de Zayas, an old friend from Paris who was now Stieglitz's partner at the 291 gallery.

On top of all this, and for him most important of all, he had to orchestrate his love life, which was, as always, both vigorous and varied. He needed to console Nuk, whose nose had been put out of joint by the Vanderbilt ball, to which of course he had not been able to invite her. He was becoming increasingly interested in Louise, whose cheerful hedonism he found wholly sympathetic. And now, Beatrice. He saw her almost every day, not only on *The Blind Man* business but also because she was a friend of the Duncan family and an assiduous attendee at the Copeau lectures, at one of which, he noted with pleasure, she sat next to Nuk. Pierre especially enjoyed that kind of incident, where two of his women met, and where he alone was aware that he was the link between them.

What was he hoping for?

That would become clear three days later. On April 2 Norman Hapgood's friend Woodrow Wilson asked a special joint session of Congress to declare war; on April 6, both the Senate and the House passed the resolution; on April 7, war was declared. Not that either Pierre or Beatrice seemed especially worried. "Am curiously untouched," Beatrice noted on April 2, while Pierre, although this surely presaged the end of his official job, never mentioned the war at all. It was, after all, still very far away.

Pierre's diary entry for April 7 revealed other concerns:

> Travail avec Béa chez Totor. Lecture, poème, serieux talk. Encore no K[iss]. Les dessins—un peu bossing me.

It was Beatrice who recorded the day's truly significant news:

> Dentist. Batik. Independent. Dine Rocher at Chinese Restaurant. Discussion about "Richard Mutt"'s exhibition. Read Rocher my articles. We work at Marcel's.

* Roché, *Victor*, 84–85.

MR. MUTT'S FOUNTAIN

Here, then, making his first appearance, is R. Mutt, the mysterious purveyor of sanitary ware.

Years later Marcel said that the idea that would become *Fountain* arose just before the Independents Exhibition opened, in conversation with Arensberg and Joseph Stella, an Italian-born doctor and futurist painter who had made his home in America.[*] Since there was no time to waste, they immediately went out and bought the item at the J. L. Mott Iron Works store on Broadway. Next morning, "there was a glistening white object in the storeroom getting readied to be put on the floor."[**] In one corner, a black-painted signature read "R. Mutt 1917," and beside it was the requisite six dollar entry fee, identifying it as an exhibit.

Mr. Mutt's object was an upside-down urinal bearing the title *Fountain*. Perhaps not coincidentally, J. L. Mott offered, inter alia, a comprehensive selection of cast-iron fountains. They were also the origin of the name Mutt, which as Marcel explained in the sixties—when everyone suddenly wanted him to clarify everything before it was too late—was based on Mott, slightly adjusted to Mutt, which happily referenced the daily strip cartoon *Mutt and Jeff*. Then he added Richard, which is the French word for a plutocrat. "Not a bad name for a *pissotière*," he observed.

Mr. Mutt's urinal, the most-parsed item of sanitary ware in the history of plumbing, posited the entirely novel possibility that signing an

[*] In conversation with Arturo Schwarz, 1966, quoted in Camfield, *Marcel Duchamp*, 21.

[**] Wood, *I Shock Myself*, 29.

object—any object—and exhibiting it in a gallery made it, ipso facto, art. *Fountain*, and the identity of its perpetrator, instantly became the talk of everyone connected with the show. And although only Arensberg, Stella, and Marcel knew who R. Mutt actually was, it was not hard for Marcel's friends to make an educated guess. Beatrice, for one, "never [doubted] for a moment that Marcel was the scoundrel."[*]

The hanging committee found Mr. Mutt's contribution when they arrived to finish the exhibition's installation at the Grand Central Palace. By then everyone was exhausted. America's artists, young and old, amateur and professional, had seized this unique opportunity to exhibit their work in downtown Manhattan with professional critics in attendance and no fear of rejection. Twenty-four hundred pictures and 350 sculptures had been sent in by 414 women and 821 men.[**] To emphasize the show's stand against selective judgment, they were to be displayed alphabetically. But that did not mean the exhibits would begin with *A* and end with *Z*. On April 6 all the letters of the alphabet were put into a hat. Marcel, whose idea this had been, dipped in and drew out the letter *R*. The *R*'s would start the show! Beatrice, also on the hanging committee, despairingly surveyed the endless ranks of canvases leaning with their faces to the wall, all to be in position by the following day. Most of them, she gloomily noted, seemed to be by people called Schmidt.[***]

And now—this!

"It was a joke," Marcel said,[****] which was obviously true, even if only part of the story. The Armory Show had shown him what fun scandal might be, though sadly, he hadn't been present to enjoy it. He wasn't going to miss his chance this time. But *Fountain* was rather more than a joke. It was the first public outing for a wholly new concept, that of the "readymade," an object that became a work of art simply by virtue of being signed and exhibited by an artist.

[*] Wood, "Marcel," in *Marcel Duchamp*, ed. Kuenzli and Naumann, 14.

[**] Figures quoted by Ades, *Three New York Dadas*, 8.

[***] Wood, "The Work of a Picture Hanger," *The Blind Man*, no. 1, 1917

[****] Beatrice Wood to sculptor Anthony Caro, who told filmmaker Randall Wright, who told me.

Marcel later told Pierre Cabanne that his choice of readymades was "always based on visual indifference and, at the same time, on the total absence of good or bad taste." That was certainly true of his snow shovel and bottle rack. But those qualities were wholly absent from *Fountain*, which was, among other things, the epitome of bad taste. Indeed, tastelessness was intrinsic to its effect. What was more, it was touted, from the beginning, for its aesthetic qualities, real or imagined.

Nor was that all. Marcel's aim, said Gaby Picabia, was "to exclude all emotion, all sensation, all personal sensibility" from his work. The paradox, she remarked, was that this *was* his personality.* But if the exclusion of emotion and personal sensibility was really his aim, then *Fountain* failed miserably to achieve it. On the contrary, it was as personal a statement as could be imagined, totally lacking indifference, visual or otherwise. On the contrary, it expressed all the anger Marcel's life was otherwise devoted to denying—about his mother, about the art world, about the war. And because it was so charged, it provoked (unlike the snow shovel or the bottle rack, or indeed most of the conceptual art to which it would, decades later, give rise) extreme reactions.

Despite Marcel's leading role in the exhibition, the hanging committee did not consist solely of his modernist friends. There were also William Glackens, the president of the Society of Independent Artists, who was an enthusiast for Impressionism and Post-Impressionism and whose pictures were often compared to Renoir's, and George Bellows, a gritty realist. When *Fountain* was discovered, a furious argument broke out between Walter Arensberg and Bellows, who was not in on the secret. Bellows "was facing Walter, his body on a menacing slant, his fists doubled, striking at the air in anger. 'We cannot exhibit it!'

'We cannot refuse it, the entrance fee has been paid,' gently answered Walter.

'It is indecent!' roared Bellows."**

Bellows' fury was not just about the object's indecency. He also objected to its message. Whoever Mr. Mutt might be, his contempt for

* "To exclude all emotion . . ." Buffet-Picabia, *Aires abstraites*.

** Wood, *I Shock Myself*, 29.

the art world could hardly have been clearer. If *Fountain* was included in the exhibition, what would that say about the rest of the exhibits? The rules were unequivocal: it could not be refused. But how could they allow its exhibition? In a puzzle-maker's triumph, R. Mutt had presented the committee with a question it couldn't possibly answer. A vote was taken, and by a small margin *Fountain* was voted down. Marcel and Arensberg instantly resigned.

In fact, as *The Blind Man* would soon point out, *Fountain* was neither decent nor indecent, it was simply "a fixture that you see every day in plumbers' show windows." On the other hand, it undeniably and insistently reminded onlookers of functions that usually went unmentioned. And with good reason—or that was the opinion of one of the more squeamish refuseniks, the art collector and Duchamp devotee Katherine Dreier. In one of the drafts of *Victor*, Pierre has Gertrude, his Dreier character, remark: "A country that is basically Anglo-Saxon cannot be rid of its prudishness in matters concerning the lavatory with just one swipe. Rabelais wasn't from these parts."* Since only the French ever refer to Britain and America as being Anglo-Saxon, this sounds more like Pierre than Dreier. But the worries about lavatories probably hit the mark. Her official explanation for her vote against *Fountain* was that she couldn't see anything original in it—grounds on which almost all the exhibited works except *Fountain* might have been excluded. When she later found out that the perpetrator was her beloved Marcel, Miss Dreier was mortified. Had she known, she would never have voted against it.

"I wanted to see how far one could push art," Marcel explained forty years later,** adding that he had not expected it to be rejected. Not that he minded—far from it. "You would really have been disappointed had *Fountain* been welcomed," Pierre Cabanne said. "Almost. As it was, I was enchanted," Marcel replied.***

Soon after the vote, *Fountain* vanished. Various rumors circulated as to its fate. In one account it was spirited away by the Noes, who wanted

* Roché, *Victor*, 5.

** Interview with *Lazarus*, April 4, 1962.

*** Cabanne, *Dialogues with Marcel Duchamp*, 55.

to make sure it would not, in spite of everything and to their chagrin, reappear; in another, that William Glackens, who had several pictures in the show and was a "no" voter on the committee, had smashed it to pieces in a fit of fury; in yet another, that it was placed behind a curtain and forgotten. The one certainty is that it did not appear in the exhibition.

"The Independents opened here with huge success," Marcel wrote his sister Suzanne. "One of my lady friends under a male pseudonym, Richard Mutt, sent in a porcelain urinal as a sculpture;

"It wasn't at all indecent. No reason to refuse it. The committee decided to refuse to exhibit this object. I handed in my resignation and there's some gossip about that which may be useful in New York.

"I'd have liked to do a special exhibition of the Independents' *refusés*—but that would have been a pleonasm!*

"And the urinal would have been *lonely*—"**

By a heroic effort, all the paintings were hung in time for the vernissage. The result, as many headlines pointed out, was an unprecedented two miles of art.

What a party! Mrs. William K. Vanderbilt, Mrs. J. Borden Harriman, Mrs. William Astor, Mrs. Harry Payne Whitney, and other society art fanciers, stood in the welcoming line, and a brass band played as the guests awaited New York's mayor, who had promised to come (he never showed up). The Grand Central Palace was an enormous space, and the exhibition filled it to the brim. Henry McBride, the *New York Sun*'s art

* *Pleonasm*: the use of more words or parts of words than are necessary for clear expression.

** Marcel Duchamp to Suzanne Duchamp, April 11, 1917. The reference to "one of my lady friends" has led some people to claim that the real Richard Mutt was the bizarre German baroness Elsa von Freytag-Loringhoven, who was one of the Arensberg attendees at this time, and who, like so many others, was vainly in love with Marcel. But since *Fountain* exhibited so many of Marcel's hallmark characteristics (e.g., his fondness for puzzles and for crude and subversive jokes), since the readymades were his invention, and more crucially since she took no part whatever in the subsequent activities and none of the many other participants in the action so much as mentions her name, this seems unlikely.

critic, declared the evening "gorgeous and gay," like the foyer of the Paris Opéra on a Ballets Russes night. He felt the show had the look of a real salon, though he calculated the proportion of inoffensive (read: boring) work to offensive (read: interesting) was about ten to one. McBride's only caveat was that it was almost impossible to find your way out. After four unsuccessful circuits of the labyrinth, during which he found himself constantly bumping into the huge boxer-poet Arthur Cravan, "I'm glad I don't owe you money!" he declared. "What an awful place this would be to escape from a creditor! When you turn these corners you don't know what you're getting into."

Others were less enthusiastic. The *New York Tribune*'s critic, Royal Cortissoz, headlined his piece "Independent Artists Show Discredits Idea of American Salon." "It is as though a delirious paperhanger were to cut his stock into eight-foot strips, mix them together and then paste them on the wall, one by one, just as they came to hand," he opined. Like most of the press, Cortissoz headed straight for the *D*'s, hoping for a repeat of the Armory Show's 1913 Duchamp sensation, and unaware that the sensation, though duly supplied, had been suppressed (and in any case would have been placed among the *M*'s.) The only Duchamp piece on view was disappointingly uncontentious: a painting entitled *King and Queen Surrounded by Swift Nudes*, of the same 1912 vintage as the *Nude Descending a Staircase*, which it in many ways resembled. But that was yesterday's sensation: there was nothing to say about it that had not already been said. "The charm of the Armory enterprise was that it supplied some irritating sensations. On this occasion one is only bored," sighed Cortissoz.

If he had only known that the Duchamp exhibited under his own name was by no means Marcel's only contribution to the show! In fact, the New York Independents can be seen as a sort of double-blind experiment to prove whether or not Marcel Duchamp was truly as inflammatory as the Armory Show had made him out to be. And even in *Fountain*'s absence, the answer was a resounding yes.

Marcel's second contribution echoed *Fountain*'s bathroom theme. Despite his refusal to become Beatrice's acknowledged beau, they remained close friends and she continued to draw and paint at his studio.

Naturally, she wanted to exhibit one of these works in the Independents Exhibition, and in his role as her premier critic and mentor he picked out two paintings he thought might be suitable. One—she later thought it "a horrible composition"—was called *Nuit Blanche*. Fifty years later, when she saw it hanging in the Philadelphia Museum, Beatrice thought she had "a speck of understanding into why Marcel chose it. After all, what is taste?"[*]

The other was an unremarkable sketch, the torso of a curvy nude girl lying in a bath, seen from above, her pubic area concealed by a coyly strategic scallop shell. Marcel, however, saw its possibilities and suggested a slight alteration. He said, "You must put a soap there, real soap," and sent Beatrice out to buy a suitable item of the right size, shape, and color. When she returned he helped her glue the scallop-shaped cake of soap to the canvas, then got her to name the picture. She intended to call it *A Bit of Soap in the Water—Un peu de savon dans de l'eau*—but mistakenly said, "Un peu d'eau dans du savon" (A bit of water in the soap). Delighted, Marcel insisted she use the second version.

Soapless, the picture was nothing; soaped, it was transformed. Marcel's addition drew maximum attention to precisely the feature the original scallop shell had discreetly veiled, transforming Beatrice's anodyne sketch into something smuttily suggestive in the characteristic Duchamp manner, the effect magnified by the contrast between the inoffensive nature of the drawing and the crude suggestiveness of the addition. And, unbelievably, this production was signed by a young lady! The world reacted accordingly. "To my astonishment," wrote Beatrice, "the painting . . . attracted more attention than any other entry. Crowds stood in front of it chuckling, men left their calling cards . . ."[**]

Finally, a hint of sensation! Unanimously, the reviewers homed in on Marcel's soap. The *New York Evening Journal* thought it was there to "achieve atmosphere"; the *Philadelphia Ledger* was deliciously outraged. "An oval piece of dirty soap pinned on an unframed square board, painted

[*] Wood, *I Shock Myself*, 32.

[**] Wood, 32.

in a somewhat 'greenery-yallery' manner, and entitled in bad French—but the French is not half as bad as the art—a 'Little Water With a Piece of Soap,' in the W section, by Beatrice Wood, is the keynote of the childish whim, the unbridled extravagance, the undisciplined impudence and immature ignorance and even derangement that have been allowed full and free fling in the first jury-free exhibition of the Society of Independent Artists at the Grand Central Palace, N.Y.," the newspaper thundered.

Beatrice's parents were understandably horrified. If they needed any proof of her new friends' malign influence, here it was!

Their daughter, however, had other things on her mind.

8

BEATRICE'S SENTIMENTAL EDUCATION, 1917

It was at the printer's that Beatrice first realized she was falling in love with Pierre. When she made his costume, when they visited City Hall and nearly got married, even on the Staten Island ferry—not a flicker. She was still too obsessed with Marcel. Finally, however, a small flame began to take hold.

It was April 9, the day of the Independents vernissage. *The Blind Man* had to be ready to go on sale by the time the show opened, and Beatrice and Pierre had arranged to meet at the printer's office at 9:00 A.M. to make final corrections. Pierre was late—he was always late—and seemed tired (he had spent the previous evening at Isadora's, watching her dance and chatting late into the night). When he arrived, he sank into a chair. Beatrice felt a sudden access of empathy. He sat down, she stood behind him, and as they began to check the proofs for the last time, she leaned over the back of his chair (she was wearing that hat again, her favorite turban with the fanlike feather), he leaned back—"and we forgot all about the printer!"*

Making a heroic effort, they returned to the proofs. The magazine would be ready in time, though it would not sell many copies, for it was not only feeble, but had been wholly overtaken by events. The only talk at

* All this account of the vernissage is taken from Beatrice's long love letter to Pierre, *Pour Toi*.

the vernissage, Pierre noted, was of *l'urinoir*, of which everyone seemed aware even though it was nowhere to be seen, and which *The Blind Man* did not mention.

When they'd finished at the printer's, Pierre and Beatrice wandered off together. They lunched at Child's, the self-service cafeteria that Pierre considered one of the wonders of America, then went on to what he liked to call her "witch's kitchen," the room where she dyed fabrics and made her batiks. They spent the rest of the afternoon together there, chatting, not touching, but in that heightened state when everything is thrilling potential, the next move merely a matter of time. It was the state Pierre lived for, but Beatrice had never before experienced it. (And despite her long, long life—she would live to be 105—she would not experience it again.)

And then it was time for the vernissage, the culmination of all their efforts.

Finally it was over and everyone began to drift away. Marcel, Louise, and the Arensbergs were planning to dine at the Beaux Arts Café, but Beatrice felt suddenly drained and collapsed onto a chair. Pierre found another, brought it close, and persuaded Beatrice to join the party. He was gentle and loving—for the first time, he called her *tu*, not *vous*. They would get a cab together, she wouldn't have to do a thing.

In the cab, for the first time, he kissed her—"on the right eye, I seem to think"—and after that, she couldn't remember exactly. The moment was so beautiful that, later, the mere thought of it made her cry. "We made some progress" was her laconic diary comment.

After the dinner, Beatrice returned home to sleep. She was very happy. Now her dreams were of Pierre, not Marcel; she relived, in every detail, those first caresses.

For Pierre, by contrast, the night was far from over. When they left the restaurant he did not go home, but accompanied Louise to her place. To begin with, he bedded down by himself on a divan, but in the middle of the night he climbed into Louise's big bed, where in the morning they were joined by a friend who had also stayed the night. The friend, however, didn't much enjoy the threesome—in Pierre's opinion she was a bit provincial—and soon he and Louise were left alone again. They

had a fine time, followed by breakfast in bed, then went back to sleep. He didn't get home until the afternoon—and then it was time to meet Beatrice again, this time at de Zayas' gallery. And finally, home to bed. "Fatigué," he unsurprisingly concluded.

This time it was Beatrice who went on to dine out. Her companion was Alissa, whose life only a few months ago had seemed so glamorous and adventurous, but which, from Beatrice's current standpoint, must have appeared comparatively drab. Yet all this present joy was thanks to Alissa, who had suggested she visit Varèse! Whether Alissa regretted having made that suggestion, we are not told.

Nor do we know what they talked about. But it would have been strange if their conversation had not included Pierre, Marcel, *Fountain*, or the vernissage, which for Alissa must have been both fascinating and tormenting. If she attended the vernissage, it was not as a member of the inner circle. She knew them, or some of them, but (unlike Beatrice) she was not one of them.

And that was perhaps worse than not knowing them at all.

9

THE BUDDHA
OF THE BATHROOM

Although R. Mutt's *Fountain* had been excised from the exhibition, it was far from done with. It was easy to imagine the headlines had it appeared. But it had not appeared, and Marcel's business now was to prevent its descent into obscurity.

His first line of attack was to contact the press directly. Just after the opening the artist Charles Demuth, a regular Arensberg habitué and evidently in on the plot, wrote to Henry McBride: "A piece of scultor [*sic*], called: 'a Fountain,' was entered, by one of our friends, for the Independent Exhibition now open at the Grand Central Palace. It was not exhibited. 'The Independents,' we are now told have a committee—or jury, who can decide 'for the good of the exhibition.' If you think you could do anything with this material for your Sunday article we would appreciate it very much." He added: "P.S. If you wish any more information please phone Marcel Duchamp, 4225 Columbus, or, Richard Mutte, 9225 Schuyler"—a number that actually belonged to Louise Norton.* Whether anyone tried to call either number is not recorded.

A number of news stories soon appeared. In them, Mr. Mutt acquired a certain amount of backstory. He came, it appeared, from Philadelphia, which may have had something to do with the fact that Charles Demuth

* Archives of Henry McBride, Beinecke Rare Book and Manuscript Library, Yale University, quoted Camfield, *Marcel Duchamp*, 29.

came from Pennsylvania and had studied at the Philadelphia Academy of Fine Arts. But although they all agreed on that, the stories otherwise differed in the most fundamental details. What, for example, was the mysterious Mutt's first name? In *American Art News* it was Jeff; the *New York Herald* confined itself to the initials J. C.; in the *Boston Evening Transcript* he appeared as Richard. *American Art News* also got the artwork wrong. The "scultor" it assigned to Mr. Mutt on April 14 was not *Fountain* but the (admittedly also watery) *Un peu d'eau*, albeit substantially reimagined—the very picture that, under Beatrice's name, and in a distinctly reduced form, would outrage it a week later. "[Duchamp's] resignation was due to his disapproval of the committee's rejection of a work (it could not be called a picture) sent in from Phila, presumably as a joke since it was signed 'Jeff Mutt' and which is said to have been a startlingly lifelike rudely done portrait of a nude young woman stepping into a real papier maché bathtub, with a real cake of soap affixed to the canvas." The *New York Herald*, also reporting on April 14, was better informed as to Mr. Mutt's entry, and also added in a new Duchamp, which made a fleeting appearance in this story never to be seen or heard of again. Its Mr. J. C. Mutt had "shipp[ed] from the Quaker City a familiar article of bathroom furniture manufactured by a well-known firm of that town." But "'The Fountain,' as his entry was known, will never become an attraction—or detraction—of the improvised galleries of the Grand Central Palace, even if Mr Duchamp goes to the length of withdrawing his own entry, 'Tulip Hysteria Co-ordinating,' in retaliation." And in Boston, on April 25, the *Evening Transcript* moved the story into the lawcourts. Its Mutt had reverted to his original name: "A Philadelphian, Richard Mutt, member of the society and not related to our friend of the Mutt and Jeff cartoons, submitted a bathroom fixture as a 'work of art.' Mr Mutt now wants more than his dues returned. He wants damages."

Marcel had evidently had a lot of fun with journalists. But it was clear that Mr. Mutt's *Fountain* would never achieve the scandalous reach of the *Nude Descending a Staircase*. *Cette demoiselle*, as he liked to refer to her, had become a national bone of contention at a time when nothing much else was happening. By contrast, the Independents was a minor

affair, heavily overshadowed by the war, and the newspaper stories about Mr. Mutt meant very little to anyone not actually in on the joke.

The *Fountain* story, however, was far from over. For now *The Blind Man*'s real purpose was revealed: its second issue was the one that mattered, and would be devoted to Mr. Mutt's work. Of course a photo would be needed, and of course the item had vanished. But that presented no problem, for the whole point of readymades was that unlike laboriously constructed traditional artworks, another, just the same, was always available. You just had to go back to the shop.

The photography session was conducted by Stieglitz. Then in his fifties, he had spent his life establishing photography as an art form. His gallery at 291 Fifth Avenue exhibited both photographs and modern art, and Roché's friend Marius de Zayas, a skilled and successful cartoonist, had had two extremely successful exhibitions there, and was now Stieglitz's partner. On April 12 Pierre and Beatrice visited Stieglitz at 291 to sound him out before the urinal was actually transported to his studio, and Beatrice was there again the next day, this time with Marcel and the, or a, *Fountain*. A long conversation ensued. "[Stieglitz] was greatly amused," Beatrice remembered, "but also felt it was important to fight bigotry in America. He took great pains with the lighting, and did it with such skill that a shadow fell across the urinal suggesting a veil. The piece was renamed: *Madonna of the Bathroom*."[*] It was set in front of a picture, which can hardly be made out in the photograph, but was in fact Marsden Hartley's *The Warriors*, whose central motif echoes the form of *Fountain*. "I have, at the request of Roché, Covert, Miss Wood, Duchamp & Co., photographed the rejected 'Fountain,'" Stieglitz wrote Henry McBride on April 19. "You may find the photograph of some use—It will amuse you to see it—the 'Fountain' is here too."

The Blind Man 2 appeared on May 5. Surprisingly, considering that its chief purpose was to extend and enlarge the life of *Fountain*, Stieglitz's photograph of it did not appear on the cover. Instead, beneath the magazine's title and the initials PBT was a reproduction of Marcel's machine picture the *Chocolate Grinder*, to which he had given dainty Louis XV

[*] Wood, *I Shock Myself*, 30.

legs. This allowed him to put his name on the title page, the only time his name appeared in either issue of *The Blind Man*.

Where *Blind Man 1* had sought in vain for content, *Blind Man 2* overflowed with it. There were pictures from Clara Tice and Frank Stella; a number of poems; some satire, including an article by Mina Loy on Louis M. Eilshemius, an exhibitor at the Independents whose works particularly appealed to Marcel, and which included "three fine nudes in an evening sky, each with a different coloured ribbon" (the piece ends "Duchamp, meditating the levelling of all values, witnesses the elimination of Sophistication"); a spoof letter from "A Mother," by Beatrice, urging that "we keep this exhibition sane and beautiful"; an article by Gaby Picabia on Marie Laurencin that ended "It would be odd to see Marie Laurencin in America"; another piece by Mina Loy, "O Marcel . . . otherwise, I also have been to Louise's," which consisted, in a style then modish, of snatches of overheard conversation; and a letter from Stieglitz on the Independents Exhibition, ending NO JURY—NO PRIZES—NO COMMERCIAL TRICKS.

These, however, were all subsidiary to the contributions devoted to *Fountain*.

Stieglitz's photograph, on page 4, announced the coverage. *Fountain by R. Mutt* appeared in small type in the top left-hand corner, and in the right-hand corner, *Photograph by Alfred Stieglitz*. The photograph itself, which took up three-quarters of the page, showed the signed urinal, carefully lit, on its plinth; the canvas behind it, scarcely visible, remained an extremely obscure joke confined to, at the most, four people. Beneath it a caption read THE EXHIBIT REFUSED BY THE INDEPENDENTS.

The other two contributions were written by Beatrice (or so she said) and Louise Norton.

The first of these contributions was placed opposite the photograph, under the banner THE BLIND MAN. It bore the headline "The Richard Mutt Case" and set out, in multiple typefaces, the opposition's reasons for refusing *Fountain*. "Some contended it was immoral, vulgar . . . Others, it was plagiarism, a plain piece of plumbing." It refuted them— "Now Mr Mutt's fountain is not immoral, that is absurd, no more than a bath tub is immoral. It is a fixture that you see every day in plumbers'

windows"—and summarized, in the clearest terms, the principle behind the readymades: "Whether Mr. Mutt with his own hands made the fountain or not has no importance. He CHOSE it. He took an ordinary article of life, placed it so that its useful significance disappeared under the new title and point of view—created a new thought for the object." The piece finished with a peroration: "As for plumbing, that is absurd. The only works of art America has given are her plumbing and her bridges."

In her memoir, Beatrice says she wrote this piece. Marcel, on the other hand, said it was written by "the editors of *The Blind Man*"—of which he, of course, was one, and Beatrice another, and on another occasion, that its author was Louise Norton.* But although Mr. Mutt was living in Louise's apartment, or at least on the end of her telephone, it seems unlikely she wrote his manifesto. Her all-over-the-place writing with its hit-and-miss spelling was very different from the succinct and expressive style of *The Richard Mutt Case.*

The answer is probably that Marcel wrote the piece in French and Beatrice and/or Louise translated it. Although it is in English, it reads slightly awkwardly—it reads, in fact, like a translation from the French. At the same time its eloquence regarding Mr. Mutt's thinking can surely only have come from the artist himself, and certainly not from someone who admitted she knew little about modern art and was more interested in Marcel as a person than in his works.

Louise's contribution was entitled "Buddha of the Bathroom" and discoursed at length and at random (amid a scattering of greater and lesser names—Montaigne, Dante, Gertrude Stein, Remy de Gourmont) on old-fashioned ideas, the institution of marriage, the spirit of blague, and *Fountain*'s aesthetics. She complained that "like Mr. Mutt, many of us had quite an exhorbitant [*sic*] notion of the independence of the Independents," and echoed the introductory manifesto's fundamental assertion that "the *Fountain* was not made by a plumber but by the force of an imagination."

* In answer to questions posed by Serge Stauffer, *Marcel Duchamp, die Schriften*, Zurich 1981, quoted in Camfield, *Marcel Duchamp*, 37.

Although publication day was officially May 5, it was not until May 7 that copies of *The Blind Man* actually appeared, and at that point the two sides of Beatrice's life collided in earnest.

Her parents had made it clear that they disapproved of her new friends. But although they disliked them in principle, it was hard to put a finger on *why*. Marcel and Pierre, the only ones they had actually met, were so polite, so well-presented, so generally charming; and the notion that Beatrice might actually be spending time alone with Pierre *in his room* was so unthinkable that her parents probably refused to imagine it. The problem, as the Woods saw it, was not what Marcel or Pierre were, but what they were not—not American, not rich, not in steady jobs, and although not married, clearly not acceptable marriage material. Nevertheless, Beatrice still continued to see her old New York friends, if less often than before. So things might even now have passed off without an explosion. The arrival of *The Blind Man*, however, changed everything.

In the normal way of things, the Woods would never have known *The Blind Man* existed. Unfortunately it was forcibly brought to their attention, for on the day before it was due to be distributed to newsstands, the entire print run was delivered to the Woods's apartment.

In her diary Beatrice notes simply, "Parents shocked at Blind Man," but elsewhere she explains what actually happened. She had been out to have a cyst removed from her chin, and returned home to find stacks of magazines piled high in the apartment entrance.

If the rationale for putting Marcel's *Chocolate Grinder* rather than Stieglitz's *Madonna of the Bathroom* on the cover had been to avert at-a-glance public outrage, the strategy had not worked for Mr. Wood. In her memoir, Beatrice described what happened:

> My father came out of the sitting room to greet me. He had a strange expression on his face.
>
> "It took two men to carry these packages. I couldn't imagine what they were, so I opened one and saw they were magazines. I was astonished to find your name as publisher. You must be out of your mind. This is a filthy publication. I cannot believe a child of mine could be associated with such

thoughts. I have never before interfered in your life, but I beg and plead with you to withdraw this from publication. You are too young to understand the implications of what you are mixed up in. There are words in there no young girl should ever know. If it goes through the mail you will tangle with the law and be put in prison."*

Mr. Wood was doubtless thinking of the birth-control pioneer Margaret Sanger, whose incarceration the previous year for sending contraceptive instructions through the mails had been the subject of front-page stories, with photographs, in all the New York papers.

Beatrice was enveloped in gloom. Her father, though (in her words) "traditional and conservative," was also "a good and decent man," and she loved him. She wasn't at all perturbed by the thought of going to jail—on the contrary, she characteristically thought it would be "another new and exciting experience"—but couldn't bear the thought of hurting him. Also, there was a large mailing-list subscription. What was to be done about that, if she couldn't put copies in the post?

Luckily she had a friend who might know: Frank Crowninshield, the cultured and influential editor of *Vanity Fair*, which he had transformed from a fashion magazine into a journal of literature and the arts. He was also a great supporter of the Independents. A letter from him appeared in *Blind Man 2*, the only contribution not composed by a member of the inner circle. "Dear Blind Man, Fine for you! You are, I hope, to be the instrument for the accomplishment of an important and much-needed work in America; namely, the fostering and encouragement of a truly native art . . . that mirror[s] accurately the time, with all of its complexities, graces, horrors, pleasures, agonies, uncertainties and blessings. Admiringly yours, Frank Crowninshield."

First thing next morning, Beatrice rushed downtown to the *Vanity Fair* offices to seek his advice. Crowninshield welcomed her warmly. He was surprised to hear her story, for he had gone over the proofs with the editors only the previous week, and had found nothing especially risqué.

* Wood, *I Shock Myself*, 31–32.

But that, it seemed, depended on your point of view. Clearly the Woods' point of view was very different from Frank Crowninshield's. Yet they were cultivated people, and so were their friends. And their friends, too, were shocked. "Mrs Clarke disapproved of Blind Man" Beatrice recorded on May 9, on May 10 "Scolding Mrs Reynolds," on the 14th, "Daniels furious at Blind Man," on the 18th, "To see Mrs Colman at Scarsdale for scolding."

Beatrice concluded that the magazine would have to be distributed by hand. Crowninshield could not disagree. Nothing would please prudish politicians more than to use the law to suppress *The Blind Man*. In that, if nothing else, Beatrice's father was correct. But his outburst, as always with her parents' remonstrations, achieved a result the direct opposite of what they might have wished. For distributing the magazine brought her closer than ever to her bohemian friends. And the ruckus, far from killing *The Blind Man* stone dead, drew far more attention to it than it would otherwise have received.

Marcel continued to work on his mysterious Glass, *The Bride Stripped Bare By Her Bachelors, Even*, the complex project that brought together all his interests—esoteric geometries, affectless sex, imaginary physics, Rousselian jokes, and puzzles. It was slow work and he was bored with its seeming endlessness. Not only was it highly complex in conception, it was also very demanding technically. Every line (he used lead wire) was the result of calculations, experiments, and measured drawings. Visual puns were elaborately staged and detailed preliminary studies made, on paper and on glass, before taking their place in the huge mathematical, architectural, sculptural, and intensely intellectual construction that would become the *Bride and Her Bachelors*. Nevertheless, he persevered, for he had promised it to Walter Arensberg in exchange for the rent on his studio, and one of the few things that did concern him was keeping his promises.

Meanwhile, however, the shocking excitement of New York had begun to fade. The Independents and *Fountain* had been amusing for a

while, but with the publication of the second *Blind Man* the whole *Fountain* affair had come to an end without, it seemed, having made much impression. And now the war had followed him across the Atlantic, and the anomie that had driven him from Paris to New York, and that New York had for a while miraculously banished, was beginning to descend once more. There were the usual small pleasures—he went shopping for a hat with Beatrice, continued his affair with Louise, and enjoyed his affectionate friendship with his court of wealthy and cultivated lady fans, in particular Ettie Stettheimer. But they were not enough to supply the missing spark.

Yet he remained as captivating as ever: in Roché's words, "Incomprehensible, unlike anyone one had ever met, and wearing a train of captured hearts."[*] All the women fell in love with him, and not just the women. Men presented less emotional threat—being heterosexual, he wasn't expected to marry them, or make impossible promises of fidelity—and for Pierre and his other male acolyte, the young American artist and photographer Man Ray, who in 1921 would follow him back to Paris, the enchantment would be lifelong. "His presence was a grace and a gift," Roché wrote, "and he was quite unaware of the effect he had, even though he was surrounded by crowds of disciples. The memory of his personality remains even more present than his works—he became a legend, like a young prophet. His words were in everyone's mouths, and stories about his daily doings made them seem like miracles."

Beneath the charm, the jokes, and the ever-more-frequent whiskies, however, lay a deep well of pitiless nihilism. Marcel didn't care about making a name; he distanced himself from love, and as for wanting to change art, he had, in Gaby Picabia's words, "No interest in artistic manifestations other than for their scandal-making possibilities." William Carlos Williams was admiring one of Marcel's pictures in the Arensberg salon when its maker passed, drink in hand. "I like your picture," said Williams. "Do you?" said Marcel, and passed on. Williams, the most committed of men—to his doctoring, to his wife, to his poetry, and despite this insult, to Marcel—was shattered. "He had me beat all right,

[*] This and the following quotes, Roché, "Souvenirs sur Marcel Duchamp," in Lebel, *Sur Marcel Duchamp.*

if that was the objective. I could have sunk through the floor, ground my teeth, turned my back on him and spat."[*]

Yet Marcel continued to fascinate him; he fascinated them all. "Poor little floating atom," mused his friend Ettie Stettheimer, one of the few to sense the loneliness beneath the sociable surface. "A strange boy, but a dear."[**] Everyone longed to pierce his shell: none succeeded. They still, however, longed. When the war ended, and he moved back to Paris, people joked that whenever an American arrived in town the first thing he said was, "And how is Marcel?"

Perhaps the key to this fascination lay in his indifference. What people sensed in Marcel's presence was a mesmerizing absence of limits. His singular mix of wit, fun, nihilism, and piercing intellect reflected the anarchic freedom indifference conferred. It was the same mix that when combined with his genuine kindness, made him, and his creations, both mysterious and irresistible.

This nihilism found further expression in two more events, both connected to the Independents exhibition.

The first, which took place on April 19, ten days after the exhibition's opening, was a lecture, supposedly on Futurism, billed to be given at the gallery by the *boxeur-poète* Arthur Cravan.

Cravan was a huge physical presence, very tall, with a perfectly proportioned body, and handsome in a moody, full-lipped way. His aunt Constance, his father's sister, had been the wife of Oscar Wilde (Cravan's real name was Fabian Lloyd), and on the strength of this connection he had built himself a kind of literary reputation. Born in Switzerland, of British nationality, but based in Paris, he wrote poetry and produced a little magazine called *Maintenant*, in which he achieved notoriety by publishing an "interview" with his dead uncle Oscar, whom he claimed was still alive and living in Paris (in fact they had never met even when

* Williams, *Autobiography*.

** Gough-Cooper and Caumont, "Ephemerides," July 23, 1918.

he *was* alive) and insulting most of the exhibitors at the 1914 Salon des Indépendants. His style was not subtle. "Better be careful what I say about Robert Delaunay, we've already had a fight and I don't want anyone to think this is personal, [but] . . . he looks like an impassioned pig, or a high-class coachman." Or, on Marie Laurencin, who painted pastel watercolors of her artist friends, "[She] needs a good seeing-to if only to teach her that art isn't just a pretty pose in front of the mirror."

On the outbreak of war Cravan had left France to avoid the draft, and spent some time drifting around Europe and dodging the frontier police of many nations before fetching up in Barcelona. The Picabias were already there—Picabia had cousins there—and so were various other artistic émigrés, including, as it happened, Marie Laurencin, along with her then-husband, a German aristocrat whom she had met when she accompanied Pierre on a more-than-usually orgiastic trip to visit friends in Germany, and whom she would soon divorce.

The world heavyweight champion Jack Johnson also happened to be in Barcelona. Cravan challenged him to a fight: he enjoyed the company of boxers and their semi-criminal entourages, and liked to think of himself as one of their number. His skill, however, did not match his size, and he was knocked out almost at once. He then left Barcelona for New York, where he arrived just after the Picabias, and where, since the outcome of his bout with Johnson had not made headlines on the other side of the Atlantic, he was able to advertise himself as the poet who had successfully challenged the world champ to a fight. "I know [Johnson] is generally reputed to have a knock-out punch, but, having fought him, I realized that this was not true," Cravan told *The Soil*, one of New York's many little avant-garde magazines.

Cravan soon became part of the Arensberg scene as the lover of Mina Loy, whom he had met at a fancy-dress ball when her official partner, who happened to be Marcel, abandoned her for another woman. His lecture was the indirect result of a suggestion made by Heidi Roosevelt, a great-niece of Theodore Roosevelt and a friend of the Picabias. Some of her society friends, who had become interested in art at the Armory Show and were all agog at the Independents, wanted to

learn about "Developments in Art," and Mrs. Roosevelt had suggested a lecture series might be in order. On April 18 the lecture had been given by some poets and had been unremarkably herbivorous. For the 19th, Mrs. Roosevelt had hoped the lecturer would be either Picabia himself or Marcel. Either would have been a draw, but the prospect of becoming a society attraction did not appeal to them. Instead, they decided to organize a scandal—to which end they co-opted that specialist in scandal, Cravan.

The idea was that, with a little encouragement, Cravan might startle the audience with some choice volleys of abuse regarding the canvases displayed around them. In fact, this was not what happened. But there was certainly a scandal, and one much bigger than either of the plotters anticipated. No one present that day at the lecture, or purported lecture, would ever forget it.

Cravan, sober, was a charming fellow, reserved, courteous, a faithful lover and devoted friend. This was the *poète*. Drink, however, liberated the *boxeur*. Accordingly, the Picabias and Marcel prepared for the occasion by inviting him to lunch at the Brevoort beforehand and getting him drunk. Since Cravan was totally broke, and lived by mooching off his more fortunate friends, he eagerly accepted their invitation and drank deeply.

The official lecture hour came and went. From time to time Marcel or one of the Picabias would phone Walter Arensberg, who was chairing the event, to assure him the speaker was on his way, and Arensberg would pass on this assurance to the waiting audience, which consisted largely of Mrs. Roosevelt's fashionable New York friends, who were assembled to hear, as had been promised, about Futurism. After several such calls they became restive; Arensberg pacified them by offering free drinks from the bar that ran along one side of the room.

At long last Arensberg's prayers were answered and Marcel, the Picabias, and the speaker appeared. Cravan, who could barely stand, lurched his way unsteadily through the packed room to the podium, where he sank down behind a small table. A canvas by the photographer and painter Edward Steichen had been hung behind him; after a few violent gestures that almost dislodged it, he muttered that he felt intolerably

hot, took off his coat and waistcoat, unfastened his suspenders, leaned over the table, and began to hurl obscene epithets at the audience. At this point, before the trousers could actually fall, several policemen, alerted by a member of the audience, entered the room, handcuffed the speaker, and dragged him out. They would have taken him to jail, but Arensberg stepped in, paid a fine, whisked the sodden lecturer away before the enraged matrons could tear him to pieces, and delivered him home to sober up.

The Cravan lecture marked a high, or low, point. When Cravan came to, and realized what had happened, he was furious, and felt he had been made a fool of. Marcel, in contrast, was delighted. "What a wonderful lecture," he happily remarked, when everyone had reassembled at the Arensbergs.* Roché, however, says in *Victor* that Marcel "stayed behind after the rest had left, [and] for the first time thought he felt a certain bitterness directed at himself and his friends."

This may well be true, but Roché did not attend the lecture. He had spent the previous evening engaged in energetic sex with Marcel and Louise, did not get back home until one in the morning, then received a morning visit from Beatrice—the occasion of their "erste grosse K"—and needed to catch up with his work. That evening, however, he visited Beatrice's for dinner, when she doubtless filled him in on all that had happened. Her parents were out, and they ate in the kitchen. When her parents got back and found out about this impromptu visit she and her mother had another of their spats, with Mrs. Wood lamenting that she was afraid Beatrice was on the way to losing her reputation.

Beatrice had no hand in the Cravan debacle. But she was very much involved with the second event: a party, the Blind Man's Ball, which took place on May 25 and was effectively the final celebration both of the Independents and of an America still untainted by war.

The ball was advertised on page 2 of *The Blind Man*, the obverse of the *Chocolate Grinder*:

* This account of the Cravan lecture is taken from Buffet-Picabia, *Rencontres*, and in Motherwell, *The Dada Painters and Poets*, 16–17.

EVERY READER OF THIS MAGAZINE IS INVITED TO THE
BLIND MAN'S BALL, A NEW-FASHIONED HOP,
SKIP AND JUMP, TO BE HELD ON
FRIDAY, MAY 25TH

AT PREHISTORIC, ULTRA-BOHEMIAN WEBSTER HALL.
THE BALL IS GIVEN FOR THE BLIND MAN,
A MAGAZINE OF VERS ART.

AXIOMS DU BAL

THE DANCE WILL NOT END UNTIL THE DAWN.
THE BLIND MAN MUST SEE THE SUN.
ROMANTIC RAGS ARE REQUESTED. THERE IS A DIFFERENCE
BETWEEN A TUXEDO AND A TURK AND GUESTS NOT IN
COSTUME MUST SIT IN BOUGHT-AND-PAID-FOR BOXES.

CONTINUOUS SYNCOPATIONS.

ADVANCE TICKETS COST $1.50, OR CAN BE BOUGHT
AT THE DOOR FOR $2.

Balls like this were one of New York's favorite amusements. The syn-copated rhythms of hot jazz music had got everyone dancing: Beatrice's diary mentions a different ball almost every week—the Florentine Ball, the Rogue's Ball, the Independents Ball, the Beaux Arts Ball—any event was an occasion for a ball. Despite the grand name, however, these balls had nothing in common with the society events that were Mrs. Wood's idea of a ball—the kind of thing where Beatrice had miserably dressed up in pale blue satin, and where matrons sized up potential marriage prospects—but were more like Paris's *bals musette*: cheap informal dances to popular music; in Paris usually provided by an accordion; in New York by an ensemble playing jazz and ragtime.

For Europeans in flight from the darkness enveloping their conti-nent, such occasions embodied all the delight they felt in New York.

They seemed to have escaped into a dream world, a place that—unlike Europe—permitted total liberty of thought and action. The Arensberg salon, with its shifting population of artists and its perennially available chocolate cake, was very much a manifestation of this joyful and innocent dream, and the Blind Man's Ball, although it touted excess, was its culmination. Its frame of mind was summed up by its poster, a bright red high-stepping stick man thumbing his nose at the world—designed, at Marcel's insistence, by Beatrice. On April 29 he had sat her down on a hard chair in the middle of his room, watching while she, delighted as always to be in his company, made sketch after sketch. When she had finished he took the sketches, spread them out on the floor, and chose one of the lively scribbles he always preferred to her more considered efforts: "He liked the ones that were free expressions of the unconscious. I had no idea what they meant."* In the middle of the afternoon Roché called by, fresh from lunch (asparagus, the first of the year) with Nuk, the first of his New York mistresses, since joined by so many others. He thought the stick man "inspired."

Beatrice spent most of May 25, the day of the ball, at Webster Hall helping with the decorations. Then she rushed home to change, for she was to open the proceedings with one of her Russian dances. Pavlova's choreographer Ivan Clustine had supervised the making of her elaborate costumes for these dances—she wore a Russian peasant's high square cap on her head and carried in her arms a very small token bundle of firewood—and had arranged for her to perform them for the fabled Nijinsky, who, she later remembered, politely sat through her performance. But the Blind Man's Ball was a very different matter, almost a family affair. Everyone in the audience knew and loved her, and the applause was as much for her sweet smile and blithe unselfconsciousness as for the actual dance.

As the evening progressed, however, the abundant alcohol soon began to make itself felt, and the atmosphere of lighthearted gaiety metamorphosed into something rather darker. Cravan loomed drunkenly, while Joseph Stella, the Italian doctor-painter who had been one of Marcel's confidants in the *Fountain* affair, fought a duel to protect Beatrice's honor—"which no longer existed!" His opponent's name is not recorded,

* Wood, *I Shock Myself*, 25.

and Beatrice had no idea why Stella should have felt concerned about such a thing.[*]

The Arensbergs, Picabias, Marcel, and what Roché described as "the general staff of rebel artists" had established a base in a big box in the center of the hall's gallery. A long flagpole protruded from it at an angle of forty-five degrees, and around midnight Marcel, apparently bent on suicide, decided he was going to climb out along it. By then he was extremely drunk. It was a dangerous trick even had he been sober: everyone tried to dissuade him, and Beatrice hung on to his foot. But he was determined, shook her off, and struck out, straddling the pole. He was wearing a voluminous domino cloak and a pink paper hat, and looked, Pierre thought, like a ladybird on a thick twig. "He's going up into his ivory tower," commented Picabia.

At first it looked as though he might fall, and for a while everything stopped. But when it became clear he was probably going to make it, the spectators resumed their dancing, stopping again only to watch the final, most dangerous stretch. He reached the flags to general applause, which he acknowledged with a sweep of his pink paper hat, before sliding back down the pole.

In *Victor*, Pierre assigns a second semi-suicidal move to Marcel that evening. In this version, "Victor left with Winifred, a young widow he was comforting in his way. In a sporty mood that day, he practiced some balancing tricks with her on the white line painted on the edge of the platform of the Elevated."

What should be read into such tricks? Obviously they were not actual suicide, for Marcel survived them. Neither, however, were they the actions of a man who much cared whether he lived or died. The Blind Man's Ball marked the end of the euphoric blaze of friendship and creativity that had framed his life, and the lives of his friends, for the past few months. Now that the infection of war had crept across the Atlantic, New York was no longer a haven, the old ideas were yesterday's news, and he had no new ones to keep him going.

At three o'clock, when the ball ended, *toute la bande* assembled at the Arensbergs' for scrambled eggs and wine. After that, since it was

* Wood, 33.

too late to go home, five of them—Beatrice, Marcel, Charles Demuth, Mina Loy, and Aileen Dresser (Louise Norton's friend and an occasional participant in her lovemaking sessions with Marcel and Pierre)—all went up to Marcel's room, where they tried and failed to get some sleep on his double bed. Demuth draped himself across its foot; Marcel stretched himself out against the wall, where Beatrice pressed up against him. She was in heaven. "I could hear the beating of his heart, and feel the coolness of his chest. Divinely happy, I never closed my eyes to sleep."

10

PIERRE'S AMERICAN LOVES, 1917·

B eatrice went on from Marcel's to a rehearsal of *Jeanne d'Arc*, which was being revived at the French Theater. Eventually, however, she would have to return home. And at that point, the battle would begin. As indeed it did: when she arrived, there was her mother, "standing like an Inquisitor at the door, ranting over my spending the night with Marcel."**

The fuss was ostensibly (and to some extent really) about appearances. However disappointingly chaste the reality, nothing altered the fact that Beatrice had spent the night in Marcel's room. But Mrs. Wood's temper tantrums were also about jealousy. She wanted her talented daughter to shine, yet at the same time couldn't bear to let her go. A "suitable" marriage would keep Beatrice within the parental sphere of influence. But that seemed less and less likely, as she slipped away into worlds where she threatened to become both unreachable and unmarriageable. "I would rather see you dead than have a lover," Beatrice remembered her mother saying, and reflected, "Imagine if she had known about Roché!"***

* My account of Beatrice's affair with Pierre is taken from her love letter to him, *Pour Toi*, from her memoir *I Shock Myself*, and from his diary and hers.

** This and the preceding quote are from Wood, *I Shock Myself*, 33.

*** Wood, 33.

In fact, the two had been introduced. In a sweet but hopeless attempt
to reconcile her two warring worlds, Beatrice had invited Roché to dinner
at her home. But whatever her hopes (presumably that he and her parents
would get along, and that this would confer on him the status of a quasi-
fiancé?) the occasion didn't go very well. As Beatrice herself recognized,
Pierre was quite conventional in many ways, and this mother's boy to end
all mother's boys was shocked at the way his new girlfriend treated her
mother. The conversation turned to flowers, in the arrangement of which
Mrs. Wood took a great interest; Beatrice said she couldn't imagine a
more boring subject, and this rudeness (so American!) made Pierre feel
very uncomfortable. His discomfort, however, did not allay Mrs. Wood's
suspicions. She saw him as an unalloyed threat, an emissary from the
artistic netherworld that threatened to swallow her daughter, and a few
days later staged one of the melodramas that were her recourse whenever
she felt Beatrice slipping out of her control. It took the form, in this case,
of declaring that she would seek a divorce. Beatrice said that in that case
she would live with her father, and the threat faded away.

Since he had no intention of becoming Beatrice's official boyfriend, all
this was perfectly irrelevant to Pierre's campaign. What most intrigued
him was finding out that Beatrice was a virgin. They'd talked about
it over lunch a few days previously, and he had noted it in his diary—
"Vierge!" Given his sexual progression—from women who answered his
ad requesting sexual partners to the free-and-easy society of artists in
Paris and the more or less debauched wing of the German aristocracy—he
had probably never met such a creature before, or not in a potentially
sexual context. Such a bright, forward, artistic girl—and still a virgin,
at twenty-three?

Clearly this strange situation presented opportunities for a con-
noisseur like Pierre. In France, a girl like Beatrice would probably be
respectably married. Given the French bourgeoisie's unromantic view
of marriage, this did not by any means imply lifelong fidelity; what
was primarily required was discretion. But in America, as Pierre had
observed, you stuck it grimly out and took refuge in your business, if
you were male, or, if female, in shopping or your women's club. Since
Mr. and Mrs. Wood in every way complied with this observation, it was

clear that getting married, for Beatrice, presented no particular attrac-
tion. And yet she held herself in virginal readiness! This presented a
personal challenge that he felt compelled to overcome, and that was
anthropologically irresistible. As the first stage in his campaign, he
asked Béa to explain it.

The result was *Pour Toi, Adventure [sic] de Vierge*,* a long, illustrated
love letter in which she described their affair and worried about virginity.
"It isn't easy, what you've asked me to write," she began. "Darling, you've
got to understand that this is my home, and has its own rules, and I spend
my life trying to come to terms with it all!"

Looked at objectively—which of course Beatrice could not do—the
singular thing about virginity was that although the cherry notionally
belonged to the virgin, the conflict—to keep oneself for marriage, or to
give in and be modern?—was all about male ownership.

For Mr. and Mrs. Wood and their milieu, the virgin's womb and its
potential offspring belonged not to the woman but to her husband. In
the absence of the public display of bloodied sheets, the chief enforcer
of this contract was the fear of unsanctioned pregnancy. That was why
reliable female contraception was anathema to conservatives, and
why, in 1917, birth control occupied the obsessive place in American
conservative psychology presently filled by abortion. The fight, in
both cases, was—and is—about men feeling threatened in what was
once their unassailable control over female lives. The judge who sent
birth-control activist Margaret Sanger to prison in October 1916 made
this perfectly clear. Sanger had broken a New York law prohibiting
the distribution of contraceptives or contraceptive advice through the
mail; sentencing her, the judge announced that women did not have
"the right to copulate with a feeling of security that there will be no
resulting conception."**

Pierre and his friends regarded the virginity cult as a medieval throw-
back. Modern women, they rightly assumed, enjoyed sex quite as much

* It was written in French, which Beatrice spoke fluently.

** Jill Lepore, "Birthright: What's Next for Planned Parenthood?" *New Yorker*,
November 14, 2011.

as men, and were as entitled to indulge their desires. But even if anyone could go to bed uncensured with anyone they fancied, this overlooked the little question of contraception—which in America in 1917 was controversial even for married women.

Of course, not all sex risks pregnancy. But if Beatrice is any guide, the working assumption—for women, though not for men—was that without penetration, there could not be love. "Even now," she wrote, in the midst of an unbridled love letter, "I'm not sure I love you. I don't think that can happen until we sleep together" (i.e., until vaginal penetration). And that almost certainly did not happen. Not only would it have gone against all her parental conditioning, it was too dangerous.

It need not have been. Pierre could have offered to use a condom. But it is clear such a thing never crossed his mind. His permanent Paris girlfriend, Germaine Bonnard, underwent two abortions; more than once, in his American diaries, he notes his relief that the woman of the moment was thankfully not pregnant ("no kid"), a relief doubtless shared, in spades, by the woman in question. (Marcel appears to have been equally oblivious in this regard. Although he told Pierre Cabanne he had never wanted children because he needed "to keep the expenses down," he already had a daughter, to whose expenses he did not contribute, by the time he left for America. Her mother was Jeanne Serre, with whom he had a liaison in 1910: the child had presumably been conceived just before the affair ended, for Marcel knew nothing of her until some years later, when he and Jeanne met by chance, and Jeanne, as they chatted, nodded meaningfully toward the little redheaded girl by her side. She had meanwhile married a financier, who was bringing up the girl as his own. Forty years later, the child, now a middle-aged woman, and her biological father met again. The relationship was then acknowledged by both, but for his daughter Marcel remained "a little like a legend, no more. He did everything so gracefully . . . but in the end there was still an immense barrier between us, impossible to cross.")

So what should Beatrice do, now, on this momentous April 19, alone in a room with Pierre?

It was not her first visit to his room. That had been when Marcel and Picabia tried and failed to (literally) throw them together; and she had visited him again, this time voluntarily, on the recent occasion of their first kiss. Nevertheless, the part of her that was a denizen of her mother's world knew she shouldn't be there. She'd prepared her phrases: she'd visit him just this once, didn't want to seem a prude. She perched on the table in front of the window and made the brittle conversation of nervousness. He suggested she take her hat off; she hesitated; he came over and removed it himself. "And then you kissed me!"

And then they lay down on the bed, and he undressed her.

Until recently Beatrice had thought that this alone—being in, or on, a bed with a man—constituted the dreaded loss of virginity; her first thought was, *This is it! I'm a lost woman!* But it was so delightful, and Pierre was so kind, that she soon calmed down. "I became fonder of you. Because, you know, I didn't love you. I told you so. And you didn't love me either. You were even afraid I'd be hairy!* Even now, writing this, I'm not sure I really love you. I think that perhaps that doesn't happen until you have proper sex together. But I like you so much!"

She lists all the things they do together—*the theaters, the Childs, the Sundays I so adore.* She notes with pleasure that he likes onion salad, to which she evidently introduced him, and that being so conventional he's very easy to tease. Nor does she avoid the awkward question of his other mistresses. She loves the way he feels free to talk about them with her: it's a mark of the confidence they have in each other. She can understand why Germaine loves him so much, and is afraid of making her suffer—*perhaps I shouldn't really love you, after all.* She feels sorry, too, for her mother, who is so anguished on her account. And finally she comes to the big question. *Am I, or am I not, a virgin?* Will he have to force her, in the end? She quotes a limerick—

* Body hair, in particular too-abundant pubic hair, seems especially to have repelled Frenchmen of this generation. One of Marcel's wordplays ran: *Abominables fourrures abdominales.* It was evidently deeply felt, for Lydie Fischer Sarazin-Levassor, his first wife, records in her memoir, *Un échec matrimonial,* that he depilated obsessively, removing any trace of body hair, which he felt was an unwelcome reminder of man's animal origins.

There was a young lady from Siam
Who said to her lover, "Oh, Priam
You may kiss me of course
But you'll have to use force
And God knows you are stronger than I am . . . !

But of course he won't force her, and in the end she can't bring herself to do it; it's the one betrayal she can't inflict on her mother. Besides, is it really necessary? Could their pleasure be any more intense than it is already? *So I've come to the end, and I'm still a virgin. And don't always be warning me I must be careful not to get fat.*

That's it. I love you.

Pour Toi was dated June 2, 1917, but, with its careful grammar and its numerous carefully placed illustrations (here she is onstage in her scanties—"I'm an exhibitionist, I can't deny it!"—and here, that first time they kissed, wearing her favorite blue turban with the feather, later discarded at the bottom of the page, beside a picture of the two of them entwined), this was clearly the painstaking culmination of many hours of devoted work and thought.

Pierre was terrifically pleased with it. He adored getting letters from his mistresses—loved by so many women!—always noted when they arrived, and always kept them unless specifically instructed not to. This one was so extraordinarily pleasing that in an act of almost unbelievable betrayal, and despite its intimacy, he couldn't resist sharing it with Marcel.* The disjunction between Pierre's feelings and Beatrice's is reinforced by penciled grammatical corrections in his handwriting, and an observation on the title page that strikes a jarring note when taken in conjunction with such an uncensored baring of the soul: *Reread many times between 1917 and 1953! Charming—and remarkable, in its way.*

* We know this because it was one of the papers left behind for Pierre to pick up when Marcel left for Buenos Aires the following year.

One of the surprising things to emerge from *Pour Toi* is Beatrice's happy conviction that nobody in their close-knit clique of friends suspected what was going on between them—that the two of them inhabited a small private world of delight of which nobody, not even *cher Marcel*, had any idea. Since one has to open one's heart to someone, and since Beth was now married and living in New England with her husband, Norman Hapgood, Alissa Franc, who was neither part of the Arensberg group nor a family friend, was Beatrice's confidant. But she told no one else. Of course, people knew she liked Pierre. Walter had teased her about it; Lou took it for granted. But they didn't know how far things had gone. As for Pierre, discretion was his lifestyle's imperative. He revealed his current amours only to his diary.

It is true that Pierre had told Beatrice how often he fell in love, and about Germaine, his girlfriend of twenty years in Paris. But the impression she took away was that this was all far away, on the other side of the Atlantic. In New York, she was the one. Quite apart from sentiment, there was the mundane question of time. Between his work, about which he was conscientious; social life at the Arensbergs; visits to theaters, the circus, and restaurants; the cultural offerings of friends such as Copeau and Varèse; and the more or less constant company (or so it seemed to her) of Beatrice, his days and nights were filled to overflowing. How could he possibly find time for anything more?

All this was true. But that was to think like a normal person. What Pierre required was not normal. He needed constantly to know that several women were competing for his sexual favors. Once he had one in the bag, so to speak, he immediately felt compelled to begin the hunt anew. They were all aware of Germaine, partly because he felt a genuine loyalty to her, partly because that let him off having to promise commitment elsewhere, and as Beatrice had found, his frankness was misleadingly reassuring. But if all this was to work, his current mistresses, as far as possible, must not be aware of each other.

While he was courting Beatrice, Pierre's most constant recourse for sex was Louise—sometimes just the two of them, sometimes in a threesome with Marcel or a foursome with one of Louise's friends. He would often see Beatrice during the day, then spend the night with Louise. He

also kept up with Nuk, but they had never met particularly often—once or twice a week—and she was now dwindling into an occasional pleasure.

Did Beatrice really have no inkling of all this? Consciously, she did not. But we often intuit what our conscious selves are unwilling to admit. Thus on May 13, Pierre, having spent the previous night at Louise's in a foursome, returned home, where he was to meet Beatrice at one. But he found her cold and standoffish; the reason why is not recorded, but unfocused jealousy seems the most likely explanation. Lots of KPF soon melted this; she waited at his place while he went to a lecture, before continuing together to the Arensbergs', where there was a big party. Everyone was there—the Van Vechtens, the Gleizes, the Picabias, Cravan. Beatrice gave her Russian dance; she thought the evening "splendid," while Pierre noted "I love B"—the only time, in all his diaries, that he allows himself such a sentimentality. Next day, however—it was the year's first warm day—he spent the night with Nuk, and on May 15 rejoiced to receive a letter from Helen Hessel—a "voix amie."

On June 3, Beatrice gave Pierre *Pour Toi*. *Merveilleux*, he thought, and recorded that, for the first time with her, he came—*dos*, he records, so perhaps they had anal sex. After that she felt "much nearer to him. On the point of falling in love."

In Beatrice's diary, the next two days are blank. Then on June 6, she saw Alissa Franc, who was "sweet and worried about me. Upset over Roché."

Who was upset? Beatrice or Alissa? Either is perfectly possible, for on that day Pierre records that he spent the evening with Alissa—and that they went to bed together. From then on he saw her most days, referring to her in his diary as Nuk III—Nuk I having been his first English lover, and Nuk II the New Yorker he had bedded soon after his arrival, who resembled her; both were presumably small and round, like Alissa.

When, some weeks later, Beatrice found out about Pierre and Alissa, he pretended that it had been a mere spur-of-the moment thing, an aberration that had not been repeated. "Little one, believe me, it did not mean a thing. I do not love her. I was calling on her, talking about a book, the fire reflected on her white neck—and it happened."* But that

* Wood, *I Shock Myself*, 36.

was misleading, to put it mildly. Pierre, caught unawares and forced to improvise, told her what he thought she wanted to hear. But it was not the truth. Pierre and Alissa's liaison was not a matter of chance.

For dinner with Beatrice was far from being Alissa's only social event on June 6. On the contrary, she had earlier attended a lunch at the Beaux Arts, with Lou Arensberg, another friend, Helene Freeman, and Pierre—a "charming" occasion, he noted, followed by a trip upstate along the banks of the Hudson in Lou's chauffeur-driven car. They had returned to New York in time for Alissa to dine with Beatrice, but before the motoring party broke up she and Pierre had agreed to meet again later that evening. They spent a long and satisfying night together at her place, and he didn't get back home until nine the next morning.

So when Alissa warned Beatrice, during their dinner, that Pierre was untrustworthy, she knew what she was talking about. Since she could hardly say why, or not in so many words, she confined herself to hints and vague warnings. But Beatrice was long past the point where mere hints could undermine her devotion to Pierre. The day after Alissa's warning, they went to hear the evangelist Billy Sunday (Beatrice didn't like him, but Sunday was an avid enthusiast for America's participation in the war, so perhaps Pierre felt he should check him out. Or maybe he just wanted to witness the bizarre phenomenon of American revivalism). Then they dined, and despite the weather (it was raining slightly), spent a while canoodling on a moonlit bench on Riverside Drive. The day after that they went down to the Battery and took the Staten Island Ferry, and Pierre was his usual beguiling self. After which Beatrice went home and enjoyed a dinner with family friends, who admired her batik work.

Pierre, however, did not go home after the ferry trip. On the contrary, he met Alissa for dinner, after which they repaired to her place and spent a "blissful" night together. Alissa, unlike Beatrice, made no problems about virginity, either because hers no longer existed, or because she was only too pleased to bid it farewell. And the fact that she was no longer a mere spectator of Beatrice's exciting new life must have made the whole affair doubly sweet.

For the next couple of weeks Pierre alternated between Alissa and Beatrice. On June 7 he dined with Beatrice and Marcel, and they all went

on to see an operetta, *For the Love of Mike*. On June 8 he spent the night with Alissa, who on June 9 made a scene because he had gone to a party in the country without her. On June 10 Beatrice, who now appeared in Pierre's diary under the name Ghi—presumably the noise she made when in the throes of pleasure—came to see him at midday for the usual litany of caresses; on June 11 he was back with Alissa. On June 12 he and Beatrice had dinner, which he adjudged *charmante*: they talked about his Paris girlfriend, Germaine, and he saw her home on the bus, then went dancing with friends, and flirted with a charming girl from San Francisco. On June 14 a jolly lunch with Beatrice at the YWCA was followed by more KPF and KPH ("*progrès*," Pierre noted; Beatrice thought him "very sweet" that day.) On June 15, he spent another night with Alissa . . .

And on June 16, with Alissa safely conquered, yet another game began.

-:::-

After spending the night of June 15 with Alissa, Pierre made for Lou Arensberg's. The weather had turned very hot, and Lou had invited Pierre and Beatrice to join her for a weekend in New England, where her family's textile business was located and where her brother had a summer house on the beach between Providence and Boston.

They traveled in Lou's luxurious chauffeur-driven car. After picking up Beatrice they took the scenic route, the three of them sitting in the back of the car with Lou in the middle. After an enjoyable ride ("Bonne société nous 3") they spent the first night in Springfield, where they saw a Charlie Chaplin film, then danced and played silly games in Lou's hotel room until two in the morning, after which Beatrice visited Pierre in his room. Next day they motored on to Boston in a cold rain that Pierre found "delicious" after the stifling heat. There they stayed in the luxurious Plaza Hotel, where Lou had reserved a suite of three interconnecting rooms—two double rooms, one for Lou and Beatrice, one for Pierre, with a lounge between them. Lou and Beatrice dressed for dinner, and Beatrice, to her delight ("Awfully good time!"), got drunk on champagne—"Just like Totor," Pierre commented.

When Pierre had been in bed a little while, there was a tap on his door and Beatrice appeared. In *Victor* he has her "wearing an enormous nightdress as if she were a little girl.

"She got straight into bed and laid Pierre's head upon her shoulder.

"They chatted for a while.

"We snuggle up to talk and sleep. She'd rather be with Victor, but that's not an option. She makes everything surprising and fun. Where are we heading?"

The reality was rather different. "Sl. avec Ghi—jeu nu," Pierre noted in his diary. And the fun, as he described it in *Victor*, continued over breakfast. Beatrice, evidently excited at having, for the first time, spent a whole night with Pierre, was "in fine form, beaming and putting on an act, telling their futures, teasing and making mischief.

> Then she put her hair into two tight plaits and was quiet once again. She placed one of her feet next to [Lou's].
>
> 'Look,' she said. 'Mine looks like a potato with five little sausages, this one looks like a swan's. I am really not beautiful enough! It's a constant burden to me and that's why I use my eyes and my voice as much as possible. I have to behave eccentrically to capture people's attention, but it has to be rationed. If I could be beautiful all the time, like [Lou], I would never move a muscle. I'm just a clown doing hard labour.'

Was this how Beatrice saw herself? It has the ring of truth, but perhaps the truth is Pierre's—as is the rosy view of Lou, who despite her many fine qualities was not beautiful.

From Boston they went on to visit Lou's brother and his family at the seaside. "See little puppies," Beatrice noted. "Pierre and I take train back. Wonderful time"—which from Pierre's account, we can see is code for a night of energetic love in the sleeping car. The logistics were demanding— "How narrow the beds were! They held on to each other so as not to fall out." But they didn't let that put them off, and even succeeded, toward morning, in falling asleep in each other's arms.

This blissful weekend of love and friendship gains a rather different emphasis, however, when it is seen through Pierre's eyes. For his attention had now turned to Lou, though for the moment it was just a matter of setting things in motion: indicating possibilities, suggesting feelings. "Seaside, sand, house, dogs, return, Lu's hand, rest, kiss Lu's hand . . ." To which she made no objections; for she had previously told Beatrice, when they discussed Pierre, that she liked him a lot: he had, she thought, "a certain insidious charm."*

They returned to New York in record-breaking heat, and Beatrice and Pierre went straight to his apartment, where he worked while Beatrice napped on his bed before visiting Coney Island with Marcel and Picabia. They "tried everything" and had their photo taken by a beach photographer: Marcel sitting on a railing, birdlike and alert; Picabia chunky and unreadable in a white suit and black bowtie; Beatrice in front, spaced out and smiling in a filmy dress and huge sombrero. After which she went home to confront her mother, who expressed her displeasure in the usual way by taking center stage and threatening to sue for divorce.

Pierre had recently moved from his basement room to a larger, brighter apartment that had fallen vacant on the floor above, and now, in addition, rented a studio above that, with a bathroom where he and Beatrice, when she visited, took cold baths every half hour "quite chastely." The hot weather gave him a migraine: Beatrice came to look after him, and (headache or no headache) they ended up entwined.

Fortunately, the migraine had cleared by the next day, for he and Lou had arranged to take a boat trip up the coast to visit her brother for another seaside weekend. Before leaving he was briefly visited by Beatrice, in tears because her mother was persecuting her ("she worries me to death about Roché") and also (though she did not admit this to him) because she was starting to feel jealous of Pierre and Lou. He comforted her; then they went their separate ways, Beatrice miserable, Pierre happily anticipating a delightful weekend of sun, sea, and country air with a new potential love. And indeed it was all as wonderful as he had hoped.

* Wood, *Pour Toi.*

Though he and Lou did not sleep together, they both knew they were about to fall in love.

On the Monday, Pierre and Lou returned to New York. He spent the day at home writing letters and working, and the evening with Alissa. Next morning, Beatrice (who had also spent the weekend in the country, at a place called Brocken, where some family friends, the mildly bohemian Mowbray Clarkes, had a house with log cabins for guests) visited him at home: "kpf sweet jolie—weeps en lisant lettre de [Germaine]." Beatrice, however, remained suspicious. She told herself she must stop seeing so much of Pierre, and took refuge with Marcel, who was "sweet." Always ready to offer refuge, kindness, and a shoulder to weep on, his sympathy and genuine fondness were doubtless redoubled by relief that he, at least, was not the cause of Beatrice's misery—yet another proof, if proof were needed, that love led only to trouble.

Despite Pierre's advances, Lou still seems to have assumed he belonged to Beatrice. She had remained in Providence, and the following weekend invited them both to join her there. Before they left (they were booked on the morning Pullman from Grand Central), Beatrice met Alissa—who did not disclose that she was fresh from spending the night with Pierre. On the train Beatrice painted watercolors while Pierre read; at Providence, "notre Lou" met them in the car.

For Beatrice, the weekend began well. She and Pierre were given a bedroom upstairs in the guest house while Lou slept on the ground floor; it was cool, the house was luxurious, everyone enjoyed themselves, the three of them went walking by the sea. Beatrice sang by moonlight—off-key, Pierre noted: "My finger on her throat." She showed them a drawing she had done entitled *Beatrice and Her Twelve Children*. It showed Beatrice, a baby labeled PIERRE at her breast, surrounded by children whose garments were labeled with the names of their fathers: the men she loved—Pierre, Totor—and others, like Cravan, Picabia, and Walter Arensberg, who were simply beloved friends. "It was easy," she explained. "I pictured my life and domestic situation with each of the fathers." (In fact, Beatrice would never have children.)

It soon, however, became clear to everyone that Pierre's allegiance was changing. Twice, he and Lou went driving alone, and talked of love and

Germaine. "My cheek against hers," he noted. And on Monday night the storm broke.

The occasion was a real electric storm, with thunder overhead and constant flashes of lightning. Lou, as all her friends knew, was frightened of lightning, and Pierre went to comfort her (at Beatrice's insistence, he says in *Victor*). He began with a consoling kiss on the cheek, but then she fell shivering onto the bed—"puis tongue . . . et pur bref chaste . . . kpf." She was Germaine II, he told his diary: the American counterpart to his Parisian almost-wife. In *Victor*, they declare their love for each other, and Lou tells Pierre that no, she isn't happy with Walter, to which he replies: "I thought you were happy. This changes everything." Lou asks him whether he's going to marry Beatrice; he says neither of them wants that, and anyway, Beatrice loves Victor. And how about Germaine? How does he love her? To which he replies, "Like I love you. Completely." He wanted her to come to Paris; he was sure she and Germaine would love each other. Beatrice, meanwhile, was dismissed as "a little dog he had looked after for a while, who loved a different master but who lived with him."

While this was going on Beatrice, upstairs, wept. Pierre tried to make it up to her when he returned: "Alors tendre, merveilleux kpf . . . et elle kph comme négresse jusqu'au bout." But no lovemaking, however sensuously satisfying, could erase her terrible jealousy. Of course she couldn't *know* what went on downstairs, but she could, and did, guess. "Suffer on account of Lou as much in p.m. and evening as I ever have in all my life!!!"

They all returned to New York the next day. Lou, noted Beatrice, was "dear," but when they arrived, people made fun of a brass mock-wedding ring Beatrice had worn, and Pierre was "not kind." She then returned home, while he stayed for a late game of chess at the Arensbergs', where Lou, transformed by love, was beautiful, gay, and joyful.

It couldn't last: everything was getting much too complex. On July 6 Pierre spent the night with Alissa, lunched with Beatrice ("2 kpf superbes"), who then went to Brocken for the weekend, leaving him free to dine and spend that night, too, with Alissa. On the weekend of July 14–15, he spent most of the day at an interfaith conference, after which he and Beatrice met briefly before he went on to Alissa's, he, too,

nervous by now, especially when she was sick next morning ("Kiddy? Non: concombre"). After that he went on to a party at Isadora's with Marcel, Picabia, and *les girls*—their names not specified, but probably including Louise Norton. Beatrice, however, was not invited. "Sick over P. Cannot admit his going to Isadora Duncan's." Her next words, "Am neither modern nor reasonable," perhaps tell us how Pierre tried to justify his behavior. (*Be reasonable, Béa, you're a modern woman, after all!*)

Who did she suspect? Lou? Isadora? On July 17, when the thunderbolt arrived, it was from the most unexpected quarter. "See A. Franc," Beatrice noted, and evidently Alissa, who had just lunched with Pierre, could no longer bear the weight of her secret.

It was six weeks since Beatrice had delivered the blaze of happiness that is *Pour Toi* to Pierre; ten months since she had met Marcel and entered the dreamworld over which he presided. That had been thanks to Alissa, and now, also because of Alissa, it was all over.

Pierre had his first inkling of what was to come when he and Beatrice met later that afternoon, over tea at a mutual friend's, and she addressed him coldly as *vous*. They went hurriedly back to his place, where he tried to explain. Pierre assured her "it did not mean a thing. But I knew that it did. I saw the whole betrayal. He kissed my neck, my cheek, never had he been so tender." He promised he would be more faithful—or at least try. They both wept; the scene ended with "3 kpf."

"Roché," wrote Beatrice in her diary. "Weep. Tell him how dreadfully I feel over his action. He is sweet, but the end."

"For the whiteness of a neck he threw away our relationship.

"We both wept. His tears fell on my cheek, and mine on his. For an hour we remained in each other's arms.

"Finally I moved from his embrace and, trembling inside, kissed him goodbye and walked out of his room.

"With tears pouring down my face I took the subway and went home.

"I never suspected the world could be like this."*

* Wood, *I Shock Myself*, 36.

Beatrice spent the next day with old friends from her previous life. They, at least, were unchanged. But she felt terribly alone. It was the worst crisis she had ever had to confront, and she had no one to confide in. Beth was in Washington with Hapgood, who had just been appointed American ambassador to Denmark. Her mother, far from offering support, would descend into hysteria if Beatrice so much as hinted at the truth. And all her other confidants—Lou, who had been a second mother figure; Alissa, who had been her best friend; Pierre, who had been her lover—were the very people who had betrayed her.

Pierre, meanwhile, was once again en route for Boston. Lou met him at the station, and the car whisked them to her brother's house, where they walked into the countryside and fell into each other's arms. "Drunk d'l," he recorded. Back at the house Lou played and sang; then they took the train back to Boston, where Pierre was booked in at the Plaza. They spent a "nuit inoubliable," breakfasted on cherries, and after lunch telephoned Beatrice, who was not grateful. "Roché and Lou phone me from Boston. Sick to my stomach."

So here they all were: Beatrice broken, Alissa triumphant, Pierre more than usually entangled.

And Lou? Since she left no account of all this, we must deduce from the little we know.

She and Beatrice had become fond friends and would remain so for the rest of Lou's life (she would predecease Beatrice by almost fifty years). Where love, in the end, failed them both, female friendship endured. Meanwhile, however, Lou felt terribly guilty. Calling Beatrice from Boston had to be her idea—Pierre would never have done such a thing unprompted. Did she hope to offer comfort? To receive absolution? To explain? Probably a mix of all three, though each seems less realistic than the last. But in the end, the fear of inflicting pain was not enough to keep her from stealing Pierre. For on the other side of the balance was nothing less than Lou's whole life. It wasn't as though Pierre was just offering sex. He was proposing that she move with him to Paris, where they would spend the rest of their lives together.

Should she accept, or stick with Walter? They got on well enough, but their marriage was far from ideal. Beatrice described it as it was a few years later, when it had resumed its pre-Pierre rhythm:

> During the day Walter was furiously preoccupied with two secretaries deciphering cryptograms. During the night he and Lou shared a dark wooden bed together, circa Queen Victoria. And possibly their sexual relationship came from Victoria's period, too, because somewhere there was a wall between them. In front of me they discussed Walter's amorous pecca-dilloes openly, referring to the fact that Walter had permission to visit these little chippies [*sic*], whom he paid . . .*

Set against this background, the revelation of love in all its physical and emotional glory must have been so eclipsing that guilt and friend-ship simply lapsed into insignificance. How could she possibly let such an opportunity drop?

Pierre probably helped assuage Lou's guilt (and his, if he felt any) by playing down the importance of his liaison with Beatrice. The less than flattering picture he paints of her in *Victor*, where she appears naïve and slightly galumphing, no doubt reflects the story he told himself and Lou. "Go downstairs to her! You love her," Lou says, when they first discover their feelings for each other, to which he replies, "No, I cherish her. That's quite different." He assures Lou that in any case it isn't him Patricia/ Beatrice loves: it's Victor.

Indeed, in her memoir, Beatrice says that following the break with Pierre her relationship with Marcel took "a more personal turn . . . It was natural that we would become as close physically as we were emotionally." The implication is that she moved more or less directly from Pierre's bed to Marcel's. In fact the break with Pierre was far from being final: they met often, and continued to make love, until mid-August, when she finally left New York. But she did meet Marcel on July 16, when she was

* Wood, *I Shock Myself*, 83. "Chippies"—Beatrice was thinking in French: *chipies* means "bitches."

beginning to suspect there was something amiss between her and Pierre, and again on July 19, when Pierre was in Boston for a weekend with Lou, two days after Alissa's confession. No doubt she wept on Marcel's shoulder; no doubt he took her in his arms and did his best to comfort her. But it seems very unlikely that his best extended to removing her carefully preserved virginity.

In *Victor*, Totor tells her:

> You don't love me—it's a crush. An invention, a ballet, a work of art on your part, a soap bubble. Sleeping together would do nothing but amuse us and help us register each other's existence. Then misunderstandings. Perhaps the end. No virgins for me. Pierre seems "busy," from what you say. You treat him a bit like a parent. But you've got to find your own way, like everyone else. There's a part of you that's like a spoilt child, and another part that's like an abandoned child.[*]

Of course it is Pierre who's really speaking. But in this case, the ventriloquism is probably accurate.

Back in New York, Pierre called Beatrice again, and she agreed to see him the following day. She arrived in a sorry state: it was unbearably hot, and she had been stood up by Marcel and Picabia, who were supposed to meet her that morning, but had called at the last minute to say they couldn't make it after all. She took a cooling bath, she and Pierre kissed and wept, and she explained that it was Alissa she couldn't forgive. Jealous though she might be of Lou, that at least was out in the open; but Alissa! It had been the vilest deception. Who could she ever trust again? It would be best if she and Pierre didn't meet alone anymore.

[*] Roché, *Victor*, 113.

Pierre was (for him) devastated. "Lovelorn!" he noted, and quoted Goethe's "Rastlose Liebe" ("Restless Love"). "Alle das Neigen," he wrote—the first line of a verse that goes on:

> *Von Herzen zu Herzen,*
> *Ach, wie so eigen*
> *Schaffet es Schmerzen!*

(All this affection / of heart for heart / ah, how strangely / it creates pain!)

What should he do? "Thinking—renoncer Nuk III? 3 Lieben. Nuk III le moins pur et le plus fickle. Renoncer à Ghi? Mais elle est un miracle . . ." As for letting Lou go, that was out of the question.

The description of Alissa as "less pure" and "fickle" presumably refers to her terrible, triumphant betrayal of Beatrice. Pierre nevertheless, although with some hesitation and not entirely happily, continued to see her as before. They met for dinner that very evening, and later made love, enjoyably though not, on his part, wholeheartedly—"demi je proches et demi no more." Next day he met Marcel and Picabia for chess, then returned to Alissa's at 4:00 A.M. for a quickie, as she was due to leave New York the following day. "No progenies," he recorded with relief. In the evening he went over to the Arensbergs', where the party included both Lou and Beatrice, followed by a walk with Beatrice in Central Park, where they had a "grave joli talk, sans K." (i.e., they didn't kiss.) Next day at noon he saw Alissa off on the train to Washington "½ querelle" (i.e., Alissa was bad-tempered), then met Lou for tea and a long talk followed by an evening of chess at the Café des Artistes with Marcel and Picabia, during which Beatrice, who was also present, leaned against the back of a chair "en pose d'ange nu." "Beaucoup pensé à [Lou] et à Ghi, et à Nuk III pas pur . . ."

<center>⋰⋱</center>

In labeling Alissa fickle and impure, Pierre showed remarkably little self-awareness, either of himself—if this was true of her it was even truer of

him!—or the times. For these were not pure times, and the impurities extended well beyond sex. For a while, New York had been a haven for Europe's escapees: frenetic, unbridled, but miraculously open-handed and free. Or so it had seemed. But that illusion, Gaby Picabia observed, was soon destroyed. "American neutrality turned out to be nothing but a cauldron in which bubbled slag from the inferno on the other side of the ocean . . . Where day and night were indistinguishable and conscientious objectors from everywhere jostled for space in an unimaginable atmosphere of sexuality, jazz and alcohol. . . . You couldn't speak or write or breathe freely: you were always constrained." (The word she used was *ligoté*, which literally means "trussed up.") That, she thought, was the source of Marcel's anger and aggression, what lay behind the drunkenness, *Fountain*, and the Cravan lecture; it was why Marcel, despite his friends' entreaties, turned his back on all artistic production, why Picabia's jokes became increasingly cruel.

After April 1917, when America entered the war, the atmosphere became even more sulfurous. The Picabias saw someone fed so much whiskey in an attempt to steal his identity that he later died of alcohol poisoning. Gaby, who spoke English with a strong French accent, found that the shoeshine boy at the Brevoort, her dentist, and her hairdresser all took the opportunity of close and private contact to tell their temporary prisoner about their access to inexhaustible stocks of rifles and cartridges, offering a good commission if she would introduce them to the official French buyers of wartime materiel headquartered at the Hotel Lafayette—who had also slightly lost their heads, she thought, what with all the dollars and whiskey.

At parties, of which there was an endless succession, people drowned rational thought in jazz and alcohol, and everyone spied on everyone else. At a cocktail party given by Mrs. Payne Whitney, a prominent collector of modern art and one of the greeters at the Independents' opening, the hostess introduced Gaby to Count Bernstorff, the German ambassador, with the words "Mrs. Picabia speaks any language." "But what's your native language?" the ambassador inquired, and on being told it was French, insisted on speaking French himself. The conversation that followed was both trivial and guarded, but it was observed, and the

following day, Picabia was summoned to the French High Commission. Did he know that the Whitney gun factory was one of France's most important suppliers of arms? And that it was rumored Mrs. Whitney was reputedly the German ambassador's mistress? Perhaps Picabia could use his friendship with Mrs. Whitney to find out, discreetly, just what was going on here?*

What was going on was, in fact, the stuff of John Buchan novels. Since the outbreak of war, Bernstorff had not just been in competition with the British ambassador, Sir Cecil Spring-Rice, to influence American policy, but had financed a number of sabotage missions—including the explosion, in July 1916, of a thousand tons of munitions stored in Jersey City and destined for Allied troops. The explosion shattered windows in Times Square and caused $20 million of property damage. Meanwhile, the British Secret Service distributed a photograph of Bernstorff, in a swimming costume, with his arms round two ladies, also in swimming costumes, neither of them his wife . . .

For a while people tried to pretend that life could continue as before. July 28 was Marcel's thirtieth birthday, and his devoted fans the Stettheimer sisters proposed yet another party—a birthday party for Marcel at the country estate near Tarrytown in upstate New York where they spent every summer.

Florine, Carrie, and Ettie Stettheimer were the formidably clever and talented daughters of rich German Jews. Their father had deserted the family early on, and after two older siblings married and moved away, the three youngest lived with their mother, Rosetta, in a close-knit female unit. After several years in Europe, they now spent their time between New York and Tarrytown. They had struck up acquaintance with Marcel by enrolling for his French lessons, which they did not need, for they spoke excellent French. Florine was an artist, whose painting of this party was to become her best-known work. Carrie spent her time constructing elaborate dollhouses, while William James had told Ettie, who had written a doctoral thesis on his ethics, that there was "no university extant that wouldn't give you summa cum laude." They all adored

* Buffet-Picabia, *Aires abstraites*.

Marcel, and he was extremely fond of them, particularly Ettie—not least because "inveterate celibates entirely dedicated to their mother,"* they did not make the kind of emotional demands he found so hard to deal with. "We've had such fun, and all without flirting," he reminisced in a letter to Ettie a few years later. "It isn't given to everyone to be able not to flirt—the gods must be keeping a special eye on us."** (Pierre, predictably, found the Stettheimers a little tedious. He couldn't understand Marcel's enthusiasm for middle-aged ladies; his interest extended only to those who were beddable. He nevertheless came to their party.)

The weather had been impossibly hot, but the appointed day was perfect—brilliantly sunny, with a cooling breeze—and everyone, but everyone, was there: the Gleizes, Leo Stein, Carl van Vechten and his actress wife Fania Marinoff, Isadora, who gave an impromptu performance on the grass . . . Marcel arrived last, in Picabia's red speedster: Florine's picture of the party shows him waving as he enters the garden beneath a triumphal arch of greenery. There was tea under the maples, billiards, and later, dinner at tables decorated with Chinese lanterns. Ettie had asked Marcel to make place cards for the guests, which he had done in characteristically unstraightforward fashion, drawing each name on a sheet of paper so that in order to read the name you had first to fold the paper in half then hold it up to the light. Pierre's, which survives, was drawn in spindly, almost anamorphic characters: not only a puzzle, but a reflection of Marcel's continuing fascination with the strange geometries of the seventeenth-century mathematician Jean-François Niceron.

Beatrice was not at the Stettheimers's party, but had left her tangled life in steamy New York to spend a few days with the Mowbray Clarkes at Brocken, their country place upstate, where they liked to welcome artistic friends, where it was cooler, and where an old friend, Rollo Peters, was putting on a production of *Macbeth*. She sent Pierre a "beautiful" letter from there, along with another of her little illustrated albums: *Psychologie—Fin*. This one, however, unlike the joyful *Pour Toi*, was full of sadness, ending "Forgive me, Pierre—I love you," for it had been written

* Marcel Duchamp to Calvin Tomkins, quoted in Tomkins, *Duchamp*, 172.

** "We've had such fun . . ." Marcel Duchamp to Ettie Stettheimer, July 6, 1921.

on July 17, the day of Alissa's thunderbolt. Pierre was deeply gratified, not least because Lou had also written to him that day, as had Germaine. What greater tribute could there be to his magical way with women?

He returned to New York to find a letter from Alissa in Washington: to his relief she was not planning to visit New York that week. Pierre spent it working naked in his room, flattened by the heat, then on the Friday took the train to Brocken, where he was to join Beatrice. "The walls of the cabins only went two-thirds of the way up and the top part was made of a translucent metallic material. There was another cabin on either side of theirs. Avant-garde artists of all kinds were staying there, all very fond of [Beatrice]. They worked out the following points:

1. She had a strange relationship with Pierre.
2. They were in love but not making love. That was such a pity.
3. There was no danger in leaving them alone together.

They bathed at dawn and shaved in the river, Pierre his beard, [Beatrice] her lower legs. He went looking for fish which [Beatrice] grilled on some small sticks."

Pierre loved Brocken—the bathing, the simple communal meals in the barn, the performance of *Macbeth*—and everyone there was charmed by him. That included Beatrice who, delighted that he had made such a hit with her friends and despite her resolve that "all that was over," found it impossible not to slip back into the old, loving ways. Whenever the two of them went for walks in the woods, Pierre made love to her and she did not resist. "Play allright. Jolly fun. Pierre dear," she noted. On the Tuesday they returned to New York together and went back to his place, where she spent the night and they had many KPFs and KPHs.

Was it all, then, to start again—with the difference that this time, instead of his being her (apparently) devoted and single-minded lover, she would know she was just one of Pierre's several "girls"? It seemed possible. For the next week they met and made love every day, Pierre's passion apparently revived by his having almost lost her.

But no: to be part of a harem was more than she could bear. She had to get away.

On August 9, a possible solution presented itself. A friend, Wallace Reynolds, introduced her to a Madame Dambrine, of Montreal's French Theatre. "She wants me absolutely to go to Canada to play," Beatrice told her diary, and that evening informed Pierre of her decision. "Alors tendre . . . lyrisme virginal," he swooned, overcome with love now that the end seemed finally to have arrived. Next day, having told her mother of her decision (but Mrs. Wood didn't really believe it), Pierre saw her onto the ferry for a final weekend at Brocken.

With perfect timing, Alissa arrived from Washington the next day, thinner, less sure of herself, and (Pierre felt) improved. He confessed he had been unfaithful, but pretended it had been with Nuk II, his first American lover, whom he had, in fact, not seen for weeks, rather than admitting that the object of his renewed ardor was Beatrice, of whom Alissa remained violently jealous. It was with some relief that he returned, after two hot, edgy days, to an evening with Beatrice, cool baths, and love. "Roché—lovely understanding," she noted.

When the time came for final farewells, Mrs. Wood deployed her usual tactics and declared herself dangerously ill. (In the Wood family it was the mother, not the daughter, who deployed the universal teen fantasy of "I'll die and *then* they'll be sorry!") There was just one fatal flaw: she wasn't ill. When the doctor was called, he found nothing wrong and told Beatrice not to worry. It was the final straw: if she was to have any life at all, she had to get away. "This was when I made my break with home," says a note added years later to her diary entry for this day.

There was a final afternoon of passion in Pierre's bed, which made her sad again, after which she paid a farewell visit to the Picabias, who promised to visit her in Montreal. (They did not.) Pierre, meanwhile—unbelievably even for him—went on to Alissa's, where more sex was expected and provided. However, he did not stay the night—"ich home sans schleep," which evidently disappointed her, for she called him to complain about it.

Next day, August 15, was the day of Beatrice's departure. At eight in the morning she called Pierre to bid him a last good-bye before catching the train for Montreal, Madame Lambrine, and the French Theatre. That same evening Alissa, too, departed, in her case for Washington. Pierre saw her off on the train, then returned home. "Je seul à N.Y. assez ouf!"

LEAVING NEW YORK 1: BEATRICE·

Betrayed by her lover and her two closest friends, desperate to escape from her mother, Beatrice—like Titania under the spell of Oberon's magic juice—was ready to be seduced by the first man to cross her path. And there he was, her very own Bottom, waiting to meet her off the train when it got in to Montreal: Paul Ranson, the manager of Montreal's French Theatre, a heavyset broad-shouldered Belgian whom she later described as resembling "a faded copy of Mussolini." He took her off to lunch; an agreeable fellow, she thought.

Beatrice had arrived in Montreal with just $15 in her purse, so the first thing was to find somewhere cheap to live. Ranson took her to a boarding house that charged only $7 a week. It was her first lesson in the realities of poverty: a drab room with no running water, skimpy curtains, and two thin towels. The landlady demanded a week's rent in advance, which, having nowhere else to go, she paid. But when she sat down to write a letter on the rickety table—she had promised her parents she would always let them know where she was—she noticed an ashtray full of old cigarette ends. Weeping, she wondered if she could really bear to stay.

How she longed—"hélas! hélas!"—for New York and Pierre. But if she returned now, then her mother would have won—and that was

* Details of Beatrice's time in Montreal are taken from her diary and from her correspondence with Roché, now at the Harry Ransom Center (HRC).

unthinkable. For the result of Mrs. Wood's petulant blackmail was, as ever, the precise opposite of what she intended. Far from bringing her daughter to heel, she had made it impossible for Beatrice to turn back, however much she might wish to do so.

In the night, things got even worse. Beatrice was awakened by a terrible itching, and when she put the light on found her pillow crawling with bedbugs. It was the last straw. She would have to abandon her $7 and move to a better place, sans bugs. She moved next morning: "Much more expensive. Also much happier," she noted. Fortunately, since she now had only $8 to live on until her first paycheck, the management agreed to extend credit. For the next three weeks she lived on crackers and bananas.

For the first few days, until she was given a part and could start rehearsals, Beatrice spent most of her time in her room sleeping and drawing. Although more comfortable it was still lonely, and despite a few outings—for tea with Ranson, to see a movie—she felt terribly homesick. In New York, Marcel would be painstakingly gluing another few inches of wire to his glass, while beside his window her chair remained empty; her dog Patricia would be pining; the Picabias would be laughing; Pierre would be—well, better not think about what Pierre might be doing. In time she would be able to tease that "Je suis sûr [*sic*] que tu me trompes avec 6 show girls," but such detachment would not come for some years. (In fact, far from deceiving her with anyone, Pierre spent the week after Beatrice's departure solidly working, without a single sexual encounter. The previous few days' sexual marathon had been too much, even for him.)

Things improved when she started work. She had been given a small part in a musical called *Ma mie Rosette*, and although at first sight her fellow actors had seemed "common but goodnatured," rehearsals round the piano in the evening turned out to be very jolly, and made her feel as though she was part of a large family. "So happy to be independent," she noted. Perhaps this had been a good idea after all.

Even so, she needed more distraction than could be provided by a small part in a mediocre production by the down-at-heel repertory company that was Montreal's French Theatre, and it quickly became

clear who would provide it. Paul Ranson was in the direct dazzling line of leading men with whom she fell unsuitably in love, from the itinerant actor in France who had given her her first kiss to Madame Yorska's friend Ruben at the New York French Theater, who had tried to rape her. From this point on, she saw him almost daily. He took her out to dinner; she found him "very sympathique." They visited the theater, and he flirted "outrageously." They went on a boat ride and had "a lot of good fun together . . . He makes me think of Napoleon." (Why, she doesn't say. Because he was short?) He thought her singing voice atrocious, but liked the way she danced. They spent the day together; she "like[d] him a lot." He took her to supper and she did not return to her hotel . . . By September 12, just a month after fleeing New York, she was "worried over Ranson and Roché. Do not know what to do about the situation." She had been writing to Pierre two or three times a week, but now almost two weeks elapsed with no letter. "Silence prolongé de Ghi," Pierre noted on September 10, and her next letter, which did not reach him until September 18, told him not to come and see her, as they had planned, in Montreal. She was clearly set to stay there well beyond the month she had originally intended.

Beatrice's relationship with Paul Ranson could not have been more different from that with Pierre. In particular, Paul was not much interested in sex. In her memoir, she says that after she moved in with him, "To my surprise, he made no attempt to make love to me. This pleased me, as it labelled me a 'bad woman' without having to be one." What she told Pierre was slightly different—not that they had no sex, but that they had very little, which he thought a shame. On the other hand, very little is not the same as none at all, and after she moved in with Paul a series of crosses began to appear in her diary every four weeks, a sign that surely both signified the welcome arrival of a period and indicated that there might be reasons to fear its nonappearance. This had never appeared during the Pierre days, for the very good reason that they had never had that sort of sex. But it is hard to explain if her life with Paul was wholly celibate.

With or without sex, however, the dingy reality of Paul and provincial Montreal was a sad anticlimax after the galaxy of brilliant artists and

world-class charmers with whom she had spent the past year. In New York, when not making love, helping to plot outrageous artistic manifestations, experimenting with batik in her workshop, learning Russian dance from Pavlova's teacher, or drawing and painting in Marcel's studio, life had been a constant round of soirées, theaters, restaurants, movies, and balls amid the most fabulously entertaining group of friends it was possible to imagine. She had never had so much fun, and never would again. And she missed it all terribly, in particular the unconstrained conversations she had enjoyed with Pierre, which were unlike anything she had experienced before. "J'aimerai tant te voir—te causer—je crois que je n'ai jamais si librement causer [sic] avec personne," she wrote wistfully, in one of the heartfelt letters she sent him from Montreal.

But that chapter was irretrievably over, and in Montreal Paul was almost her only friend. When not with him, or rehearsing (of which she did less and less), she was alone—for so long that she couldn't help brooding on her plight. "Je deviens self-centred terriblement," she wrote, in the same letter. Her diary is full of entries such as "Fear I cannot stand the loneliness." "Always the struggle not to be homesick." "Tu es heureux d'etre perdu en travail," she told Pierre. *You're so lucky to be buried in work.*

Even when Paul was there to keep her company, things were not easy. He seemed to be constantly on edge, and was prone to fly into unpredictable rages, in particular about neatness. He could not bear untidiness, either in her person or in the rooms they lived in, and scolded her for "leaving the theater looking like a pig." Nor could he bear any sign that she might be unhappy. When she wept, as she often did, he demanded to know why, and when she failed to explain—for what could she tell him? That she hated Montreal, the filthy and increasingly cold theater, the dubious lodgings? That she longed for her old life?—he threatened to leave. Once or twice he came home drunk, which disgusted her (as Marcel's drunkenness had also disgusted her). Fortunately, or perhaps unfortunately, these rages never lasted long enough to provoke a break. Instead, life was a switchback: one day she would spend the evening in tears, the next they would have fun, Paul would be kind, she would be happy again. They took long walks together, which she loved. And she tremendously enjoyed domesticity, especially cooking, which she had

never done, and which was, after all, another branch of art. "Cook both meals, almost make omelette," she noted proudly on October 11, and a month later, "Cook lovely meals. Very, very happy."

It soon became clear that Paul's relations with money were problematic. Even though Montreal's French Theatre, like most such enterprises, existed from hand to mouth, and ticket sales were often bad, there should have been enough, for he had told Beatrice that he also owned a canning factory. But once it was clear they were a pair, worrying little items of gossip filtered through. One of the actors told her Paul was not honest; another said he was slow at paying his bills. Should she believe them? After she moved in with him, he had taken an apartment for them at the Ritz-Carlton, the most glamorous and expensive hotel in Montreal, so clearly there *was* enough. And there were good moments, enough of them to cancel out the bad. "Today I made a wonderful pot-au-feu and a strawberry cream," she told Pierre. "And there's a piano—We're so happy, it's such a lovely life, after my family. I want to be worthy of Paul because he's a good man."

Beatrice's parents, meanwhile, were frantic with worry. They wrote constantly, urging her to come home and demanding to know what was happening to keep her so long in Montreal. The letters made her sad and uneasy. What should she tell them? She knew they would disapprove, not only of her irregular situation, but of her choice of lover. "Wonder how I will ever tell mother of Paul," she mused to her diary. Once again, however, Mrs. Wood's nagging achieved precisely the result she hoped to avert. Montreal might be less than ideal, but every letter that arrived from New York reminded Beatrice that it represented freedom. She sent her mother a harsh reply: all New York's myriad attractions, all Paul's fits of bad temper, and her own terrible loneliness, could not counterbalance the horrors of an ignominious return to daughterhood and the parental home.

On November 6, after a particularly upsetting letter, Paul suggested a way out. Why didn't they get married? After that, Beatrice would be legally independent of her parents, and able to do what she liked without interference.

Beatrice was not attracted by this idea. Marriage was not something she had ever envisaged; her lack of enthusiasm for it had been one of the

chief bones of contention between herself and her mother. And yet—what if Paul was right?

All through the eight months that elapsed between his first mention of marriage as a possibility, in early November 1917, until June the following year when they actually did the deed, she agonized. "Feel I will fail at it," was her first reaction, while he, evidently having second thoughts, dismissed wives as "selfish." But a couple of days later it seemed possible: "I do not think he would ever fail at anything fair. Admire him tremendously." On November 22 she "fear[s] we will never pull it off," on December 9 "am seriously considering marrying him." On January 5 "day of adoration for Paul. We discuss marriage." And on January 23 they burned their boats: "Letter from Mother. Paul and I decide to announce our engagement. Happy."

Next day two telegrams arrived from Mrs. Clarke, the friend who owned the house at Brocken. Before she left New York, this same Mrs. Clarke had advised Beatrice that she must make up her mind, take one path or another, get married or become a proper actress. What she must not do was drift. Now both her telegrams urged Beatrice not to marry. "Upset dreadfully," Beatrice noted. "Know Paul does not want to marry, absolutely do not know what to do." The telegrams were followed by a "beautiful" letter, also from Mrs. Clarke, that left her slightly consoled, but no nearer a solution. Nobody was enthusiastic about this marriage, least of all the two principals, but she saw no other way of staying with Paul.

Now that she and Paul were officially engaged, Beatrice decided she could risk a visit to New York. Among the arrivals from France in 1917 had been the film director Léonce Perret, who with financial backing from Walter Arensberg was now busy shooting patriotic films. He needed actors, Beatrice needed work, and Pierre had arranged for her to have a screen test.

The test was to take place on the afternoon of February 15, and although she and Paul had decided to go to New York together, in the end Beatrice traveled alone. Her friend Mrs. Clarke met her off the train, and took her to the studio of an old friend, the theatrical designer Rollo Peters. Then all three went to meet Pierre, who accompanied her to the Vix studios.

Just as commitment, offered or demanded, terrified and repelled Pierre, so the assurance that the girl in question was attached to another man invariably increased her attraction. "Her voice on the phone—I only want her more, now that she loves another," he noted. "Happy for her, but not for me." Beatrice had intended, once the test was done, to go straight on to Penn Station and the train that would take her to the Hapgoods in Washington. But he persuaded her to put off her departure for a day, and spend the night with him. She agreed, but dampened any hopes he might have had by informing him she was engaged to a man she loved—a strong, fair-minded man to whom she was united body and soul. The news had its desired dampening effect: "P.h. le sent et se tait," Pierre recorded.

He had arranged to go out for dinner; she agreed to wait for him at home, and he came back to find her in bed, looking very pretty, but still dressed—as she would remain for the rest of the night. They talked until four in the morning, without restraint, without kisses, and with great affection—"Ex et peut-être futur amour." She cried and showed him her Montreal diary, which explained everything. At eight she rose and left to get the Washington train at Penn Station. "Ouf!! Et irréparable," he noted. "I'm glad, but I feel upset." Beatrice, too, was upset. She noted only that she had spent the night dressed at Pierre's house, and regretted it.

She spent the next couple of nights with the Hapgoods, missing Paul terribly, nostalgic for Montreal, whose pleasanter moments were the only ones she allowed herself, at this point, to remember, and summoning up the courage to brave her family. It was not until February 20, five days into her trip, that she finally visited them. Their reactions varied. Patricia, her dog, went wild with delight, fawning on her for almost an hour; her father was glad to see her. But her friend Trix Smith was "catty." And her mother was furious, "full of instructions and insinuations." She could not forgive the relationship with Paul.

Beatrice spent the next two days mainly with Pierre. He headed these days in his diary *Béa Béa Béa*, and his account is full of wistful affection. They met at their old trysting spot, one of the benches at the Public Library; she looked very womanly, he thought, and beautiful in a newly womanly way. *Her frank conversation, her eyes, her voice . . .* He

was curious to meet Paul, of whom he had now heard so much. What kind of man had displaced him in Beatrice's affections? At the very least, Pierre concluded, he and she would remain great friends. Picking her up at home to take her to the Biograph studios for her second screen test, he noticed that she kept him well away from her mother.

Beatrice was by then very tired, and Barlatier, the director, was unexpectedly kind, correcting her hastily applied makeup, helping arrange her hair, taking great care over the long test itself. Some of it worked wonderfully well, Pierre thought, though other parts were not so good. Afterward, they took the subway to Grand Central Terminal, where they parted. She would be back in a month, she told him, but this time with Paul.

Paul met her off the train, and they spent the following day together at home, happiest, as always, when they could shut out the world and its all-too-numerous worries. But the interlude of calm was fleeting. Mrs. Wood telegraphed to say she was ill with worry and intended to come to Montreal, and followed up her telegram with a long letter to the same effect; Mrs. Clarke telegraphed to say Mrs. Wood was frantic, and Pierre telegraphed to say the screen test was only so-so. This provoked an outburst of fury from Paul, who had assumed the tests were free, when in fact they had cost $60—or maybe more: "Are you sure they only cost $60?" Beatrice asked Pierre.

For money was a problem, after all. It seemed Paul's business affairs weren't going too well, though everything should come right in a couple of months. Meanwhile, Beatrice had written to Perret and was waiting to hear from him; he had not yet replied. She was staking her hopes on getting a chance in films, she told Pierre. And above all, "Don't let my mother know any of this."

On February 12 Beatrice and Paul went to see *Lest We Forget*, the first of Perret's New York films.

With any luck, she would be in his next.

<p style="text-align:center">❖</p>

On March 26, 1918, a month after returning to Montreal, Beatrice received a particularly violent letter from her mother, instructing her

to leave Paul and return home at once. She was so upset by it that Paul decided to take matters into his own hands, and wrote to Mrs. Wood himself. He received a cutting reply, which as usual achieved precisely the effect Mrs. Wood did not wish. On May 17 Beatrice wired Beth Hapgood to say that there was only one thing for it: the following Saturday she and Paul were going to take Beth up on an invitation she'd recently made and come to visit the Hapgoods, who were now living in Hanover, New Hampshire, where they would get married. "Damn it," she told her diary.

It is hard to imagine a less enthusiastic prologue to a marriage— especially since it was, after all, perfectly voluntary. It wasn't as though Beatrice's furious father was standing over them with a shotgun. On the contrary, if Mr. Wood *had* been there, and had had a gun, he would surely have used it to make sure Paul Ranson never came near his daughter again. Events, however, had acquired a momentum of their own. Beatrice had tasted too much liberty to revert once more to dutiful daughterhood. The tug of war that had begun in Paris had intensified in New York, where the vision of what life might be, as exemplified by Marcel, Pierre, and the Picabias, was both irresistibly alluring, yet remained unattainable because of her emotional and financial dependence on her family. But in Montreal, although there was no one to stop her from doing exactly as she pleased, her freedom seemed paradoxically to have melted away. It was as though she had stepped into some sort of quagmire that sucked her in deeper with every step she took. Turning back was impossible, for that would mean her mother had won. Yet Paul did not, on the whole, make her happy. And now it seemed she would be tied to him forever in a marriage for which neither she nor he had any enthusiasm. Only marriage, however, would free her from her mother, and only Paul was offering it.

In fact, the following Saturday, May 25, found them still unwed and still in Montreal. But to their horror they learned that the New York papers had nonetheless announced their marriage. And on May 29, at 9:30 in the morning, Beatrice was awakened by a phone call from Paul: Mrs. Wood was in Montreal. Paul had told her Beatrice was out of town.

But she had better leave the apartment at once, in case her mother didn't believe him.

Beatrice jumped out of bed, dressed, and ran into the street. But where could she go? Not to the theater, obviously: that was another place her mother might look. She took refuge in the library, and later went to see a Douglas Fairbanks film. Next day she didn't dare go out at all, for fear of meeting her mother in the street. "I am a prisoner," she told Pierre.[*]

On May 31 her mother was joined in Montreal by her father, and Beatrice was unable to evade them any longer. They told her they had engaged Pinkerton's, the famous detective agency, to investigate Paul. The report had just arrived, and was very bad. Quite apart from anything else, there was no canning factory.

This time it was Paul who refused to meet them. Instead of explaining himself, he gave Beatrice twenty minutes to choose. Was it to be him, or her parents? Put like that, the choice made itself. Mr. and Mrs. Wood returned, without Beatrice, to New York.

Even at this point, she wondered if she might be making a mistake in staying with Paul. "He isn't an artist," she mused to Pierre, "and I'm afraid I often drive him mad. But then," she continued, clearly trying to convince herself, "we seem to get on so well, we both like to live simply, *sans chichi*, and that reassures me."

On June 1, therefore, "weeping and sad,"[***] Beatrice and Paul set out for Hanover, the Hapgoods, and a marriage that was to be as unlike most people's idea of marriage as they could contrive. "We've agreed that it's nothing but a formality," Beatrice told Pierre. "I shan't wear a ring and I shall still be called Beatrice Wood. Paul isn't telling anyone in Montreal. But I'll finally be free of my mother and will be able to come to New York and not stay with her."[****]

The ceremony took place two hours after their arrival at the Hapgoods'. The red-eyed bride wore the dress she had traveled in, dark blue

[*] Beatrice Wood to Henri-Pierre Roché, n.d., but presumably May 30, 1918, HRC.

[**] Beatrice Wood diary, June 1, 1918.

[***] Beatrice Wood to Henri-Pierre Roché, n.d., HRC.

with embroidered white flowers at the neck. Neither set of parents was there: the Woods were sulking furiously in New York, and as for the Ransons, Paul had refused even to tell them he was getting married. They were devout Catholics, he said, and as Beatrice was not a Catholic he thought it better not to say anything until the fait was safely accompli. Which it soon was, although Paul, who spoke little English, seemed to find it impossibly difficult to repeat the priest's words, which made Beatrice both laugh and cry. Afterward, the bride and groom went for a carriage ride together and, as they had planned, threw the wedding ring into a field. "No bride could have been unhappier," Beatrice wrote in her memoir, but her diary tells a rather different story: she thought the ceremony "charming," felt "very much soothed," and (for the moment at least) did not regret her decision.

Happy or unhappy, the contrast with the Reynolds/Hapgood ménage could not have been more pointed. Both Beth and Norman Hapgood were busy, fulfilled, and extremely successful. Beth, who had just had a baby, had been appointed instructor in Russian at Dartmouth College, the first woman to hold a post there, while her husband, as the editor of a leading magazine, was a national figure. And as befitted such a brilliant and fortunate couple, their house (Beatrice recorded wistfully) was large and comfortable. In their company, Paul did not shine. "Hapgoods like Paul so-so," she noted; they were clearly being polite, though Beth was probably as alarmed as Mrs. Wood at Beatrice's choice of husband. But she was a staunch friend, and if that was what Beatrice wanted, it was what she wanted. In the difficult years to come, Beatrice would often turn to Beth, and Beth would never fail her.

Beatrice and Paul stayed just two nights at the Hapgoods' before taking the dusty train ride back to Montreal and the Ritz-Carlton. Paul thought he might sue Pinkerton's, though quite what for was unclear: if the canning factory did not exist, it did not exist. Nevertheless, it was a comforting thought. Meanwhile, he had a headache, and Beatrice massaged his head, and pictured herself tasting her newfound freedom in New York.

On June 11, 1918, a week after returning to Montreal (and just a year since she had first arrived there), Beatrice and Paul checked out of

the Ritz-Carlton. They had found a new apartment and would soon be moving in; hopefully it would be cheaper than the Ritz, whose bill came as an unpleasant shock to them both. Fortunately, Beatrice's family had contributed $3,000 as a wedding present, so they could afford to pay.

They would not, however, be moving into the new apartment quite yet. First, Beatrice wanted to spend a week in New York, and since they were now married, she could spend it there with Paul, not her family.

They traveled on the overnight train, and when they arrived, despite the unwelcome reality check of the Ritz's bill, made for yet another expensive hotel, the Seymour, on West 44th Street. From there Beatrice immediately telephoned Barlatier, for whom she had done the contentious screen test in February; Perret, who was filming *Lafayette, We Come*; and Marcel. Perret agreed to see her at three that afternoon; Barlatier, the following day; she would go to Marcel's after seeing Perret.

The interview with Perret was encouraging. Beatrice had brought him the screen test, and he promised to view it and get back to her the next day. But when she returned, full of hope, he turned her down: her eyes, he told her, were too light, and the test was "horrible." "If it's really true my eyes are too light for the movies I'm *foutue*," she lamented to Pierre,* who was not available to comfort her in person, having just moved to Washington.

After leaving Perret, Beatrice went on to see Barlatier, who told her she had made a mistake in showing the test to Perret. Too late, the damage was done. "Discouraged utterly," she noted; and then, after all, Perret gave her a day's work as an extra in a hospital scene he was shooting (in which Marcel also appeared, as a wounded soldier being tended by a nurse.)

When the shoot was over, Beatrice and Paul rushed for the train that would take them to the Mowbray-Clarkes at Brocken. And there, for the first time in a year, Beatrice felt genuinely happy and relaxed. Not only was Brocken as fresh and beautiful as ever, but for once her friends actually seemed to approve her choice of partner. "Lovely day at Clarkes. Paul likes it. Clarkes like him," she recorded, in evident relief. On another

* BW to H-PR, n.d. but probably ca. June 20, 1918, HRC.

visit to Brocken she similarly noted, "Mr Clarke thinks Paul absolutely honest." She could only hope he was right.

And then it was time to return to Montreal and the new apartment.

"We are very happy," Beatrice noted, though after seeing a disturbing war film, Lee Gerard's *Four Years in Germany*, she felt "the war makes happiness seem wrong." Indeed, the war was far more present in Canada, which as a British dominion had been in it from the start, than it was in the States. But it did not affect the Ranson/Wood ménage, and for the moment all was well with them. They both liked the apartment, and when the weather was hot, slept out on the balcony, which they both enjoyed.

Beatrice was starting to give Paul English lessons, so that he could work in New York if necessary. And in September she herself was back in New York, looking for work and seeing old friends. Pierre met her at their familiar bench in the Public Library. They dined at the Algonquin, then returned to her hotel, where they talked until late in the evening. As at their last meeting, in February, the occasion was strictly platonic—they lay comfortably stretched out on the bed, but not touching or flirting while Beatrice told Pierre how deeply she and Paul were in love. Normally that would only have encouraged Pierre, but Beatrice, predictably, was strictly faithful. How was her sex life? Pierre inquired. At his request Beatrice described Paul's penis (Pierre does not give the details: his own penis, he remarked a few years later, was the one part of his body he really liked—during his passionate affair with Helen Hessel, he referred to it in his diary as "God"). He told her he hoped that at some point in the future, he and she might make love again. (They never did.)

Feeling she must find work of some kind, Beatrice resumed the familiar disheartening rounds of meetings with theater directors. They were as unrewarding as ever; finally she was rescued by her friend Mrs. Coburn, who invited her to lunch and offered her a small role at the Greenwich Theater—they needed someone urgently, Mrs. Coburn said, and would be grateful if Beatrice could help out.

But now another problem arose, for if she took the job it would mean staying in New York, while Paul's base was Montreal. She took it anyway, but they had a dreadful fight that evening, and she felt sick going to rehearsals the next morning. And her role was *very* small. Two

days later she decided to give it up: if it came to a choice between Paul and the stage, Paul won. Mrs. Coburn, who had only wanted to help, was very understanding. Meanwhile Mrs. Wood, as usual when worried about Beatrice, was drawing attention to her own unsatisfactory life and threatening divorce, and a wire arrived from Paul's stockbrokers saying they needed more margin. He had already gone through the $3,000 wedding money: the previous August, Beatrice had had to ask her father for more, and to her mother's fury he had agreed to give her some bonds. She had passed them on to Paul, in theory so that he could open a New York bank account. But evidently it had all gone—where, was a mystery that apparently she did not seek to plumb.

The declaration of peace on November 7, 1918, found them back in Montreal. But Beatrice found that she could no longer bear living there. She returned to New York, where she and Paul—no longer able to afford hotels—took a cheap apartment in Greenwich Village.

Beatrice's diary records that she enjoyed searching out and painting pieces of secondhand furniture for their apartment and felt very happy there. At last, a place of her own in New York! "Think my apartment most luxurious and beautiful," she noted. But Pierre and Lou, visiting her there, saw neither luxury nor beauty. On the contrary, they found the building shabby and Beatrice herself sadly subdued, with none of the energy and joie de vivre that had marked her out when they first knew her. She told them Paul treated her well, but was quite strict: he got upset if the apartment was untidy, because it stopped him from working. (He wasn't there—had been called away suddenly, Beatrice explained: being an impresario, he often got work at short notice.) She showed them her saucepans all neatly arranged, and her larder. "This probably won't last forever, but right now I really need it," she told them. "I only do things that are useful now, I'm paying for my past. I'm not ruled by my fantasies any more, and it's very refreshing."*

Her agent, she told Pierre and Lou, was trying to find her a role in a burlesque film. A couple of weeks after this conversation, with or without the help of an agent, she indeed landed a small part in a Famous

* Roché, *Victor*, 110.

Players film. It earned her $750, though when she came to see it on its release she found, to her bitter disappointment, that her scene had been cut. And she was still keeping up with the theater world. Her old friend Rollo Peters had just been asked to take over as director of the Theater Guild; she hoped to be included in his plans. He asked her if she would act temporarily as his secretary, and she found him "very nice to work for." Meanwhile, Paul had told her he was earning $10,000 a year—how, she didn't inquire. Perhaps she felt it was better not to know. And maybe it didn't exist after all, for there were soon a couple of unpleasant incidents involving bounced checks.

The true, dire situation was revealed one day when Beatrice announced she was off to buy a new dress in a sale. Paul forbade her to buy the dress; when she asked him why, he blurted out, "I have no money."* It was a business emergency, he explained. In a few weeks everything would be back on an even keel. He just needed a loan to tide him over: would she perhaps approach her friend Walter Arensberg for a loan of $800? Walter was always lending money to needy artists. Why not to his friend Beatrice?

"There are times when reason and feeling stop and the weight of the world makes a person numb," Beatrice wrote, recalling that horrible moment. At first she refused; she could not bear the thought of becoming one of Walter's financial hangers-on. But Paul persisted, and she eventually gave in. "We are at an end," she concluded.

Who could she talk to, who could she turn to? Not her husband—he was the problem. Her first port of call, despite everything, was her mother, who lent her $10 (perhaps for the dress), followed by Beth Hapgood, who was now back in New York and lent what was equally essential: a sympathetic ear. And the next day she forced herself to approach Walter for the $800. "It is excruciating," she noted. "Feel dishonorable."

Walter agreed, instantly and without question. The Arensbergs clearly understood how searingly painful it was for Beatrice to be forced to approach them in this way, and they did all they could to minimize her distress. If adversity shows who your friends are, Beatrice's were the

* Wood, *I Shock Myself*, 40.

Arensbergs, Beth Hapgood, the Coburns, and her parents, with whom, despite everything, she dined twice a week—occasions on which her favorite dishes were served and Paul's name was never mentioned.

Of course the Arensbergs could afford the money—to people as rich as they were, a few thousand dollars meant very little, a few hundred almost nothing. But there are many people of whom this is true, and few are so tactful and generous. The day after her conversation with Walter, Beatrice met Lou, who gave her the $800 check; in exchange she signed a note promising to repay $100 a week. After which she unburdened herself to Beth over tea and returned home for dinner "much relieved." Once again the switchback of her marriage had returned to the upswing. On December 28 they had been "at an end"; on January 18 "we are both happy but broke," she noted.

For three weeks, Paul repaid the weekly $100. Six weeks later, however, he told her he needed another $500. This time she insisted he come with her to face the Arensbergs: Lou was "very nice" and gave them a check. But however nice the Arensbergs, nothing could erase the fact that they had become beggars. Beatrice began to acquire the aggravated sensibilities of the newly poor. Or perhaps people really were beginning to treat her differently; at any rate, she felt her old friend Rollo Peters had become condescending.

Three weeks after the $500 loan, Beatrice and Lou went to the theater together. The play was called *Paid in Full*, and perhaps it was this that prompted Beatrice to mention the loan, which she hoped was now well on the way to being repaid. To her horror, however, Lou informed her that far from repaying the rest of the debt, Paul had borrowed an additional $1,200. By the end of 1919, he owed the Arensbergs a total of $8,000. It is a measure of their affection for her that during these difficult months, when they were Beatrice's chief source of moral support and she saw one or other of them several times a week, they never told her about this money. And even when all was revealed, Walter continued to behave with astonishing kindness, even visiting Paul in the hospital when he had to undergo an operation for appendicitis. Beatrice loved him more and more: "Crush on Walter," she told her diary.

Despite the Arensbergs' generosity, however, Paul and Beatrice were still broke—so broke that the bank had closed their account. What had he done with it all?

In her memoir Beatrice implies that the disappearance of the money was an inexplicable mystery. But what had happened seems fairly clear. Her diary mentions increasingly frequent communications from Paul's stockbrokers, demanding more margin, which can only mean that Paul was gambling on the stock exchange. Every time he bet he presumably hoped, as every gambler does, that this time he would strike lucky, recoup what he'd lost, repay everyone, and make his fortune. But he never did win, and loss after loss left him deeper and deeper in debt.

What is perhaps most puzzling about the whole Paul episode is Beatrice's passivity. She had been so energetic, so curious, so intelligent, so bold: "Un miracle," as Pierre observed. People like Marcel, the Hapgoods, the Arensbergs, the Coburns—people for whom all doors opened, and who could choose their friends carefully—were devoted to her. The little drawings scattered through her letters are full of wit and sharp observation. But the move to Montreal seems to have paralyzed her. The day-by-day diary record of her life's descent into misery is as compulsive as a novel: What will happen next? Will she make her escape? Tomorrow? Next week? It's plain that no good can come of this, that Paul is hopeless, that they are sinking into the mire. Why can't she see this? Why doesn't she cut her losses, get up and leave, abandon him to his fate? *How can it have it come to this?*

Part of the answer must be that she was quite simply exhausted. Once the combination of Pierre's betrayal and her mother's bullying had propelled her from New York to Montreal, Paul, and marriage, the prospect of summoning up the psychic energy to change direction once again must have seemed impossibly demanding. In any case, where was she to go?

None of this, however, explains the astonishing fact that this sparky and intelligent young woman never seems to have asked what Paul was actually doing with all their money. Or rather, her money: for neither the $3,000 wedding present nor the Arensbergs' loans would have been available without her. There were countless signs that things were out of control—sinister hints about Paul's honesty from Canadian

acquaintances, bounced checks, phone calls from the bank, the stock-brokers asking for more margin, the constant shadow of the still-unpaid Arensberg loans—"Do not think Paul sees loans the way I do," she mused. Obviously she knew something was wrong; thinking about their financial affairs left her "nervous," "petrified," "nearly out of my mind" with worry. Yet she still left money matters entirely to him.

Perhaps it was just a question of habit, a way of thinking ingrained since her childhood. In the Wood family, as in so many similar families, money matters had always been a strictly male preserve. Her father did what he did in the mysterious world of business and she and her mother spent the result. There were ups and downs, business difficulties and market worries that Paul occasionally confided when he took Beatrice out to lunch or the theater. They frightened her, but not for long. For like her mother's constant threats of divorce, these hints of possible bankruptcy never came to anything; the river of money continued to flow unimpeded. And now that he had become the man in her life, it felt natural to transfer that trust to him. He was, after all, a businessman. And he did not, to put it mildly, encourage questioning. Anything was liable to send him into a rage. Their life together was a constant balancing act, almost every other evening ending in a fight. If Beatrice wanted a quiet life, let alone the affection she craved, the price was acquiescence.

It was only when their Greenwich Village landlady asked her why that week's rent hadn't been paid that she was jolted out of this almost patho-logical passivity. She was astonished: she had given Paul the rent money and had assumed he'd paid it over. But the landlady was not sympathetic. In her view it was Beatrice's business to know whether or not her rent was paid. "It is about time you came out of your dream world and faced reality," she said. "Some of us are pretty tired of your irresponsible attitude." Only then did Beatrice grasp what Alissa Franck had always known: that when push comes to shove you can rely on no one but yourself.

For the next three years Beatrice and Paul lived from hand to mouth. She took a job in a factory, only for him to veto it, presumably thinking

it déclassé. She gave French lessons at $4 an hour, took in sewing, wrote occasional articles for *Women's Wear Daily*, worked for a book wholesaler, even spent some time touring in vaudeville: they remained continuously broke. More than once she resolved to leave him. But each time he persuaded her to give him one more chance.

Beatrice had never known anything about Paul's life before he met her. She had never met his parents and knew little about them. His father, he said, was a functionary at the court of the Belgian king; his mother, a religious fanatic. Although letters occasionally arrived from his mother in Belgium, he didn't show them to her. But then a friend from this obscure past life appeared in New York. His name, said Beatrice, was George, and he had known Paul from Belgium. Because Beatrice continued to use her maiden name, George did not realize she and Paul were married, but assumed she was his mistress.

One warm evening George invited them out to dinner in a café uptown. Afterward, they decided to walk down Broadway instead of taking a bus. Paul walked with George's lady friend, while George and Beatrice walked ahead.

> Casually taking my arm he said, "You are good for Paul. His wife was somber, a religionist. She prayed most of the time."
>
> Even though I knew I had heard correctly, I repeated, "His wife . . . oh, yes," and continued in an offhand manner. "She couldn't have been good for him—You said she was a religionist," I went on as if barely interested. "Did they divorce, or did she die?" In a flash I saw the whole sorry picture.
>
> "Catholics cannot divorce. She is still living in Belgium."

A gambler—and now a bigamist! This surely outdid all Mrs. Wood's worst fantasies. George's revelation finally convinced Beatrice that she must bring this chapter of her life to an end. She would leave. But not just yet: even now, despite everything, she could not bring herself to act. She might not love Paul, but she knew him deeply, and pitied him. "No decision had ever been so hard for me," she wrote. "It had taken years to find the courage to defy and leave my mother, but that was hardly

comparable to leaving Paul alone to face the world. All my maternal instincts were involved and I felt immeasurably sad."[*]

It was the same old story. After every bitter quarrel she was tempted to leave; every time, he charmed her back into compliance. Paul might be hopeless, but he was not weaponless. It was true that he did not live in what most people liked to call the real world, but he had exactly the skills necessary to survive in his own world, the world of the con man, which in many ways so closely resembles the world of the theater, in which, perhaps not coincidentally, he had chosen to establish his base when he fled Belgium and those inescapable reminders of reality—his wife and child. What the con man needs is the actor's ability to persuade his audience that these tawdry costumes, this painted scenery, are not lies and props but the real thing, and this was Paul's real talent, so much so that even those he repeatedly deceived and let down seemed powerless to resist him. However many disappointments there had been, they always, in the end, trusted him just one more time.

The Belgian wife, however, once revealed, could not be dematerialized, though Paul did his best. To begin with, he flatly denied that there was any truth in George's revelation. He had no previous wife, in Belgium or anywhere else. Did Beatrice believe him, or not? She had to admit that she did not. The existence of a wife explained too much to be doubted. She now understood why he had not told his parents about their marriage, and why he had been unable to utter the vows at their own "marriage" ceremony. "He probably thought if he mumbled the marriage would not be valid."[**]

Disbelief, however, did not make leaving any easier. For years Beatrice had been plagued with pain in her back and neck, and now, as Paul screamed, wept, and pleaded with her not to abandon him, the spasms were such that she could hardly move. Beth Hapgood, outraged (and probably feeling a little guilty, for it was she who had encouraged and facilitated the "marriage") thought she should report Paul to the police. Bigamy was a crime: he should face trial for what he had done. But despite her misery, Beatrice couldn't bring herself to do this.

[*] Wood, 52–53.

[**] Wood, 53.

It was Mrs. Wood who finally cut through the thicket of assertions and denials, by traveling to Belgium and meeting not only Paul's parents but his wife and little boy. Paul was nearly apoplectic with fury: without her mother, Beatrice admitted, she could never have untangled herself. Mrs. Wood gathered together the legal papers and affidavits that would be necessary to annul the marriage, and as soon as she returned to America, the proceedings were set in motion.

In court, the judge seemed bored and irritable. He slumped on his elbow, hardly listening to what was being said, and Beatrice was afraid he might dismiss her case. She need not have worried: it took just fifteen minutes for the court to dissolve the marriage on grounds of bigamy and nonconsummation.[*]

Just before the annulment hearing, she had received a call from Walter Arensberg's lawyer. Walter was trying to put his affairs in order, and Paul's debts were far, far greater than Beatrice had ever, in her worst moments, imagined. He owed Walter $19,000, not including interest: all that money had now vanished. He had, however, given a surety: a legacy of $10,000 that Beatrice hoped to inherit from her grandmother—who was still very much alive, and the legacy far from assured. He had never mentioned this to Beatrice, but although her parents insisted that since she was not and never had been Paul's wife she could not be held responsible for his debts, she insisted that should the legacy ever materialize, she would hand it over. Her father thought this so stupid that he concluded Beatrice should never be entrusted with money, and cut her out of his will, leaving everything to her mother—a decision, Beatrice observed, that turned out to be "an unfortunate mistake."[**] Effectively, Paul had condemned her to a lifetime of poverty.

"I could not understand how Walter had continued lending money to Paul," Beatrice wrote. But of course she both could and should have understood. Had Paul not played the self-same trick on her?

[*] Nonconsummation was one of the grounds for a marriage to be annulled. In fact, it seems likely Beatrice and Paul did sometimes make love, but he didn't argue.

[**] Wood, *I Shock Myself*, 55.

12

LEAVING NEW YORK 2: PIERRE.

Beatrice was not the only woman to have her life plunged into disorder by Pierre.

His pursuit of Lou was not public knowledge; she insisted they owed it to Walter to be discreet. Not that Walter had a leg to stand on, for everyone knew he was habitually unfaithful. Lou, however, did not want to hurt him. She even made Pierre promise to burn all her letters. He complied, though unwillingly—he especially prized the letters he received from his mistresses: one of his favorite pastimes was rereading and comparing them.

Embarrassingly, Walter's kindness and generosity were such, and continued to be such, that even such a hardened operator as Pierre had felt a smidgen of unease at seducing, possibly even stealing, his wife. The only possible justification for such behavior was Lou's confession that her marriage was not happy. Sexually, this was clearly true. In other respects, however, it could not be denied that the pairing worked excellently. "Do I like Walter? Sometimes yes, sometimes no," Pierre mused.

In New York, therefore, when Pierre was seen in public with a woman, it was usually Alissa, who had taken Beatrice's place as his acknowledged girlfriend. By contrast, he and Lou permitted themselves little more than

* Main sources for this chapter are Pierre's diary and Beatrice's correspondence with him at the Harry Ransom Center.

occasional passionate, but necessarily restrained, rides in Lou's chauffeur-driven car. It was only in Boston, where they spent more and more time, that they could abandon restraint and indulge in long sessions of slow, exquisite sex.

All these complications took their toll. He and Lou held ever-longer and more unsatisfactory telephone conversations; when things got too much, Lou took refuge in fainting fits. She thought she might go away for a while; Pierre was desolated at the prospect. It transpired that she did not, as he had hoped, welcome the thought of sharing a possible life in Paris with Germaine. On the contrary, she would only leave Walter if she and Pierre were to marry and (preferably) live in America. But he could not contemplate doing such a thing to Germaine. Or perhaps Germaine, not for the first or last time, provided a useful excuse. "Je m'ennuie de [Lou]!" he confessed to his diary a few months into their affair. "Quoi ahead pour uns?" he trilingually wondered after another fraught conversation.

Pierre's official function as a translator for the French industrial mission had ended in June 1917 following America's entry into World War I. After that, as well as his journalism—he wrote a regular column on America for *Le Temps*—he was vaguely attached to the French High Commission, for which he did translation, liaison work, secretarial work (replying in English to various letters and invitations), and helped with propaganda: this was the office to apply to if you needed, for example, French flags for Bastille Day celebrations. The exiguous pay didn't bother him, for like Marcel he didn't mind living on very little. His charm, ready enthusiasm, and talent for networking, along with American generosity, meant that hospitality was frequently on offer, whether at the Arensbergs' or on other people's journalistic expense accounts. And all the time he was making useful friends, people like Gaston Gallimard—"futur ami je crois, il me plaît"—who would eventually publish his novels; or Marius de Zayas, with whom he was planning a big New York exhibition of French art from Ingres to Picasso; or John Quinn, a rich Chicago lawyer and Arensberg habitué who had recently become a voracious collector of modern art.

Quinn had originally collected old manuscripts, but had sold this collection after visiting the Armory Show and becoming interested in

French modern art. He soon realized that Pierre, with his nose for talent and matchless network of artists and dealers, was the agent he needed if he was to build a serious collection. The works Pierre bought for Quinn during the four years he acted for him included nearly thirty Brâncuşis, Rousseau's *Snake-Charmer* ("I can't get it out of my head, for me it's *the* Rousseau," he wrote in his letter advising the purchase), Matisses, Derains, and at least twenty Picassos.

Who knows what else Quinn might have bought, given the time? But in 1924 he died, and his heirs—who had always resented his lavishing money on such worthless fripperies—proposed to break up his collection and sell it at auction. Since it was clear that as far as Brancusi was concerned this would hopelessly flood the market, Pierre and Marcel, with Brancusi's agreement, bought up the Brâncuşis before the auction. Marcel reckoned that the sculptures were worth $21,700 on the open market; the price they paid was $8,500. Some of the money was put up by Mrs. Charles Rumsey, a daughter of the railroad magnate E. H. Harriman and a friend of Brancusi; she received a *Bird in Space* and a torso of a young girl, and some other sculptures were sold to reimburse her. Pierre and Marcel divided what was left between them. For the next twenty years, whenever he felt especially broke, Marcel would say to Pierre, "I have a small Brancusi to sell, how much will you give me?" and Pierre would pay him the relevant sum, the checks made out to Marcel's alter ego, Rrose Sélavy.*

But this is jumping ahead. In April 1918, Pierre was still in New York. More and more of his work, however, was taking him to Washington, and on April 26, out of the blue, the French High Commission told him that if he was to continue in their employ he would have to move there.

That would be interesting, he allowed, but how he would miss New York! And Lou! And Totor! And the sheer physical effort would be enormous. "I've done more work than I realized over the past year and a half," he reflected as he cleared out his New York rooms, and wondered

* In 2005 a Brâncuşis *Bird in Space* sold for $27.4 million, a then-record for a sculpture. In 2018 his portrait head of Nancy Cunard, bought from the artist in 1923 for $5,000, sold for $63 million ($71 million, including fees).

what to do with the mounds of papers that had mysteriously accumulated there (a few days later, he threw most of them out).

On returning to New York after apartment hunting in Washington, he felt relieved to be home again. But he soon began to enjoy his new DC life. His apartment, near Mount Pleasant, was sunny and white-painted, very "jeune fille," he thought, and possessed a wooden deck where he could spend happy hours lazing. He had his hair cut shorter and "moins poète," enjoyed country walks, took up golf, played tennis for the first time in sixteen years—remarkably well, considering; "Still a child at 39!" It was all very different from frenetic New York, where you did *not* laze in the sun, let alone Paris, which was now, his mother wrote, being bombed.

He still, however, continued to spend weekends in New York. Pierre could not bear his love affairs to end, even when, as with Alissa, he was not particularly attached to the other party. Beatrice's departure for Canada, though clearing the decks somewhat, had not made his love life any simpler. Her spirit came between himself and Alissa as her mere body had not. Her letters—"serious, honest, sometimes pathetic, sometimes funny"—kept her at the front of his mind. In a word, he missed her, and missing her, was reminded how Alissa had betrayed her. Without that, Beatrice would not have left New York, and she and Pierre might still have been together. Seeing Alissa the day after receiving a letter from Montreal, he found himself filled with feelings of bitterness, almost hatred. They had sex, he hoped for the last time—a hope that needless to say was not fulfilled. But Alissa continued somewhat to disgust him. Hearing him speak to Beatrice on the phone, she complained that he called her *chérie* while Alissa was only *chère*; on another occasion, when the two of them had spent the night with Yvonne Chastel, he felt repelled by her—*horreur de NukIII*—though he could not deny being attracted ("sp facile").

Relations with Alissa improved when, to his great relief, she confessed that she had "taken a lover and betrayed me." That had put a welcome end to her embarrassing outbursts of jealousy, which had made her unpleasantly spiteful, first about Beatrice and later about Yvonne, of whom Pierre, in her opinion, was becoming altogether too fond. (Yvonne, who took these things less seriously, was also cross, because Alissa had called

her a liar in a Pierre-related argument.) Now, though, she was jealous no more, and a few weeks later had acquired yet another lover. Pierre exulted: finally, they could be good friends. On his New York weekends he usually spent the night at her place—free lodging with a little pleasant sex thrown in.

But that was mere diversion, quite different from his feelings for Lou. He was quite simply in love with her, and his first thought, when he moved to Washington, was that he was going to miss her terribly. On May 6 they spent a languorous, romantic evening together, dining at the Beaux Arts then dancing at the Winter Garden. The décor there put him in mind of a second-rate brothel, but what did that matter when Lou, resplendent in pale pink and black, whispered "unforgettable words of comfort and future promise"? To his frustration she told him she had a number of free days coming—"mais je pars!" And leave he did: at 4:00 P.M. on May 8 he was on the Congressional, speeding toward his new white room with its green blinds.

"Is there someone *nice* who loves you in Washington?" Beatrice queried soon after his move, for she was now able, courtesy of her romance with Paul, to view Pierre's bed-hopping with detachment. And of course there was. In fact, there were two, one of whom, widowed by the war, kept begging him to give her a child.

A child! The suggestion flattered but also appalled him. In a litany that would be echoed years later by Marcel, Pierre enumerated the price a child would exact. His freedom to travel where and when he wanted, his independence, his right to earn only the bare minimum needed for survival: all would be threatened. "Frankly—do we really want a child right now? No—so better call it off," he mused, adding that "p.h. can't cope with all this cerebration." Predictably, they did not call it off, but continued as before. It was with some relief, however, that Pierre, later that month, noted "no kid."

He kept all these balls (so to speak) in the air for almost four months, though not without some complex juggling: on one visit to New York he met with Lou for all-too-brief love at a hotel before going on to dine, later in the day, with her and Walter. At the end of August 1918, however—four months into his Washington posting—a letter arrived

from Lou ending their affair. The casus belli was a letter he had sent her, that for some reason she had found intolerable. "I have no way of replying to what you write—you have closed my heart, which was beginning to open to you."

What had he written? Pierre doesn't say, so we can't know; what he does say is that he thinks the problem must have been with some careless-ness in the way he'd expressed himself, rather than the subject matter. His nights, when he actually spent a night alone, were filled with dreams of all his various women: he often listed them in his diary, musing on the special qualities of each one. Had he allowed this assumption of polygamy to slip into some phrase? The knowledge that he possessed, at any one time, a number of devoted lovers was so important to him that perhaps he had assumed Lou, too, would rejoice with him. After all, she knew about Germaine and also about Beatrice (though that was long over, and he had surely told her, as he put it in *Victor*, that compared to her Beatrice was nothing serious, a mere dalliance). His constant hope was that he might persuade his chief loves—at this time Lou and Germaine—into a happily triangular relationship. He exulted in a letter from Germaine in which she told him she was sad because he was far away, not because he was deceiving her (a case, perhaps, of out of sight out of mind: when he returned to Paris and their quasi-marital bed, she confessed that whenever he vanished on one of his love voyages she was tortured with jealousy). Whatever it was, he had evidently asked for more than Lou was prepared to give.

Pierre was distraught. The pain of being dropped was not one he was accustomed to, if indeed he had ever experienced it. And by Lou, who of all his American mistresses was the one who meant most to him! He sent letters, he sent telegrams—in vain: there was no reply. In the end he decided to travel to Springfield, near her country house, to see if he could change her mind. He told her of his plan, but heard nothing in response. And then, passing by his apartment to pick up his suitcase before the train, he found a late telegram. Lou would be waiting for him at her house, where her friend Marian was keeping her company.

He arrived at midday, terrified that she would greet him coldly. But no—"instantly our love flows from our eyes, from our hands . . ." They

repaired to bed, then took the car to the seaside, and spent an enchanted few days of love, music, picnics on the sand, and delicious meals before the fire, eventually returning to New York and Marian's spare room, where they spent the night in "profonde naïve intimité comme avec [Germaine]." So that was all right.

Pierre soon found his life in Washington so delightful that he feared it could not last. And indeed it could not: just six months after his arrival, it was brought to an end by the coming of peace. His job in America was done. Before it ended, however, he was entrusted with one last official duty: a tour of the United States to promote Franco-American relations.

On November 20 Pierre and the colonel who was to accompany him arrived in New York to spend a few days before starting their tour. Pierre was detailed to buy tickets along with tricolor tapes to stick on their bags. Then he went back to his hotel to meet Beatrice, who had arrived the previous day from Montreal.

Beatrice was at a low point. Things were not going well. She was "nauseated of Montreal," and felt "strangely remote from Paul" yet lonely without him. She had been doing the rounds of theatrical agents and seeing her doctor about the myriad small ailments that are often a consequence of depression. But although she felt "ghastly discouraged" she tried to conceal her depression from Pierre, who found her looking pretty, though unfortunately she'd been eating garlic, so was not a pleasure to kiss. She told him she was happy with Paul, but then it all came out: she had no work, didn't know what to do with her life, couldn't seem to draw any more. "A bit lamentable," he concluded: he did not find this new Beatrice either interesting or desirable. "We'll meet again one day, I imagine."*

Later he saw Alissa, whose desirability had magically increased, for she had yet another new lover. He was, she said, tall and thin, an officer, and very good at sex. At the end of 1918, they would announce their engagement; in the meantime his existence made Pierre feel far more

* For the period November 18–December 30, 1918, when he was preparing to depart on his American tour, Roché abandoned his old diary for a separate notebook. All the detail of his activities for this month comes from that.

comfortable. For the first time, he thought, Alissa really empathized with how he felt about these things. They went back to her place, where he had a long bath, after which he most enjoyably joined her in bed. Later, her friend Biddy arrived, and all three passed the night together, Alissa and Pierre swapping the center position. "Was Biddy asleep?" Pierre wondered. There was no way of knowing; in any case, he and Alissa had magnificent silent sex. In the morning he admired and caressed Biddy's perfect breasts while Alissa, not a bit jealous, pleasured herself, and later he and she talked business—they were both hoping to publish books. She was full of good ideas, all of them hopelessly undeveloped. He concluded that everything about her could be deduced from the way she sewed buttons: she never finished them off properly, but left the thread trailing.

Returning to his hotel room, with its untouched bed, he shaved, studied a Baedeker guide to America, and received a telegram from Lou, saying she would be back in town in the evening.

The possibility of this meeting had been the main reason for his engineering a New York stopover. The rendezvous was at the Manhattan Hotel, where they had often met in the past. Pierre was fond of these sentimental landmarks, with their tender memories—another was the bench at the Public Library where he had often met Beatrice. Overjoyed at this unexpected opportunity to see each other and spend the night together, they set off on foot to have dinner at the Biltmore.

Over dinner, however, things took a darker turn. They had engineered a tryst in Washington, the excuse being the wedding of a mutual friend. Sadly, however, this would not now be possible, for Pierre's grand tour meant that on the wedding day he was now scheduled to be in San Francisco. Lou's disappointment was as extreme as had been her joy at seeing him. She descended into misery and would not look at him or speak to him but pulled her hat down and looked only at her plate.

Pierre was well acquainted with Lou's fits of blackness; in his experience they did not last but dissolved into passionate sex. And so it was on this occasion. Once they got to her place there were kisses, then bed, and the best sex they had ever had—"perfect, magnificent, athletic, witty,

world-class sex, long, infinite." Several times, however, Lou burst into sobs. And when it was done, she became sad again. "It's all over between us," she said.

They nevertheless agreed to go on a drive along the banks of the Hudson next day at ten. Although Pierre had not got back to his hotel until 4:00 A.M., he rose refreshed and cheerful from his short sleep. But when he asked Lou how she had slept, all she said was, "What do you care?" He remonstrated, but although she apologized, she didn't seem to understand why he was put out. They drove out along the wintry Hudson; it was beautiful, but Lou remained gloomy. She told him she couldn't see any future for them; their relationship hung by threads, a snatched meeting here, another there; the abrupt cancellation of their Washington plans had revealed its fragility. Pierre disagreed. He thought it cowardly to worry about the future, and stupid to be put out by a change of plan; even if they didn't meet in Washington, they could travel together later in Europe. But Lou thought this childish talk. If he couldn't even keep a Washington appointment, she wasn't about to make plans to meet in Europe. Pierre eventually persuaded her out of her gloom. "But I rather resent the effort—why couldn't we just enjoy a lovely day's drive together!"

Things went better as the day progressed and by the time they parted—Lou dropped him at Grand Central at four—they were on good terms again. It was, however, with some relief—"Un peu de ouf!"—that he left her.

On the train, he brooded happily on all his women. "2 in Paris, 1 in Germany, 4 in America—what if I had to choose? It's still [Germaine] who's the sweetest," he decided. "She understands me best and loves me as I am—doesn't try to rein me in." Then he settled down to enjoy the ride. The train was delayed; they didn't get to Buffalo, his destination, until 3:30 A.M., and there wasn't a Pullman car. But the "soldier boys" were pleasant, someone played the violin, there were Red Cross buffets on the platforms when the train stopped, and reading about Niagara in his Baedeker, he was filled with excitement.

<div align="center">⁘</div>

In February 1919, Pierre returned to Paris. He at once plunged back into the intense artistic and social life he had known before the war, and also happily renewed his acquaintance with Yvonne Chastel, who arrived from Buenos Aires in March. But he had not quite detached himself from America. He had crossed the Atlantic on the same boat as Marius de Zayas, with whom he was hoping to mount a big New York exhibition of modern French art; nor had he finally abandoned all hope of persuading Lou to leave Walter and set up home in Paris.

It soon became clear that the exhibition was not going to materialize, any more than had Marcel's grand plans to introduce modern art to Buenos Aires. Pierre still, however, held out hopes of Lou, and at the end of July was back in New York, where his first act was to call the Arensbergs.

It was Walter who picked up the phone. "Nice surprise!" Pierre noted, for Walter and Lou were both in New York, and had no plans to go anywhere this summer. Lou's devotion to New England had apparently waned now that she no longer had a love affair to accommodate.

Could their affair be resuscitated? Lou had accepted that it was over, and having achieved a certain equilibrium, felt rather unwilling to revive it. But Pierre refused to accept this. Lou (he told his diary) was "the real reason I came here": he would not be put off. As always, he was prepared to take things slowly, confident that if they saw each other often enough she would eventually succumb. They dined together on the evening of his arrival at the Plaza, then lunched at Claridge's. And so, inevitably, to bed.

Lou's passion, once reawakened, proved as violent as ever: over the course of his stay they made prolonged and inventive love several times. But despite their raptures she was not prepared to leave Walter and give up her Manhattan life for a Paris in which she would have to share her new husband (assuming they married) with Germaine. (Helen Hessel, with whom Pierre fell cataclysmically in love the following year, always referred to Germaine as "seventeen years," this being his invariable refrain when explaining why he could not drop her: "We've been together seventeen years!")

Just before their last meeting, on September 17, Pierre received a letter from Lou asking him to forgive her. But "I've nothing to forgive,

just our pain," he wrote in his diary, a high-minded sentiment that he immediately contradicted: "That and her inability to raise the slightest opposition to her husband's futile desires, who she believes loves her." But how could Walter love her when he had insisted, on their icy wedding night, on keeping all the windows open while his bride shivered? "Of course she didn't say she was cold—I, who do love her, know, and know what she wants."

They had one last day of transcendent lovemaking at a friend's apartment. Then it was time to pack his bags and set off for the boat that would take him back to Europe. He missed Lou for a while, but was soon immersed in a Paris that had once again become the center of the artistic world. And besides he had fallen in love with Helen.

For the Arensbergs, however, the emotional turbulence Pierre had brought them was not so easily navigated. Lou, now that it was all over, had told Walter about her affair, and no longer wished to live in the city where it had taken place. In 1920 they left for California, where they would start over, and where Pierre would be buried in wishful oblivion.

Marcel thought it a terrible idea. He found it impossible to imagine these supremely metropolitan friends marooned in the provinces. "What can you possibly find to do 24 hours a day every day in California? Nature must get repetitive after a while," he commented. But they stuck it out and spent the rest of their lives there. If someone happened to mention Pierre's name in their presence, it was greeted with an icy silence.

13

LEAVING NEW YORK 3: MARCEL

By the time the Arensbergs left, their salon was winding down. As quickly as it had flamed up, the artistic energy around it had flickered and died. When the excitement was over, the exhibition dismantled, *Fountain* vanished and its little flurry of scandal drained away, Marcel—who had been the center of it all—was seized by his old anomie. New York had provided a respite, but not a permanent cure. "I'm not doing anything new. If anything I'm even less interested in the few things that used to attract me," he told Ettie Stettheimer in August 1917. Both his *Glass* and the war were set, it seemed, to drag interminably on. His state of mind was not helped by the fact that French recruitment offices had opened in New York. Worried that his heart murmur might no longer be enough to keep him out of the trenches, he prudently pre-empted any attempt to enlist him by taking a job as private secretary to a staff captain in one of the French war missions. He didn't have much to do there, though more work was promised if he proved competent. But it was very dull. He had become (he told the Stettheimers), "A miserable bureaucrat who's abandoned everything he's loved in New York over the past two years."[*]

Perhaps it would be more accurate to say that his New York life had abandoned him. Beatrice had left for Montreal. Arthur Cravan had left for Mexico City to escape the draft, accompanied by Mina Loy. The

[*] Marcel Duchamp to Ettie, Florine, and Carrie Stettheimer, October 8, 1917.

Picabias were in the Catskills; when they got back, Gaby left for Switzerland to be with her children and, to Marcel's distress, Picabia soon followed. Lou's sorties to New England had become longer and more frequent, both to escape the city's summer heat and to accommodate her blossoming affair with Pierre. Walter was depressed because Lou seemed to be moving away from him. Although he did not, at this point, know she was in love with Pierre—it is clear from Pierre's diary entries that they were careful to be extremely discreet—he inevitably sensed that something was up. Varèse was a reformed character—"plus de Brevoort" grumbled Marcel; he had taken up with Louise Norton, whom he would eventually marry, and who consequently no longer held sexual court. "We drink a bit," Marcel wrote to Lou in New England. "I've been very drunk once or twice, and yesterday, at Joel's, the evening ended in a fight . . . They were drunker than us, they sent Walter flying, no damage, someone punched me in the ear, it's still bleeding and swollen, but nothing to worry about. For the rest, I'm doing almost no work. A few lessons. We go to bed earlier, 3 instead of 5."* The war had not yet claimed any of his American friends, though Allen Norton, Louise's ex, was threatened with the draft, and the Arensberg habitués had taken to table-turning, then much in vogue as desperate families tried to convince themselves that their dead sons, brothers, and husbands lived on in another sphere. "It's all very different here now, atmosphere, everything," Marcel told his soon-to-be brother-in-law, Jean Crotti. "Everything's uneasy."**

In these diminished circumstances, Marcel's social energies largely revolved around the group of wealthy and cultivated ladies, now past their first youth, who adored him and for whom he represented glamour and excitement: Katherine Dreier, who had been a member of the Independents committee and had so regretted voting against *Fountain* when it transpired that Marcel was its probable creator, and the Stettheimer sisters. The Stettheimers offered unconditional friendship without threatening to fall inconveniently in love with him. And although the same

* Marcel Duchamp to Louise Arensberg, August 24, 1917.

** Marcel Duchamp to Jean Crotti, July 8, 1918.

could not be said of Miss Dreier, both sides were clear that nothing more than affectionate friendship was on offer. Marcel was fond of them all, and always kind and gallant in his dealings with them. When he took the secretary's job in the French military mission, one of his first actions was to write to *Chère Miss Ettie* regretting that he would no longer be able to spend Wednesdays with the Stettheimers, teaching French and enjoying the country air and lavish hospitality of their Tarrytown summer residence, the scene of his birthday party.

Like Walter Arensberg, the besotted Miss Dreier wished to possess every possible example of Marcel's work. She had asked him to make her a picture to fit a long, narrow slot in her library. His last reluctant venture into what he would later dismiss as "the retinal"; it was called *Tu m' (emmerdes? ennuies? aimes?)* and shadowed, literally, his readymades. He had found a projector that cast the readymades' shadows onto his canvas, which he then traced by hand, so that the canvas contained the painted shadows of the bicycle wheel, the hat rack, and a corkscrew, together with, inter alia, a long line of what looked like diamond-shaped paint samples.

Pierre, visiting his studio on March 16, 1918, noted that "Marcel has finished Miss Dreier's painting" and found it "très beau." When he visited a month later, however, it was still in progress. Marcel was finding the paint samples very tedious, and Yvonne Chastel, who had returned to New York in hopes of sharing his bed, was helping with that part of the canvas while Pierre played chess with her roommate on the big board pinned to Marcel's wall.

Yvonne had left her ex-husband, Jean Crotti, in Paris with Marcel's sister Suzanne, whom he would soon marry. However, Marcel's bed was already occupied when she arrived. The lucky woman was an old friend from Paris called Madeleine Turban, known to everyone as Mad. Marcel told the devoted but shockable Miss Dreier that she was his sister Magdeleine, but no one was deceived. When Marcel was out, Mad spent hours talking with Pierre, mainly about Marcel. After a while she took a job in a haberdashery emporium, and enjoyed her regular life of getting up early and spending her days in the shop selling lace and trimmings, or so she told Pierre, who went to visit her at the shop and was amused to find

her wearing a pencil behind her ear. Meanwhile, Yvonne consoled herself with Pierre, who declared himself "rejuvenated by her resistant lips." On the first of these occasions she suggested a threesome with Alissa, but Alissa, although she went along with the suggestion, was rather shocked, did not enjoy herself, and became horribly jealous of Yvonne.

Marcel continued with Miss Dreier's picture. Pierre thought it "more and more magnificent." Marcel, however, was more interested in another item he was making, also for Miss Dreier: a sort of spider's web constructed of multicolored pieces of rubber cut from bathing caps. "I cut them up into irregular strips, then glued them together, not flat, in the middle of my studio (in the air), and attached them with string to various walls and nails in my studio."*

By the end of June 1918, Miss Dreier's painting was ready and the bathing-caps sculpture nearly finished. Marcel felt the urge to move on—not least to escape war bureaucracy, which had pursued him across the Atlantic: he had been classified for military duty, though only as *F* for foreigner, to be called up in the event of extreme emergency. This meant, in theory, that he was not allowed to leave the country, but the authorities made no difficulties, and he decided to make for Buenos Aires. He had no particular reason for going there, nor did he know anyone, he told Picabia in one of the letters he wrote announcing this decision in the days before his departure, but the great thing about Buenos Aires was that it was a long way away, and in a neutral country. He urged Picabia to join him—"I can't imagine you're that keen on Gstaad** after 1 year."*** The crossings from Spain took a surprisingly short time, and it was Picabia who, the previous year, had suggested Buenos Aires as a possible destination should wartime New York pall. Picabia, however, declined. Switzerland was anything but boring. He and Gaby had made the riotous acquaintance of Tristan Tzara's joyful crew of Dadaists at the Cabaret Voltaire, and Buenos Aires could hardly compete with that.

* Marcel Duchamp to Jean Crotti, July 8, 1918.

** The Picabia children had been left *en pension* in Gstaad, just across the Swiss border from Gaby's mother's house, while their parents were in New York

*** Marcel Duchamp to Picabia, August 13, 1918.

For Europeans, South America represented Elsewhere, a destination chosen less for itself than because it was somewhere one could vanish. That was, literally, what had happened to Cravan. He and Mina Loy had run off to Mexico City, where they became all but destitute. Then Mina got pregnant and they realized they must move on to a place where it might be at least possible to make a living. That place had been Buenos Aires. Mina went first, and Cravan set off in a small boat to join her, but he vanished en route and was never seen again. It was assumed he drowned, but his body was never found and his disappearance was never explained.

In a letter to Jean Crotti, Marcel gave some more positive reasons for the move. "I haven't worked on my glass since you were here and don't feel any great desire to do so. Probably a different place will give me a bit more energy." He was taking all the papers relating to his *Large Glass* and hoped to finish the drawings in Buenos Aires, so that next time he was in New York "I'll be able to finish the damned thing fairly quickly." He had one last New York engagement, a little movie scene in which he was to be a wounded man tended by "une superbe nurse" in Léonce Perret's *Lafayette, We Come*. "If it comes to Paris, you should go and see it for my two minutes." Otherwise, that was that. Yvonne Chastel, her patience finally rewarded, would be traveling with him. Ettie Stettheimer, whom he also asked, declined, but promised to help him out if he fell sick or risked destitution.

"Yvonne's glad to be getting away, too, I think," Marcel told Crotti. "She hopes it may be possible to come to some sort of arrangement with your business's agency in Buenos Aires, I think she's looking forward to a slightly less humid sun than in New York." Yvonne doubtless also hoped the trip would cement their relationship. It did not, though they continued to be affectionate friends and, when proximity permitted, lovers. Yvonne eventually married an Englishman; her son, who met Marcel a few times when he was a boy, said, "My mother didn't talk about him much, but I always had the feeling that Marcel was *the* man in her life."[*]

As in New York, Marcel proposed to live by giving French lessons. He didn't expect to find a flourishing modern art scene, but felt it might

[*] Interview with Calvin Tomkins, in Tomkins, *Duchamp*, 211.

be amusing to try and get something going. He begged Crotti not to say anything to his family before his departure: he would write to everyone from the boat. "You might feel like visiting Buenos Aires," he added, for Argentinian isolation did not seem so very appealing, now that the moment approached. "Maybe I'll see you there sooner than either of us imagine. I'll have changed a lot next time we meet."

Marcel's final, affectionate farewell was to Pierre. "Mon cher vieux, my boat for B.A. will probably leave on Tuesday," he wrote (it was then Sunday). "I'm off again—it's getting to be a bit of an obsession." He was leaving *Pour Toi* on Walter's balcony, along with a picture by his favorite Eilshemius, a pack of *Blind Men*, and some of Beatrice's drawings, to be returned to her when Pierre next saw her. "Good bye dear, à bientôt dans 2 ans—ou moins.

Affectueux Marcel—
Poste Restante
Buenos Aires."

<div align="center">⁘</div>

The Buenos Aires sojourn did not go as planned.

The voyage was long (it took a month), hot, mercifully uneventful—since America's entry into the war, American ships were lawful prey for German submarines—and dull, especially in the evenings when the lurking presence of those submarines meant that all lights were banned save for one small, stifling interior smoking room. There was no one with whom to play chess. Marcel passed the time sorting through his papers.

They arrived in Buenos Aires on September 14. Marcel was struck by the deep unfamiliarity of some of the city's aspects, in particular the fact that the men and women in the streets were, he told Carrie Stettheimer, almost all Black. Yet in other ways it seemed oddly European—there were little streets that recalled the area behind the Madeleine in Paris. And the food was wonderful: "Butter like nothing you'd ever find on Columbus Avenue chère Carrie." He knew no one, spoke not a word of Spanish, and (it being spring in Buenos Aires) looked forward to his second summer of the year.

By the time Marcel and Yvonne arrived, the devoted Miss Dreier was already there. Unable to imagine New York without Marcel, she, too, had decided to visit Buenos Aires. The only one of his New York friends actually to make the journey, her plan was to write articles on Argentine life. Neither she nor Yvonne, however, found the city very congenial. With its culture of machismo, it was no place for an independent woman. "Good" society socialized only with itself and had no desire to widen its circle of acquaintance. Nightlife did not exist; in stark contrast to New York, the only parties were family get-togethers in aid of the Red Cross. At the theater, one saw only men; the vernacular theater was so obscene that no decent woman ever showed herself there, and although there were some visiting companies, many of them French, "They make me rather conscious of the fact that I speak fluent French," Marcel told Walter Pach.* There was an English, an Italian, an American, and a French colony, the French more numerous than in New York, but very unattractive; all were firmly closed to outsiders. The Arensbergs wanted to know if he had seen Mina Loy or Cravan; he had not, "And I would be amazed if they could be here without my having run into them." (In fact he found out, just before he left, that Mina had indeed been in town; she left for Europe with Fabienne, her newborn daughter by Cravan, in the spring of 1919.)** "Buenos Aires doesn't exist," he told Ettie Stettheimer. "It's nothing but a big provincial town full of very rich people with absolutely no taste. Everything's bought in from Europe, including the stone for their houses."

Late in October, just as the war was about to end, he received the dreadful news that on October 7 Raymond Duchamp-Villon had died of blood poisoning, the lingering consequence of a bout of typhoid he had contracted two years earlier. "It's too awful," he told the Arensbergs a couple of weeks later, "you know how close and dear he was to me."

* Marcel Duchamp to Walter Pach, November 15, 1918.

** It had by then been seven years since Mina left her first two children in care of a nurse in Italy. Feminists will be glad to note that this seems to have done them no harm. Her daughter Joella became, in the words of her obituary, "a famed beauty, witty, intelligent, forthright and tremendously generous."

Raymond dead! Finally the war, which he had hitherto experienced only secondhand, via letters from his brothers and newsreels, had caught up with him in all its horror. There were many people of whom he was fond—he would have been genuinely sad to hear that Beatrice or Pierre or Picabia or one of the Miss Stettheimers or Walter Arensberg had died—but there were only four he truly loved: his sister Suzanne, his brother Gaston, his father, and Raymond. And now a quarter of this scant emotional world was no more. He tried to blot out despair by filling every moment with work or chess. "I'm working, and enjoying it," he told Ettie Stettheimer. "It feels a bit like being back in the country, where it's possible to take pleasure in one's work." He had rented a dilapidated room to use as a studio, a little way from the apartment he shared with Yvonne. Miss Dreier helped him do it up, and he spent his time between there and a chess club he had located after the first few months, when he had nobody to play with (he had started two simultaneous games with Walter Arensberg, which they played by cable). The standard at the chess club was very high; he played mostly with members classified as second- or third-rank, and took lessons with the club's best player. In his spare moments he continued to work on drawings for the *Glass*, and also began to experiment on a small piece of actual glass using a new technique of applying a mercury ground to the surface that he carefully scratched away to leave the forms he wanted. The new work incorporated some elements that would eventually appear on the *Large Glass*, and also some that would not, including an actual magnifying glass that he glued to the larger pane. Referring to this, he called the piece *To Be Looked at (from the Other Side of the Glass) with One Eye, Close to, for Almost an Hour*. He originally intended this piece for Walter, but it was snapped up by Miss Dreier, who took it with her when she left B.A.* She did not, however, like its title (Duchamp's biographer Calvin Tomkins thinks that, taken in conjunction with the *Bride Stripped Bare*, she may have found it too suggestive) and called it *Disturbed Balance*. Marcel didn't much like the new title, but sticking with his principle that every interpretation was correct, he did not complain.

* It was broken in the same transit as *The Large Glass*, en route from the Brooklyn Museum, where it had been loaned for an exhibition, to Miss Dreier's apartment.

He was also trying to set up an exhibition of Cubist paintings, enlisting the help of Walter ("Obviously I'm not asking you to send anything you own . . . everything must be for sale"), Albert Gleizes, Marius de Zayas, and the American–based painter Henri-Martin Barzun in finding "30 really good pieces." Buenos Aires was agog for anything new; he knew gallerists who would give their space for almost nothing to put on such a show. He did not intend to exhibit anything himself: "Painting interests me less and less." But as the months passed and they did not respond, or only unenthusiastically, this plan evaporated. It was a shame, he complained to Walter Pach, not least from the monetary standpoint—"B.A. is a town where anything new (to them) is financially successful—There's a market to be created here, even for modern art. An exhibition would have created enthusiasts."*

These almost-perpetual preoccupations, combined with Buenos Aires' uncongenial social mores, made for a miserable life as far as Yvonne was concerned, and in February 1919 she left for Paris. Marcel pleaded with her to stay, but she had had enough, and following once again his principle always to accede to a whim, he did not insist. Miss Dreier, however, stuck it out until April, returning to New York with the little glass piece and a sulphur-crested cockatoo named Koko.

Marcel planned to leave Buenos Aires in June, spend a few months with his family in France, then return to New York and finally finish his *Glass*. He was particularly looking forward to recommencing, in person, the chess games he so enjoyed with Walter, one of the few opponents among his friends who could match him intellectually. He had even devised a system whereby they would be able to play transatlantically by cable, indicating moves in one word of eight letters—the maximum number of letters allowed in one word by the cable companies. "But I'm dreading arriving in a Puteaux with no Raymond," he confessed to Walter Pach. "It's so awful, and you realize that more and more the further away you get from the actual event." Nevertheless, he booked his passage to France, where he hoped to arrive by mid-July.

* Marcel Duchamp to Walter Pach, June 6, 1919.

Part Three

BETWEEN CONTINENTS

1

MARCEL,
PARIS, 1919

I n the summer of 1919, four years after his departure for New York, Marcel arrived in Paris from Buenos Aires. He looked terrible. Raymond's death had clearly taken a physical as well as a psychological toll. He had become extremely thin and his hair had started to drop out; what remained had been cut very short in hopes of making it grow more thickly.

In Paris as in New York, he cut a lone figure while at the same time being loosely associated with a group—in this case the surrealists, then just getting established. Guillaume Apollinaire had died in 1917, and the brilliant, charismatic, and rather daunting André Breton, the young leader of the new surrealist grouping, had taken his place as the arbiter of all that was new and exciting in the artistic and literary world. In a country where to be stupid was to be *bête comme un peintre*, a phrase the supremely unstupid Marcel especially resented, Breton's seemingly unstoppable flow of new ideas made him tremendously attractive. But although they became close friends, Marcel did not join the surrealists. The rigid psychological discipline imposed by Breton was something he could never have tolerated, and in any case he had a horror of belonging to a recognized group. Instead, he became a sort of slippery *éminence grise*, enigmatic, charming, and elusive.

Indeed, he eluded even himself. Where did he live: Paris or New York? Breton recalled him "toss[ing] a coin and saying, Heads I go to

America this evening, tails I stay in Paris. It wasn't about indifference. He would infinitely have preferred to leave, or to stay.''[*]

Who was he, really? That, too, was uncertain. In what he liked to call "a little game between I and me," he contemplated various alter egos. He first considered taking a Jewish name, but for a Catholic that proved a step too far, and in any case he couldn't find a Jewish name he liked. A woman, then? That was a different matter. Of his many aliases the most enduring, and the one he most cherished, to the point of maintaining a bank account in her name, was Rose Sélavy, who also signed two of his verbal/visual jokes—*Fresh Widow*, a miniature French window with blacked-out panes, and *Why Not Sneeze, Rose Sélavy?*, a small birdcage, fitted inside with four wooden bars, containing a thermometer, a cuttle-fish bone, and 152 marble cubes cut to resemble sugar lumps, but of course much heavier. In 1921 Picabia added spice, along with an extra letter, to Rose's name, christening her Rrose, which when spoken aloud became Eros. The second *r* was added in the Boeuf sur le Toit nightclub, for which Picabia had done a painting, *l'Oeil cacodylate*, which was signed by all his friends, and which Marcel signed with one of his customary wordplays, "Pi Qu'habilla Rrose Sélavy." (The famously moustachioed Mona Lisa also dates from this period, her caption, *LHOOQ*, a joke along the same lines as Rrose, for when read out loud in the French alphabet it translates as "she's got the hots.")

As these jokes show, Marcel's specialty at this point was to combine his own brand of schoolboy lubriciousness with the surrealists' enthusiasm for wordplay. He specialized in filthy *calembours*—as, *Conseil d'hygiène intime: Il faut mettre la moëlle de l'épée dans le poil de l'aimée*, which trans-lates roughly as "put the pork of the sword in the fork of the broad."

Ah, but which broad? That, as usual, was the question.

The queue of hopefuls was headed by Katherine Dreier. Having pre-ceded Marcel to Buenos Aires, in 1919 she followed him to Paris. He was fond of her, and she was an important patron, so he spent a good deal of time with her, even taking her to visit his family in Rouen. (She liked his father, but thought his originality must have come from his unread-able mother, "who is very deaf and sits like an Eastern god—withdrawn

[*] "Marcel Duchamp," in Breton, *Les Pas perdus*.

yet there.""") Then they went to Puteaux to visit Gaston, who was now demobilized, and his wife. These intimacies raised her hopes: Pierre, who accompanied them to Puteaux, noted slyly that she kept taking Marcel's arm, upon which he would shake her off irritably. What could possibly be going on between Marcel and this large blonde German woman who pursued him from continent to continent?

The answer, sadly for Miss Dreier, was nothing, or at least nothing sexual. Pierre and Marcel escorted her to art galleries and theaters, and showed her the best restaurants, where she entertained them to lunch. She was introduced to Brancusi and to Gertrude Stein; Pierre described the latter meeting in his diary as "the shock of two heavy masses. Gertrude won easily. Miss Dreier seemed frail by comparison."

Unsure how long he would remain, Marcel camped in the Picabia apartment, a chaotic place filled with "books, papers, golf clubs, skis, African masks and model boats . . . leather divans and lots of mattresses to put up stranded friends".** In the entrance hall was a canvas with *Bonjour Picabia!* inscribed on it in large black letters. Picabia himself, however, was mostly absent, being now wholly taken up with a new mistress, a society beauty named Germaine Everling, who was pregnant by him.

Gaby, too, was pregnant. According to her great-granddaughters,*** Marcel was alone with her in the apartment when her water broke, and helped deliver the baby. A few weeks later, when Germaine's water broke, André Breton, who was visiting her and who had trained as a doctor, was less helpful: he took fright and skedaddled, Germaine remarked, "as if a snake had bitten him." The midwife called to Germaine's apartment was the same one who had recently attended Gaby, and recognized Picabia's flashy new Mercer car parked outside in the street. "Goodness," she said, "that's M. Picabia's car. He was showing it to me only yesterday, he was there when I went to see his wife. I looked after her when she had her baby. He wasn't even living with her, it turns out he has a mistress and

* Gough-Cooper and Caumont, "Ephemerides."

** Everling, *l'Anneau de Saturne*, 20–21.

*** In Berest, *Gabriële*.

she's pregnant, too! Artists, I ask you! What on earth can he be doing in a respectable neighbourhood like this?" *

Picabia and Gaby would soon officially separate. To begin with she refused to divorce him, feeling, as she always had, that they were united by a bond far stronger than mere sex, and the marriage did not officially end until 1930. Even then they continued to be close friends, and remained so until the end of his life. In the meantime, however, Gaby had to make a living. She got together with Paul Poiret's sister Nicole Groult, also a dressmaker, who wanted to sell her gowns in New York, and thought Gaby would make an ideal saleswoman. She arrived in New York in 1920, having deposited the children once again in the Gstaad pension.

Marcel, too, was back in New York. For the rest of his life he would shuttle between New York and Paris, as boredom dictated. And now that emotions had cooled, the drama that had begun eight years earlier on the station platform at Andelot was finally consummated.

* Everling, *l'Anneau de Saturne*, 96–97.

2

TRUE LOVE: MAN RAY, PICABIA, PIERRE, AND MARCEL

Almost the first person Marcel called when he arrived back in New York was Beatrice, who was just then at a very low point. She and Paul had no money: Paul's brokers had recently declared that everything he had put into the market had been lost. She had resumed the familiar hopeless round of theatrical agents, but their promises of parts never quite materialized. The Arensberg loans, far from being paid off, were larger every time she inquired, and although the Arensbergs refused to let this affect their friendship, it preyed constantly on her mind.

She and Marcel had spent the evening dining together; when the moment came for her to return home, he pressed an envelope into her hand, telling her she mustn't open it until she was alone in her room. "What on earth had he written? Could it possibly be a proposal of marriage? Indeed, we were close enough at one time to have thought about it. I hurried up the stairs and breathlessly opened the envelope.

"Inside was fifty dollars.

"Marcel, hearing I was penniless, quietly, in his own way, made this loving gesture. Fifty dollars meant so much to me! Marcel's friendship and kindness, far more."* "It gave me so much pleasure, seeing him again," she told Pierre on a later occasion. "Je l'aime profondément."

* Wood, *I Shock Myself*, 46.

The two had met at a restaurant, and it seems likely, too, that Marcel's meetings with Gaby took place at her apartment, not his. For his New York room, now that the Arensbergs were no longer there to provide him with a cozy niche, was not conducive to romance. Up several flights of stairs in a dismal, drafty ex-industrial building, it had some basic plumbing, in the shape of a bath he had rigged up himself, whose pipes ran across the floor to a sink. But it made few other concessions to comfort. Stieglitz's wife, Georgia O'Keeffe, visiting him there, was horrified. "The room looked as though it had never been swept. There was a single bed with a chess pattern on the wall above it to his left. Nearby was a makeshift chair. There was a big nail in the side of it that you had to be very careful of when you got up or you would tear your clothing or yourself. On the other side of the room was a bicycle upon its back wheel with a mirror stuck in the top wheel. Duchamp's two large glass creations were standing up against the wall not far from the tub, and scraps of the pieces of metal he had cut to make the patterns on the glass were right on the floor where they had fallen when he cut them. I was so upset over the dust that the next day I wanted to go and clean it up. But Stieglitz told me that he didn't think Duchamp would be very pleased."* A collection of family mementoes, brought over from France, reminded him of home: paintings by Jacques Villon, which hung from the ceiling; a portrait of his sister, Suzanne; a painting by Jean Crotti, whom she would soon marry.

Marcel's most frequent visitor in this uncozy perch was a young painter, Man Ray, with whom he had become friendly. Born Emmanuel Radnitzky in 1890 (the family changed its name to Ray in 1912, in response to anti-Semitic discrimination), he was the physical opposite of the tall, handsome Marcel, barely over five feet, with pouchy cheeks and spectacles. He nevertheless achieved considerable success with a string of beautiful women, living proof that looks are less important than energy, enthusiasm, and brilliance, particularly when it came to photographing the women with whom he was in love. "If he took your hand or touched you," said Lee Miller, whom his photographs made famous and who conducted a passionate affair with him, "you felt an almost magnetic heat

* Essay in d'Harnoncourt and McShine, *Marcel Duchamp*, 213.

. . . I was chasing him. He looked like a bull with an extraordinary torso and very dark eyebrows and dark hair. I said, 'My name is Lee Miller, and I'm your new student.' Man said, 'I don't have students.' He was leaving for Biarritz the next day, and I said, 'So am I.' I never looked back!" *

When he first met Marcel, Man was living hand-to-mouth in an artists' colony in Grantwood, New Jersey. He was trying to support himself and his then-wife, Donna, a divorced Belgian poet some years older than him, on what he could earn as a modernist painter. Marcel visited the colony in 1915, not long after his arrival in New York, and Man suggested a game of tennis, for which he produced two rackets. There was no net; Marcel, as yet, spoke no English. Man called the score; Marcel replied, "Yes." Thirty years later, Man summed up the occasion as "Yes and Love."***

The love affair thus presaged (for that, on Man's part, was certainly what it was) did not blossom at once. Man was mostly taken up with his marriage and with the problem of keeping his head above water financially, while Marcel was entirely consumed by the various dramas around the Independents, the war, his departure for Buenos Aires, and Raymond's death.

In 1920, however, they got together again. Man was still married to Donna, but they had separated, partly because she had found another lover, but largely because he had fallen unforgivably in love with her fourteen-year-old daughter by her first husband. She and her daughter had moved in with the new lover, and Man, desperate to avoid his solitary flat, ran into Marcel at a chess club. Marcel invited him back to his studio, where he was in the habit of working at night, when everything was quiet.

Man was not surprised by the disorder. It had been the same in Marcel's first, pre–67th Street studio, which Man had visited in 1915 and of which he observed that it looked "as if he had been moving out and leaving some unwanted debris lying around."**** The *Glass*, he noted,

* Francky Knapp, "The Mad, Mad Love of Man Ray & Lee Miller," *Messy Nessy*, March 30, 2018, https://www.messynessychic.com/2018/03/30/the-mad-mad-love-of-man-ray-lee-miller/.

** In Man Ray "Bilingual Biography," *View* 5, no. 1 (March 1945).

*** Ray, *Self-Portrait*, 68.

was still far from complete: drawings and calculations for it were tacked to the walls, but they had not yet been transferred to the physical object. From time to time Marcel would begin on whatever was next in line—scraping at unwanted silvering, gluing wire, or cutting metal. But he found the drudgery of mere execution monumentally boring. Anyone could do that, he grumbled. If only he could find someone else to perform it!

Man suggested that perhaps some photographic input might move matters along. He did not then envisage photography as a career—on the contrary, he still yearningly thought of himself as a painter, and would continue to do so even after he had achieved fame as a photographer. But he had a camera that he used to record his paintings, and Katherine Dreier, who proposed to set up a museum for modern art, had asked him to photograph some of the potential exhibits for postcards. Why not see what he could do with the *Glass*? Next time he visited he brought his camera along—the first time he had taken it out of his room.

> As I had already noticed, there was only a single unshaded bulb hanging over his work, but from experience I knew this did not matter in copying still objects; with the camera fixed steadily on its tripod and a long exposure, the result would be satisfactory. There was dust on the work and bits of tissue and cotton wadding that had been used to clean up the finished parts, adding to the mystery . . . Since it was to be a long exposure, I opened the shutter and we went out to eat something, returning about an hour later, when I closed the shutter. I hurried back to my basement and developed the plate— I always did my developing at night, not having a darkroom. The negative was perfect.

The result, which Marcel called *Elevage de poussière*, or *Dust Breeding*, would become famous, one of Man's most-reproduced photographs. Marcel loved the dust, and set about incorporating its blond cones permanently into the work.

Encouraged by this success, the two embarked on other optical experiments. A stereoscopic film of a globe, with a spiral painted on it, to be shot using two cameras simultaneously, failed when the film swelled and stuck together in the fixer tank. A machine intended to link two plates of glass nearly killed them both when the linking belt came unstuck and sent shards of broken glass flying throughout the room—"Rotative plaques de verre, le seul attentat heureux de ma vie; comme j'aimais le danger, et comme nous aimons le verre, et comme vous le cassez, comme les Russes. Yes, and chess."

The friendship was sealed. Evening chess games (Man was not a particularly good player, but Marcel didn't mind) took the place of the poker sessions with Raymond. When Marcel returned to Paris in 1921, Man followed him.

He arrived to find Marcel installed in Yvonne Chastel's apartment, in rue la Condamine. Yvonne was away, and Marcel offered him a spare room, but Man preferred to live independently, and moved into a hotel room just vacated by the Dadaist Tristan Tzara. (The sign outside read HOTEL MEUBLÉ, which meant "furnished rooms," but Man thought this was the name of the hotel, and gave it as his address whenever anyone asked.) When he had dumped his bags, Marcel took him to meet his friends the surrealists—André Breton, their charismatic leader and theorist; Louis Aragon, the future poet and novelist; Paul Eluard, who would one day win the Nobel Prize for poetry; and several others. Rather to Man's surprise, the group did not include any painters—that did not happen until the advent of Salvador Dalí at the end of the decade. Man particularly liked handsome Jacques Rigaut, who would become a great friend, and who, some years later, would kill himself, for no reason other than that Breton, whom he idolized, had declared suicide the ultimate surrealist gesture. Like Marcel, Man would become an intimate friend of this group, but—also like Marcel—he would never become an official member, preferring to hover around the outside, safe from Breton's whims and ukases, and joining in the fun when it suited him. It was probably no coincidence that while all the surrealists at one time or another fell out with Breton, neither Marcel nor Man Ray did so.

Man was soon firmly established in Paris. The paintings he had brought over formed the first exhibition at a gallery opened by the surrealist Philippe Soupault. None were sold. Photography, on the other hand, offered an immediate living. Dealers and painters came to him for photographic reproductions of their paintings, while Gaby Picabia procured him an introduction to the famous couturier Paul Poiret, for whom he hoped to take fashion photos. Poiret was unenthusiastic about Man's photos, though he bought two of the camera-less prints that Man called *Rayographs* for one hundred francs each. Paris's fashion magazines, on the other hand, did like the photos, and Man soon found himself both busy and solvent. He took a purpose-built studio in rue Campagne Première, off the Boulevard de Montparnasse, and installed a mistress, the ultra-parisienne Kiki de Montparnasse who, when paying customers arrived, was stowed in the gallery and forbidden to emerge.

For the rest of their lives, Man would be Marcel's inseparable friend, an essential player in the complex game that was his life. Indeed, his three chief men friends—Picabia, Pierre, and Man Ray—constituted a sort of supplementary family, each with a particular role.

Picabia, who had been the first to introduce him to life's more free-wheeling possibilities—opium (whose effects Marcel admired strictly from the outside), fast cars (which he couldn't afford), and *Impressions d'Afrique*—helped with concrete organization: it was Picabia who had arranged the job at the Bibliothèque Sainte-Geneviève, Picabia who had suggested he take refuge in New York in 1915, and who had helped pay the fare, Picabia who would soon assume the role of matchmaker. In New York, Marcel had met Pierre, with whom, uniquely, he was able to share his sex life and who would soon take on the role of his unofficial banker. For Pierre, Marcel, even—especially!—in his most disreputable moments, could do no wrong. And now there was Man, who, like Pierre, was adoring, and whose affection, like Pierre's, was returned. For the strong emotions that repelled Marcel in women comforted him when the person in question was a heterosexual man. A few years later, when he married for the first time, his bride-to-be, Lydie Sarazin-Levassor, was touched and astonished by the extent Marcel was prepared to put himself out for Man. She thought it showed a humanity (*une qualité de coeur*) quite unexpected

in a person as cool and detached as Marcel, and although she found Man irritating, an annoyingly clinging presence, she was moved by Marcel's evident affection for and deference toward his friend.[*]

In fact, the relationship was far from being as one-sided as it seemed to Lydie, for Man was still helping to give Marcel's ideas material form. One of the first of these was the little film Marcel called *Anémic Cinéma*, of spirals embellished with anagrammatic phrases, filmed on Sunday afternoons in Puteaux. After lunch with Jacques Villon and his wife, Marcel and Man would set up an old movie camera in the garden and film the spirals on an upright bicycle wheel as it slowly revolved.

More important, however, were the photos of Marcel's alter ego Rrose Sélavy. Rrose, then a mere Rose, had made her first ghostly appearance in 1920. But even after acquiring her second *r*, she had been a comparatively disembodied entity. It was Man who set about remedying this in a series of brilliant photographs. In some, Rrose appears distinctly moth-eaten, and Marcel's features, shaded by an all-enveloping cloche hat, remain recognizably masculine. But in her most famous portrait, taken in 1923, Rrose is a veritable glamour girl. Tricked out in a fashionable hat belonging to Picabia's girlfriend Germaine Everling, coyly pulling her fur collar up to frame a face whose eyes are expertly kohled, and whose lipsticked mouth pouts sexily, Man's photograph makes Rrose the personification of camp allure. Along with *Dust Breeding*, it has become one of the archetypal Duchamp images.

Picabia and Roché would both predecease Marcel—Picabia dying in 1953; Roché in 1959. But Man was with him to the very end—literally so: Marcel's last evening, in October 1968, was happily spent having dinner with a few old friends, of whom Man was one.

[*] Sarazin-Levassor, *Un échec matrimonial*, 41.

3

MARY

In 1923 Marcel, back in Paris once more, began a liaison with Mary Reynolds, a quietly beautiful young American widow. Mary's husband had died in the war: devastated, she moved to Paris, where she had spent some time before she married, and where she lived on her widow's pension and a little family money.

The profound separation between Europe and America is fundamental to the stories of Marcel and his friends. Although the details vary, the theme of all these stories is escape. Duchamp was escaping the war, but also a particular intellectual and artistic climate; America's homegrown conflicts and obsessions catapulted him into a fame he could never have achieved in Paris. And American women like Beatrice and Mary Reynolds traveled in the other direction to escape, among other things, the repressive moral atmosphere that had helped make *Nude Descending a Staircase* such an object of American controversy. Beatrice, forcibly repatriated, was almost destroyed by the conflict between American notions of decency, as represented by her family, and European notions of freedom, as represented by Pierre. But Beatrice was an unmarried girl with no income of her own. Mary, by contrast, was a widow and had an income, albeit small. She was therefore able, as Beatrice was not, to take control of her own life.

The adventures of American girls in Europe were of course a favorite subject of the great American novelists of the day, Henry James and Edith Wharton. But their tales chiefly concerned rich young women with ambitious, social-climbing mothers eager to buy a duke for the family, and poor dukes eager to be bought. Mary and her friends, by contrast, were

not rich, and had come to Paris in order to escape their mothers' world. What they wanted was the kind of independence single women, without large fortunes, found it hard to achieve in America. Husbands were low on their list of priorities, partly because many of them—Gertrude Stein and Mary's close confidant Janet Flanner for two—were lesbians but also because they wanted to build their own lives in ways not possible had they been married. So they put the Atlantic, both figuratively and actually, between themselves and a life constricted by family expectations. Not that respectable French young women were noticeably freer than their American counterparts, but American women in France were not confined by French social norms, any more than European women in New York were confined by those of America. What mattered was the fact of being foreign. Janet Flanner lived a happy Parisian life as the *New Yorker*'s French correspondent, while her friend Natalia Danesi Murray, an Italian-born American, escaped in the other direction, leaving the dead weight of Europe behind her. As she put it, "Janet found in France the tradition of beauty, art, and culture she so longed for in her Indiana days. I found in America a new climate of freedom, a new world with eyes turned toward the future."* This possibility of escape was what Beatrice had sensed in France—and perhaps, had war not interrupted her stay, she might have constructed a satisfying life there.

In Paris, however, Mary met Marcel, and fell instantly in love; whereupon, in the words of Man Ray, a good friend of them both, he "with his usual sang-froid and amiability . . . accepted the homage."**

This sounds more than somewhat cynical, but was probably a mere statement of fact. The post–Buenos Aires Marcel, trying to come to terms with a world that no longer included his beloved elder brother, was a warm and faithful friend to women with whom he was not romantically involved, such as Beatrice, the Stettheimers, and Katherine Dreier, and also with women like Yvonne Chastel, who did go to bed with him but accepted that this did not imply anything more than affection on his

* *Paris Review* 96, Summer 1985.

** Ray, *Self-Portrait* p. 236

part. But he was, if possible, even more determined than before to deny any connection between sex and commitment. He would go to bed with you and play all manner of delightful games, but if you fell in love with him, you did so at your peril and on his terms.

And those terms were outrageous. In Mary's case, they meant agreeing to Marcel's insistence that their liaison remain strictly secret. Although he visited her every day, he refused to acknowledge her in public. If they happened to find themselves in the same café, they were not to speak; if they were both invited to dine at a friend's house, he would get out of the taxi while they were still some distance from their destination and arrive on foot.* She also had to accept that he would continue to pursue other women, in quantity. Mary told Pierre she found these other women "very common," which perhaps should have been reassuring, since it meant that their only function for Marcel was sexual. But reassured or not, there it was: he couldn't and wouldn't resist them, and she could take it or leave it. Being terribly in love—Pierre, when the three of them were together, saw her literally tremble with desire—she took it.

Pierre, star-struck as always, declared that Marcel made these demands entirely for Mary's benefit, to "protect her against his life, his calm, his solitude, his chess games, his amorous fantasies."** But it would surely have been more accurate to say he was guarding all these things against Mary. He did his best to persuade her to take other lovers, specifically Pierre, who was very attracted to her and with whom, it will be remembered, Marcel had relished this rather special form of closeness before, once when the woman in question was Louise Norton, and again with Yvonne. "He's had lots of my mistresses," he cruelly told Mary. But Pierre, for once, declined to play along, although he thought Mary beautiful and was self-consciously careful not to touch her. In any case, she didn't want other men, just Marcel, and was prepared to pay the price he demanded if that was what it cost to keep him. But it wasn't easy. When, on one occasion, she got drunk and complained, he simply broke off their relationship, though it soon resumed, in its nerve-racking way.

* All these details from Roché's diary, HRC.

** Roché, *Carnets*, July 3, 1924.

4

MARCEL MARRIED: PARIS, 1927

I n 1925 Marcel's parents died, and the small income that had guaranteed his independence abruptly ceased. He received a small lump sum, what remained of his share of the inheritance, but this was mostly disposed of when he bought his half share of John Quinn's Brâncuşis. He could have made a living as an artist—the gallerist Michel Knoedler told Man Ray that if Marcel resumed painting, even as little as one canvas a year, Knoedler's would pay him $10,000 annually.[*] But this would mean succumbing to a way of life he specifically despised. What, then, was he to do?

The answer, to Mary's horror and his friends' astonishment, was to get married.

For a man who always decried the notion of marriage and children as involving financial and personal commitments he did not wish to make, Marcel Duchamp singularly failed to live up to his ideal. Not only did he have a child, albeit not one that he knew of or that had cost him anything, but he was married—and not just once, but twice.

<div align="center">⁙</div>

[*] Ray, *Self-Portrait*, 234.

Thirty years after the event,* Marcel breezily explained that his marriage in June 1927, to Lydie Sarazin-Levassor, had ended after six months because he didn't have enough money for the household, and "so, very amicably, we got a divorce. No alimony, nothing. The things life forces men into—wives, children, a country house, three cars! I avoid material commitments." His bride, he said, was "a very nice girl . . . but it didn't take, because I saw that marriage was as boring as anything. I was really much more of a bachelor than I thought."

The bride's view was rather different.

As Lydie told it,** the notion that Marcel had expected to support his wife was the exact opposite of the truth, as was his airy declaration that no one was hurt by this abortive excursion into matrimony.

The marriage, said Lydie, was Picabia's idea. Picabia had eased Marcel's departure from art by providing an introduction to a librarian uncle, and his departure from Paris by helping with the fare to New York. Now, ever the practical friend, he was once again ready with a material solution to Marcel's money problems. The answer was easy: Marcel needed to marry a rich girl. And by a happy chance, Picabia's mistress Germaine Everling, a scion of the haute bourgeoisie, knew just the one. Lydie Sarazin-Levassor was the daughter of an old family friend, twenty-four, rich—she belonged to the Levassor motorcar family—unattached, and living at home in fashionable Neuilly with her parents. Marcel agreed to meet her, and Germaine prepared the ground.

Germaine told Lydie that Marcel was a painter like Picabia but had given up painting in order to play chess. She said he had temporary cash-flow problems, having sunk his inheritance into Brâncuşis, and that he had lived a life of pleasure and irresponsibility. That was all true, and was enough to put off any respectable bourgeois parent. Indeed, Lydie's mother was suitably suspicious. Lydie was twenty-four, charming, and intelligent. But she was also plain, fat, and greedy, and her total amorous

* In the *New Yorker*, April 6, 1957.

** In Sarazin-Levassor, *Un échec matrimonial.* Written many years after the event, Lydie's book gives a much sourer view of events than do the letters she wrote while it was all going on and she was still besotted with Marcel.

experience was confined to a failed adolescent crush. Given Marcel's rackety glamour, what, if not her money, could possibly be the motive for this sudden burst of interest?

Her father, by contrast, was delighted. Serially unfaithful to his wife, Monsieur Levassor had recently acquired a new opera-singer mistress, had fallen in love with her, and wished to divorce his wife and marry her. Since the recent devaluation of the franc had seriously depleted his fortune, and the divorce would entail a good deal of expense, he intended to raise money by building on the large garden behind his house in Neuilly, then selling the whole complex. Madame Levassor, a fragile neurotic with no life outside her marriage, was naturally devastated, and made her husband promise that he would not break up the family home until Lydie was settled with a husband, something that must have seemed a safely distant eventuality. So the prospect of Marcel, whose family was, after all, perfectly respectable—the Levassors knew his sister Suzanne socially—was an answer to Monsieur Levassor's prayers.

Lydie was naturally eager to escape the poisonous situation at home, and found the prospect of meeting the person Germaine described irresistibly intriguing. How was it possible, she wondered, for Marcel to have reached the ripe age of forty without finding a suitable partner? Germaine (who, as the mistress of Marcel's closest friend, of course knew about Mary) admitted that this was indeed strange, but explained that Marcel had had enough of bachelor life and wanted to settle down. A meeting was arranged at a restaurant—not a particularly good one, in Lydie's view: one of the striking aspects of her memoir is her detailed memory of almost every meal she and Marcel ate together. Lydie was accompanied by her father; Marcel by Picabia and Germaine. Picabia kept mentioning the names of painters; Lydie hadn't heard of any of them. Turning to Marcel, Picabia said, "How wonderful, to be that ignorant! A genuinely fresh eye!"

Lydie was not, at first, particularly taken by Marcel. She found him handsome, friendly, elegant, but not especially sympathetic. Forty-eight hours later, however, she was dazzled to receive a letter by express delivery inviting her to dine with him at Prunier's. She had never before dined alone with a young man not a member of the family—"it was a

big event for me," she remembered, "and it was wonderful." Marcel put himself out to charm, and Lydie, who lived in a world singularly lacking in charm, was bowled over. He talked about his work, his experiments, his friends—a new and thrilling world unlike anything she had ever experienced. And what was more, he seemed genuinely to enjoy her company! By the time they left the restaurant, Lydie was—as Marcel had surely known she would be—deeply in love. From then on they saw each other every day, and little more than two months after their first meeting, they were married.*

Lydie couldn't believe her luck. Could it really be true that she had captivated this fascinating man? More surprisingly, Marcel, too, seemed pleased. He told Miss Dreier that his intended was "not especially beautiful nor attractive, but seems to have rather a mind which might understand how I can stand marriage."** And to Walter Pach, "A day will come when you will meet my wife, who is really very nice."****

For Lydie, these two months were a rose-colored dream. Marcel was kind and loving, and introduced her to his friends and family. Brancusi took to her at once, as did Marcel's brother Gaston. Others were less sure. Pierre thought Lydie "desastrous [sic]—but it may change—I hope it will."**** Man Ray, a close friend of Mary Reynolds, said the news of this proposed marriage had surprised him as much as if Marcel had announced he was from now on going to paint impressionist landscapes. Having met Lydie, he concluded that Marcel's taste ran, rather, to Rubens. "Married!!!" exclaimed Stieglitz. "What next, six or seven children?" Ettie Stettheimer "[felt] rather sorry for him, tho' I hope without due cause."

Marcel, meanwhile, remained at his charming best. He and Lydie met, most evenings, to dine in the Latin Quarter before going on to visit

* Sarazin-Levassor, *Un échec matrimonial*, 30.

** Marcel Duchamp to Katherine Dreier, May 27, 1927, quoted in Tomkins, *Duchamp*, 278.

*** Gough-Cooper and Caumont, "Ephemerides," July 24, 1927.

**** Roché, *Carnets*, May 27, 1927.

his friend Man Ray, who had followed him from New York to Paris. Marcel and Man would embark on a game of chess while Lydie smoked and waited impatiently for the game to end, when she and Marcel could return to rue Larrey, where he had bought a studio with the remains of his inheritance, and fall into each other's arms.

Marcel would have preferred a very quiet wedding, but Lydie disliked small weddings. She wanted the wedding of her dreams, which was very large indeed, involving multiple bridesmaids, a matron of honor, morning dress for the groom, and the bride in traditional white, complete with train and tiara. And Marcel, having embarked on the marriage game, was ready to play it according to the bride's rules. If that was the price of financial stability, then he would pay it. Meanwhile, he spent his time apartment hunting. He explained to Lydie that this didn't mean that he was about to give up his studio. But it wasn't big enough for two, and in any case he needed it for work. Domestic life would take place in the new apartment.

Lydie did not find this strange. The husbands and wives she knew did not spend their days together. The wives remained at home while the husbands went out to work, returning to the nest in the evening. Why should artists not follow the same pattern? Lydie would have her place, Marcel would have his, and he would visit her as and when he felt like it, their lifestyle comfortably underpinned (Marcel assumed) by the income from the marriage settlement.

Surprisingly, considering that the point of all this, for Marcel, was an advantageous marriage contract, he did not discuss money with his future father-in-law until the day before the wedding, when they met to sign the settlement. Perhaps the prospect embarrassed him, or perhaps he felt he didn't need to worry: Lydie, the only child of a wealthy family living in a large house near the Bois de Boulogne, would surely receive a substantial dowry. Unfortunately, however, Monsieur Levassor's income was not what it had been. He had therefore decided that Lydie's dowry would not be a lump sum, but would consist simply of a small income—2,500 francs a year, to be paid quarterly. Lydie had known this, but Marcel had never asked her about it, and she was not about to raise the matter, her assumption being that this would simply be her own pocket money.

Marcel, who had been expecting something far more substantial, tried, not very successfully, to hide his shock and disappointment. As soon as the contract was signed, however, he hurried Lydie out to the nearby Luxembourg Gardens, sat her down, and furiously revealed that, quite contrary to her assumptions, all those restaurant meals, not to say such bourgeois niceties as a lavish basket of flowers he had sent to his prospective mother-in-law after the engagement was announced, had been paid for out of his small savings, a sprat to catch the proverbial mackerel. He had no income, and had been assuming her marriage settlement would provide enough for them to live on. And now this! He would be as poor after his marriage as before it, and Lydie, far poorer; even she realized that 2,500 francs a year was barely enough to cover her expenses, let alone his. There could be no more restaurant suppers, said Marcel. As soon as they found a flat, she would have a kitchen and must be prepared to use it.

Lydie was appalled, less by the poverty to come—she had hardly been expecting luxury—than by Marcel's evident fury. Her mother and her friends had all warned her that it was inconceivable he had been bowled over by her beauty; the attraction had to be her money. But he had been so charming, and the sex had been so wonderful, that she hadn't believed them. Now, however, it was clear that they had been right.

So the marriage's raison d'être had dissolved. But there was nothing to be done. The wedding was upon them, and the only way to stop it would have been for Marcel to jilt his bride literally at the altar—an act so outlandish as to be beyond contemplation. Lydie, who had done him no harm, and of whom he had become genuinely fond, would be unspeakably humiliated in the most public possible way. On a more practical level, Madame Levassor was due to move out of the family home, where the building works in the garden were set to begin the day after the wedding. And Marcel would be exposed as a moneygrubbing adventurer. It was out of the question.

The marriage took place at the Temple de l'Etoile. A photo taken at the church door shows the bridegroom, unreadable as always, dressed up in the traditional morning suit and top hat, arm in arm with the beaming bride, who is expensively tricked out in all-enveloping white with many

meters of train, her veil held on by a sort of chin strap. Picabia, match-maker in chief, stands at Marcel's other elbow.

"It is said," Lydie remembered of the wedding day, "that the whole of Montparnasse turned up to see Picabia be a witness at a church wedding—and Marcel Duchamp's wedding! As we emerged there was Man Ray, filming everyone streaming out, with Kiki acting as his assistant. We were to dine that evening with Germaine and Francis at Brancusi's. Picabia had painted a little watercolor for us entitled *A Marriage of Intellectuals*, which we were delighted with. I asked Marcel if there were any symbols to be discovered in it, and what they might mean, but he replied that you should not try to understand a work of art; you had to feel it. 'An artist expresses himself with his heart,' he explained, 'so it is with your heart that you must take in their works. That's the only thing that matters.'" Whether he kept a straight face during this little speech, Lydie did not say.

Marcel had not yet found a suitable second apartment, and until he did Lydie would have to live in rue Larrey. He had hastily asked Man Ray and a Russian friend, the sculptor Antoine Pevsner, to help him install a bathroom, borrowing space from the already-minute bedroom. They designed a cunning door that when opened in one direction shut off the bathroom, and in another, the bedroom—an arrangement that was not only practical but that Marcel, a connoisseur of the ambivalent nature of doors (are they closing off or opening onto?), found pleasing.

He did not, however, enjoy having to share his austere space with his improbable bride. Nor did Lydie much enjoy living there. She couldn't wait to move into her own place, she told her mother a few days after the wedding. The studio had no kitchen and only the most exiguous of bathrooms, and it was so small! She had brought in what she saw as a bare minimum of possessions, including a large wardrobe and a Chinese cabinet that she loved and Marcel particularly loathed, but much more still remained at her old home; there were also a heap of useless wedding gifts that neither of them liked, about the only acceptable one being a Cona coffee machine. And life with Marcel was so unsettling, he was constantly flitting from one set of friends to another, never a quiet evening

at home.* Meanwhile, since it was impossible to cook at rue Larrey, they continued to dine out every night. Marcel paid, as always; Lydie, not unreasonably, assumed he must have access to more funds than he had admitted. But when faced with a bill that arrived for a dress that formed part of her trousseau, Marcel lost his temper. The trousseau was her father's responsibility, he declared. He certainly wasn't about to pay for it. The money was finished, and there would be no more until the next instalment of her allowance. He would go to the bank, but there was to be no more of this extravagance.

In July, he finally announced that he had found just the place they needed. It was in rue Boussingault, not too far from rue Larrey. It had a bathroom, hot water, and central heating, and no furniture money was required. They viewed it the next day and signed the papers immediately. Then they drove off in Lydie's little car to Mougins on the Cote d'Azur, the fashionable resort where Lydie's father and his mistress had a house (as did Germaine Everling). There Lydie languished on the beach, which given her figure she didn't much enjoy, while Marcel attended a chess tournament along the coast in Nice. Even when he returned, his mind was still on chess; he would get up in the middle of the night to replay the day's game, a habit that so infuriated Lydie that one night she glued the chess pieces to the board.

Lydie had looked forward to having her own place, but when confronted with the reality on their return to Paris, she wasn't so sure. The flat was gloomy, with hideous floral wallpaper, and looked out onto a row of garages. Marcel covered the walls with blotting paper, whose pink shade Lydie fortunately liked and of which he had found a huge roll going cheap. He attached it with drawing pins, and moved in all her furniture, including the wardrobe and the Chinese cabinet. He then declared the new flat ready, and prepared to leave Lydie to enjoy it.

Lydie, however, found she couldn't face it. At least in rue Larrey she had been assured of Marcel's company. Was this to be her life now, a lonely existence surrounded by pink blotting paper? The prospect of being left alone in this dank new dwelling was so depressing that to put

* Gough-Cooper and Caumont, "Ephemerides," July 31, 1927.

it off, at least for a little while, she declared she would return for one last night to rue Larrey. Marcel, horrified, went out and bought lightbulbs, got the concierge in to clean, and went out shopping for groceries. But Lydie still couldn't face it.

Marcel was furious, and when they arrived at rue Larrey, Lydie realized why. In the few hours since she left that morning, he had erased all trace of her brief occupation and returned everything to the way it had been before. All the time, far from being welcome, she had evidently been nothing but an intrusion. He had endured the burden with good grace, but now that he had (he thought) shed it, the good grace had vanished. In her memoir, she bewailed the "fatal extra night," as though that was what tipped the balance and doomed the marriage. What was certain was that it brought home to both of them its utter impracticality.

What was Lydie to do? Her old home was a building site, her father was on the Côte d'Azur with his mistress, and her mother, furious and abandoned, wanted nothing more to do with her. So next day she returned to rue Boussingault, while Marcel, relieved, plunged back into his old bachelor life. He had, until the constant presence of Lydie rudely interrupted it, been carrying on not only his romance with Mary but the longstanding affair with Yvonne, who for a birthday present had recruited two other girls to entertain him with her, resulting in a particularly delightful and energetic night. ("You should have been there to help out," he told Pierre.) While Lydie and he were living in one room, such pleasures had been off the menu. Now his nights were once more his own.

Of course, Lydie knew nothing of this. All she knew was that Marcel had promised to visit her on her first evening in rue Boussingault, to see what she had prepared in her new kitchen. She pulled herself together, cleaned, cooked, and made the bed. To her dismay, however, when the meal was finished and bedtime approached he muttered something about the last metro and abruptly departed. Before he left, however, he told her that now they were settled, she shouldn't feel under any obligation to be faithful. If she had a fling or two, or even an affair, that would be just fine. The notion of fidelity in marriage, he declared, was ridiculous. Like Mary before her, Lydie protested that she didn't want other men—Marcel was the one she loved. "Pity," he said. "A little experience would do you good."

Poor Lydie! She couldn't believe he really meant it. For her, as for Beatrice, as for Mary, making love was about, well, *love*. And even if the first flush of physical desire had faded, marriage was about more than that. Wasn't it?

Alone in her new apartment, Lydie had no idea what to do. She couldn't complain to her friends, for they had all warned that Marcel was simply using her to get his hands on her money: how could she admit they had been right? And how, without family, friends, and gossip, was she to fill her time? Girls like her had a simple social trajectory. First they were marriageable, then they got married, made a home and had children, and then the cycle began again. Marcel had been so kind and loving! Only a few months earlier he couldn't wait to marry her. And now he couldn't wait to get away. What had she done?

The answer, of course, was nothing. For Lydie, the marriage was real life, but it had never been real to Marcel. He had kept his side of the bargain, as he saw it: had taken this nice, intelligent but rather plain girl to bed, where they had enjoyed some good sex. But she was not as rich as he had hoped; the arrangement he had in mind clearly didn't suit her; the thought of spending most of his life in her company, as she evidently expected, bored him to extinction; why draw things out? The divorce, like the marriage, was orchestrated (Lydie later found out) by Picabia. Some funds had been arranged in America, something had been sold, possibly one of Marcel's Brâncuşis; there was no more need for Marcel to subject himself to this improbable and inconvenient arrangement. They married in June, and divorced the following January.

Lydie married again, happily this time, and had two children. But the fact that she survived in no way mitigates Marcel's vile behavior. Is it conceivable he imagined, when he set about courting Lydie, that he might come to love her, that he actually hoped the marriage might work out? "I am a bit tired of this vagabonding life and want to try a partly resting one," he had told Miss Dreier, announcing his wedding plans.

Indeed, vagabonding, as exemplified in the squalor described by visitors to his New York studio, sounds singularly uncomfortable. One would certainly want to escape from that. Perhaps Marcel told Lydie as well as Miss Dreier that he hoped to do so. If so, however, he probably did not

add the rider contained in the next sentence of that letter. "Whether I am making a mistake or not is of little importance as I don't think anything can stop me from changing altogether in a very short time if necessary."

Perhaps the whole affair, and in particular the elaborate church wedding, should be seen as a sort of surrealist artwork, all of a piece with André Breton's definition of the ultimate surrealist gesture as going out onto the street with a pistol and shooting someone at random. At least in this instance there were no fatalities.

After the divorce, Marcel resumed vagabonding and in 1928 left for New York, which from Paris always seemed full of life and new ideas, though the reality soon palled by comparison with Paris's remembered gaieties, until they palled in their turn.

On his return to Paris he resumed his affair with Mary. The marriage had, naturally enough, devastated her. Marcel had apparently assumed it would not interfere with their affair, but of course it did, and poor Mary had what a friend described as "a sort of wild thing," drinking heavily (Pierre often saw her at the Boeuf sur le Toit nightclub, where Marcel never went, and where he noted that "she drinks every night until she gets drunk") and sleeping around indiscriminately. And now she was expected to take him back as though nothing had happened! "That's when I should have kicked him out, when he came back from that marriage," she would say, later, when he did some unforgivable thing—slept with another woman, pretended they were not connected.* But Mary found that despite everything she could not resist him, and they continued as before. She had bought a little house on rue Hallé, where she entertained and worked—she had taken up art bookbinding—and Marcel, ever the willing handyman, helped her decorate it, papering the walls (this time not with blotting paper but with maps) and making curtains from closely hung strings. Did he ever confess the real reason for his marriage, and did she accept it? We don't know: she never said. But she did finally put

* To Kay Boyle, interviewed by Calvin Tomkins, in Tomkins, *Duchamp*, 284.

her foot down regarding the secrecy. It was to end. And, up to a point, it did, though their liaison was never very public: twenty years later, the wife of Antoine Pevsner met Mary at dinner, and was amazed to hear that that she and Marcel were long-standing lovers. For years, whenever Marcel was in Paris, Pevsner had seen him two or three times a week, and had never had the slightest idea that this was the case.[*]

One can't help wondering why, if Marcel was really tired of his "vagabonding life," he didn't marry Mary, who was beautiful and interesting, or Miss Dreier, of whom he was fond, though like Lydie she was fat, but who knew about art and was rich. The answer is probably that he could get what each of them had to give without going to such extreme lengths. Pierre believed Marcel and Mary had agreed not to marry,[**] but Peggy Guggenheim, Mary's close friend, thought it a bit more complicated. She wrote in her memoirs that "every time Mary was asked why she didn't marry Marcel, she would say Marcel didn't want to. Every time Marcel was asked, he would say Mary didn't want to."

In 1940, when the Germans occupied France, Marcel fled to Arcachon in the Unoccupied Zone, then traveled from there to New York in 1942. But Mary refused to leave Paris, her friends, and her beloved house. She grew vegetables in her garden, and the house became a Paris station for people on the run and a meeting place for a Resistance group that included Gaby Buffet-Picabia, her daughter Suzanne, and Samuel Beckett. In the summer of 1942, however, a number of members were killed and it became clear that the group was doomed. Mary, realizing she was under surveillance, left home in the nick of time. Dressed in ordinary street clothes and carrying no luggage, she crossed to a friend's house over the road. From there, an hour later, she saw two carloads of armed Gestapo surround her house.

[*] Godlewski, "Warm Ashes," http://archive.artic.edu/reynolds/essays/godlewski4.php.

[**] Seigel, *The Private Worlds of Marcel Duchamp*, 193.

Mary's subsequent hair-raising adventures were recounted by her friend Janet Flanner after she reached America in 1943.*

By 1942 the United States had joined the Allies; Americans were therefore considered enemy aliens and it was no longer easy for them to leave Paris. Official permits were impossible to obtain, and to cross the line of demarcation without one necessitated an expensive and not necessarily trustworthy guide. Mary eventually managed to find such a person and reached Lyons in the Unoccupied Zone, where she hoped to sit out the war. She had been there only two months, however, when the Germans marched in, and as too many people knew about her, she had to move on. She therefore took to the road again and made her way to Pau, on the Spanish border, a jumping-off point for escape over the Pyrenees. There ensued another long, anxious wait, while various necessary permits expired and had to be renewed, before a guide would agree to escort her, along with a renegade German and two Jewish businessmen, over the mountains.

The journey lasted several days. It was very exhausting, not least because the escapees had to carry not just themselves but their luggage (in Mary's case, including a rolled-up picture by Man Ray, who still dreamed of making his name as an artist and hoped she, and the picture, would reach America). It concluded with a terrifying climb up a gully, where Mary's legs were torn open by sharp rocks. The resulting wounds became badly infected, and although the infection was eventually cured, it was an ordeal from which she never fully recovered.

At the top of the pass was the Spanish border, where they found the Guardia Civil waiting to arrest them. However, Mary's papers, unlike those of her companions, were in order, so the Guardia reluctantly had to let her go. On December 14, 1943, she made it to Madrid, where she cabled her brother before traveling on to Lisbon, the point of departure for America. Her brother, on the advice of the State Department, had prepaid her fare from Lisbon to New York, but once again she had to wait, for every time she seemed to have booked a seat on a flight, it was filled

* In three 1943 articles for the *New Yorker* entitled "The Escape of Mrs. Jeffries," reprinted in Drutman, *Janet Flanner's World.*

at the last minute by someone better connected. Finally, on January 6, 1944, she got a seat on a Pan-Am Yankee Clipper.

Marcel was living in Greenwich Village, and Mary, after a stay at the Waldorf Astoria while her leg was treated and the OSS debriefed her, joined him there. But in 1945, when peace came, they parted once more. Marcel had no wish to leave New York, whose speed and buzz he was enjoying, as also its material plenty and a certain reputation among collectors among whom, in America, his name still resonated. Compared with all this the hardships of newly liberated Paris did not attract him. Mary, however, couldn't wait to get back. Her life and friends were all in Paris, and she took the first available ship back to France.

5

MARCEL DISCOVERS LOVE

I n 1954, four years after Mary's death, Beatrice received a letter from Marcel. She had for many years been settled in California, near Lou and Walter Arensberg. They had just died within a few months of each other, and she had written to tell Marcel the sad news. "Thank you for your sweet letter telling me of Walter's death. It is hard for me to accept that he went so quickly," he replied, then moved swiftly on to his own news:

> I married Teeny Matisse, ex-wife of Pierre Matisse (The Gallery). I am enchanted with this change in my life.

"Enchanted" with marriage? What had happened to him? Although Marcel was then sixty-seven, and Teeny forty-eight, people who saw them said they seemed like teenage sweethearts. In his old age, had he suddenly undergone some sort of epiphany?

The answer was yes. He had discovered love, and it had changed him utterly.

The breakthrough had happened eight years earlier, and not with Teeny.

Early in 1946, alone in New York after Mary's return to Paris, Marcel met Maria Martins, the beautiful and talented wife of Carlos Martins, the Brazilian ambassador to the United States. She was fifty-one, the mother of three children, a leading diplomatic hostess, a successful sculptor—in 1943 she had had a joint New York exhibition with Piet

Mondrian—a beloved wife, and a happy libertine free to live her life exactly as she pleased. Marcel became one of her lovers, and for the second time in his life, thirty-four years after his failed pursuit of Gaby Picabia, he experienced the intoxicating and obsessive state known as being in love.

His passion was returned, in that Maria fell happily into his arms. But in love, as the mot has it, there is generally one who kisses, and one who presents the cheek. With the exception of those few hectic weeks in 1912, Marcel had always been the beloved who graciously accepted other people's devotion. But fatally (for Marcel), Maria reversed that situation. Like Gaby, she was firmly anchored in her marriage and her family life, and although, unlike Gaby, she had no hang-ups about fidelity, and delightedly welcomed Marcel into her bed, she had no intention of giving up everything in order to be with him. And this wholly new combination of violent—and reciprocated—sexual attraction and ultimate unattainability enslaved him.

The enchantment was sexual (when he gave her one of his *Boîtes-en-valise*—each of which in addition to the reproductions contained one new work—the new piece was a swirly composition unlike anything he had ever produced before. Painted on celluloid backed by black satin and entitled *Paysage fautif*, its medium was semen.) But for the first time in Marcel's life, it was also emotional. In April 1946, soon after their meeting, he wrote Maria a joyful letter.

> You must know me well enough by now to realise that for the first time in my life I find myself accepting you completely as you are, without feelings of rebellion of any kind, and that it has at last been granted to me to love you simply and purely. *

For the next four years Marcel reiterated his devotion, proposing variations on the theme of fulfilment à deux in what he described as "our secular convent"—proposals that Maria constantly evaded. "You

* These letters are published at http://www.golob-gm.si/32-Marcel-Duchamp-s-letters-to-Maria-Martins.htm.

could isolate yourself here with me, and nobody would be aware that this cage away from the world even existed," he pleaded. But she remained stubbornly unwilling to take him up on these suggestions. Hers was that rarity of rarities—an open marriage that worked. Maria's husband was so crazy about her that she could do anything she liked, so long as she stayed with him. All that was required was that she not fail as hostess, mother, and ambassador's wife—activities that Marcel saw as a devastating waste of time but that Maria inexplicably (to him) enjoyed. "My love, I think of you all the time. But I suffer on account of the 14 hours a day that are not yours," he wrote during one of their numerous separations—the fourteen hours presumably being those she spent away from her sculpture, on children, friends, and social duties. And in yet another role reversal, Marcel was far from being her only lover—and hated it. "You have a susceptibility problem to sort out," he told her. "I can assure you that if each time instead of being susceptible you apply a healing balm of pure confidence, the result will be so very soft and sweet that it will cure you gently of that susceptibility throwback, inherited perhaps from remote ancestors." But Maria did not want to be cured, and Marcel, for the first time in his life, suffered love's torments. Everyone else was available: no one else was desirable.

In May 1946, soon after the first cataclysmic encounter with Maria, Marcel left for Paris and Mary, with whom he had agreed to visit Switzerland. "I am in a state of terrible depression," he wrote on his arrival. Although Paris was "not as impossible as I had feared," his studio was a mess: it had been used as a safe room by the Resistance, there had been a small fire, and some panes of its glass roof were broken, letting the rain in. And he missed Maria terribly.

He told no one, and no one suspected anything: "I have not yet detected the slightest echo, not even an imperceptible one, of our love," he wrote. According to his old rules of total freedom, there should have been no reason for this secrecy, but the old rules had been invented by the old Marcel, a person who no longer existed. Nevertheless, the fact that he had fallen in love with someone else naturally affected his relationship with Mary.

May 12, 1946, Paris

I feel more and more out of place, have not been able to make love, and feel
more and more like ending it all. Fortunately your sweetness is there to comfort
me ... Another letter soon I love you

The liaison with Mary continued. They even went house hunting—she
had a notion of retiring to a country cottage. But nothing they saw
appealed, and in January 1947, to Mary's distress, Marcel put himself on
the list for the first available berth to New York, and Maria.

Their proximity was not to last: in 1948 Maria's husband was posted
from Washington to Paris. Meanwhile, Mary arrived in New York.

August 17, 1948

No, nothing will change our love—M. R. arrived a few days ago. She is
living in the Chelsea Hotel, in Virgil Thomson's suite. Nothing has happened
nor will happen. She leaves for Chicago on the 21st, will be back in N.Y. in
Sept, and will take the boat back in the first days of October.

The newfound gift of love meant that Marcel was able, for the first time
in thirty years, to contemplate a new artwork: a diorama landscape whose
focus would be the woman who was now at the center of his life, its most
important feature a life-sized lay figure of a naked woman modeled on
the body of Maria, lying postcoitally splayed in the foreground.

When people asked him why he hadn't made any art for so long, his
reply had always been that he had no new ideas. He had said what he
wanted to say, about the art scene, about perspective, geometry, the pre-
cedence of ideas over the "retinal," about sex and puzzles and wordplay
and the pleasures of complex apparatus. And having said what he wanted
to say, why repeat himself? Chess was far more interesting.

Now, however, it seemed that this was only part of the truth. Many,
perhaps most, artists repeat themselves. Art comes not just from the head
but from the gut, or heart, which are less mutable than the flighty
head and which dictate, at a deep level, the way the head—even Marcel's

head—sees the world. For all that his intellect reigned supreme, the impetus to create needed the emotional push love had once again provided. What had held him back was not fear of repeating himself but indifference—the terrible indifference that he himself touted as his trademark. "My irony comes from indifference," he once told Pierre. "It's meta-irony."* Indifference stifles all creativity; indifference had made it possible, among other things, to treat Lydie so cruelly. But Maria had broken through that shell, and freed him to return to art.

Arguably the greatest artists are those most directly able to channel their emotions into the finished work. Without that immediacy, what is produced may seem arbitrary and make little impression. On the face of it the *Nude*, the *Glass*, the *Fountain*, not to say the mustachioed and goateed *Mona Lisa*, were products of the head, not the heart. But they have a force that feels anything but arbitrary. And since the emotion that produced Marcel's new work—his love for Maria—echoed the love for Gaby Picabia that, years before, had prompted the *Glass*, it is not surprising that the new work reprised the themes that had obsessed him then. The title—*Étant donnés: 1° la chute d'eau 2° le gaz d'éclairage*—was taken from the *Glass*, the second page of whose *Notes* had begun with this phrase, pointing out that this new work echoed the ideas and obsessions he had first explored half a century before. They both use complex geometry and perspective tricks, though in *Étant donnés* instead of being contained in a pile of allusive notes, these are set out in elaborate instructions for the peepshow's assemblage. And they are both first and foremost, about sex. "I believe in eroticism a lot," Marcel said, "because it's truly rather a widespread thing throughout the world, a thing everyone understands. It replaces, if you wish, other literary schools."**

The making of the model presented intriguing problems. The idea was to make her out of plaster, or perhaps wax, over which a skin would be stretched to give the most lifelike possible impression.

* Roché, "Souvenirs sur Marcel Duchamp," in Lebel, *Sur Marcel Duchamp*.

** Cabanne, *Dialogues with Marcel Duchamp*, 88.

I am returning tomorrow and will go back to my dry skin under its steel rods—only you can understand this sentence.
I have even started to draw the woman. (In pencil.) (September 1948)
 Before leaving, I had very nearly finished my woman's hand. When I left her she did not look too "wooden." (April 7, 1949)
Our woman is finished and goes to the molder's the day after tomorrow. I intend to work on the plaster cast a great deal because I can't see anything more to do with the plastilene . . .

Thinking about all this was fun, and Marcel hoped it would provide a constant background to their love once he and Maria finally settled together: "I have always said, the way out is your sculpture and my woman with the open pussy." But being so closely bound up with Maria, it was also a way out of his loneliness, a quasi-sexual experience that united them, he felt, even when they were physically separated.

How simple life is when there is only the inner self to think about. So I took a trip inside your inner self, and I found what I thought would be there, having guessed by external contact only—I found "things" that have no name even in the most poetical language. (Sept 1948)

He longed for their separation to end. But Maria never made the move, and in 1950, when her husband was posted back to Brazil, she returned there with him, leaving Marcel marooned in New York. Lost in despair, his only consolation was to work on his woman, "our lady of desire."

For years he had clung to the hope that she might, after all, change her mind and throw in her lot with him, that somehow she was being kept from him against her will. But her dreams did not coincide with his, and he had to accept that there was no hope they would ever be together permanently.

I do not want to ruin your life, and all that we might do to change the course of things would only bring a semblance of happiness.
—So I have come to accept the situation as it is and no longer seek to find some miracle solution.

—I am happy when I think of you.
—Love (October 1951)

Mary, too, was gone. She had never really recovered from her wartime hardships. In the summer of 1950 she became very ill, but Marcel, in New York mourning Maria's departure, refused to believe she could really be dying. Only a cable—MARY DESPERATELY ILL PLEASE COME—from her friend Janet Flanner finally convinced him. He rushed over and arrived in time to be at her bedside for the final few days.

Left for the first time in many years without an adoring woman friend, he found that he missed the ongoing relationship he had spent so much of his life evading. The problem was solved on a visit to his friend Max Ernst in Sedona, Arizona. Another guest was Alexina "Teeny" Matisse, who had recently divorced Pierre Matisse, the art dealer son of the great painter.

Alexina Sattler, always known as "Teeny," the name her mother had given her because she was such a tiny baby, was born in 1906, the daughter of a prominent Cincinnati surgeon. But she wanted more than Cincinnati could offer, and left as soon as she decently could to study sculpture with Brancusi in Paris. It was there that she first met Marcel, at a party given for her in 1923 by a fellow American. She was then eighteen.

Teeny married Pierre Matisse in 1929, when she was twenty-three. They had three children, but divorced in 1949. This was when she went to stay with Ernst, and met Marcel for the second time: Marcel, who, like her, felt suddenly alone in the world.

The two hit it off at once. Teeny was an avid chess player, they knew many of the same people, they delighted each other, and in January 1954 they married. As her divorce settlement included many important paintings, the marriage solved both Marcel's vagabonding and his money worries. They remained devoted for the rest of his life.

Part Four

LATE FAME

1

BEATRICE

Beatrice's nonmarriage to Paul had left her both emotionally and financially destitute, unable either to judge men or to trust them. "Ever since Roché my sense of security in love affairs was fragile," she wrote.* The result was that "I never made love to the men I married, and I did not marry the men I loved."** But since she had no money and did not wish to depend on her mother, doing without a man was difficult. The disaster with Paul was followed by seven years in which she lived in New York with an English actor called Reginald Pole. Predictably, there was a drawback, in the shape of a wife and child in California; when he at long last divorced, he (also predictably) left her to marry another, younger woman.

Following that debacle, Beatrice took refuge in theosophy. She became a devotee of Krishnamurti, the charismatic leader of the cult in America, and followed him to Ojai, California, where he was establishing a headquarters. And there she rejoined her old life—for nearby, in Hollywood, were her old friends the Arensbergs. Like her, they had fled from a New York made unbearable by Pierre. He had enchanted both Beatrice and Lou with his revelation of love, before cruelly betraying them both: Beatrice not least, though not only, with Lou, and Lou by his insistence that, if she was to stay with him, she must not only leave America for Paris, but share him with his longtime girlfriend, Germaine. For the

* Wood, *I Shock Myself*, 74.

** Wood, 170.

Arensbergs, California was intended as a temporary escape, but they would stay in Hollywood for the rest of their lives.

On first arriving in 1921, they settled, as was their habit, in the grandest house available, in this case a guesthouse in the Frank Lloyd Wright Hollyhock House complex in East Hollywood, recently commissioned by Aline Barnsdall. However, they did not enjoy living there. The windows, said Lou, were the wrong height, and the closets too high. So they put their collection in storage and moved to a small bungalow nearby while they looked for a suitable house to buy.

It was in this bungalow that Beatrice found them when she traveled to California with Reginald Pole, who spent every Easter in Hollywood directing *The Pilgrimage Play*, a religious play about the life of Christ, in which he played Jesus. She was astonished to find that Lou, one of the richest women in America, was living the life of an ordinary housewife—and loving it. Instead of couture gowns she bought cheap off-the-rack dresses from bargain basements; Walter pursued his Bacon studies while she did the cooking; and they ate in the kitchen, where the view from the window was of other similar bungalows.

Beatrice found it hard to believe that "the famous host and hostess of the New York art crowd" could be so happy living a suburban life in a bungalow. But they were clearly enjoying themselves, though Walter was becoming more and more absent-minded. (Once, when Lou asked him whether he wanted salad for lunch, he looked at her, his thoughts elsewhere, and murmured, "What is salad?")

In 1927 they bought a rather undistinguished but spacious house at 7065 Hillside Avenue, hired Richard Neutra to design an extension, installed their collection there, and resumed their roles as salonniers, instigating artistic gatherings that, if not as thrilling as the 67th Street salon, were nevertheless extremely lively.

Not everything had changed. Walter still had extramarital affairs, and to Beatrice's astonishment even made a pass at her, which she, horrified, rejected. "But Lou doesn't mind me having affairs," he said, to which she replied (did she think, perhaps, of Pierre, and Alissa Franck, and Lou?) "But not with her best friend!" The friendship, however, survived and

Walter evidently confessed, for later Lou laughed with her about it. Their marriage, with all its imperfections, would last until they died within a few months of each other. "Part of me died too when they both left," Beatrice wrote. "For years they had been my family."[*]

For the first years in California, Beatrice subsisted on a small monthly sum donated by the ever-generous Beth Hapgood, supplemented by large birthday and Christmas checks from her father. When her father died, however, the checks ceased. The Paul affair had convinced him she could not be trusted with money; accordingly, he had left everything to her mother, whose bad investments soon disposed of any possible inheritance.

The procession of impossible men continued. After various unsuccessful attachments, Beatrice made a second marriage to a real estate appraiser, Steve Hoag, whom she did not love, but whose realistic head for finance seemed reassuring at the time. (Later, as she became more successful, she would find his caution infuriating.) It was he who insisted they must marry if their relationship was to continue, and Beatrice finally agreed—though, presumably with Paul in mind, only on condition they could later get the marriage annulled, for, as officially with Paul, their relationship remained platonic. Nor was it a success in other respects. Steve had an unbridled tongue and insulted so many of Beatrice's friends that they had to give up the Arensberg gatherings. So Beatrice only saw her old friends when they came to visit. And although she fell in and out of love several times after marrying Steve, it was always with men about whom she could safely fantasize because they were so clearly out of the question. One was an Indian met briefly during a visit there, and rarely met again because he lived on the other side of the world; one was a Native American chieftain . . . The experience of rejecting her mother's idea of who might make a suitable husband, only to be herself rejected by Pierre, had evidently so damaged her confidence that she found subsequent relationships impossibly problematic.

[*] Wood, 135.

And then, finally, Beatrice hit on a career and found the answer to her difficulties with men.

In 1933, on a trip to Europe with a theosophist friend, she had acquired a set of luster plates. Back in America she wanted, but couldn't find, a teapot to go with them. A friend suggested she make one: ceramics classes were on offer at Hollywood High School's adult education department. She found that she loved working with clay, and although it would be a long time before she could make a teapot, or indeed a respectable plate, she modeled some little clay figures that recalled the chirpy cartoon figures in the witty sketches Marcel had liked. To her astonishment, people seemed happy to buy them; improbably, it seemed she might even make some sort of living this way. And so, like many independent American women of this generation—like Mary Reynolds, who became a specialist bookbinder; Janet Flanner, who became a journalist; Louise Norton, who became a translator—Beatrice found her way into the artistic universe and financial independence by the back door of crafts.

Might these women have done more? This wasn't a question they asked themselves. Successful female artists, like all artists, needed talent, but talent was not enough. They also needed, like Isadora Duncan or Marie Laurencin, a total disregard for social convention, or else, like the impressionist painter Mary Cassatt, or Gertrude Stein, who pioneered new writing, that universal key to independence—private means. Crafts were more forgiving. Items of a passable standard could be produced by anyone willing to put in the hours. They brought in an income and provided acceptable employment. And in the hands of the talented, the boundaries between arts and crafts could be blurred. Even at the Bauhaus, that hotbed of up-to-date thinking, women were shunted into the crafts sections. Josef Albers was an Artist with a capital A, but his wife, Anni ("Why do you paint?" asked Oskar Kokoschka, after seeing one of her portraits) was relegated to the acceptably female weaving workshop—where she went on to produce great works of art.

Beatrice took more lessons, worked very hard indeed, and began to make a small living. Steve put down money to buy a lot where they could build a house with a workshop; Beth sent money for a kiln. For the first time since 1917, luck seemed to be running her way. Her pieces sold for

what seemed to her astonishing sums. She was invited to India and made a great hit there; was invited again and took up wearing saris, which she found comfortable, economical, and aesthetically pleasing. They suited her, and so did her new lifestyle.

As Pierre, that pitiless judge, had noted, the hardships with Paul had transformed a bold and charming girl into a rather plain, ground-down woman. But pottery set her free. She grew her hair, which she had cut into a bob that didn't become her, knotted it at the nape, began wearing the folksy and extravagant garments in which she looked her best, and became beautiful once more. Men who in her previous dependent incarnation had thrown her over (Reginald Pole) or who had not hesitated to alienate her friends (Steve Hoag) begged her to support them and look after them in their old age. Pole—*Dearest B., there has been no one in my life with whom I have had the depth of love, of understanding, I had with you . . . I want to be with you again*—she refused;* to Steve, from whom she had separated, she grudgingly allotted a room in her house, where, bad-tempered as ever, he remained until he died.

By 1940 Beatrice was selling her plates and bowls for high prices, and getting orders from the best department stores—Bullocks Wilshire, Neiman Marcus—as well as from craft shops, including one on Madison Avenue. The same year saw her first solo exhibition, at the Metropolitan Museum in New York. She was an accepted artist, at last.

* Wood, 145.

2

PIERRE

I f Beatrice's inability to judge men remained a constant in her life, so too did Pierre's perennially unfulfilled hope that all the many women he slept with would love each other as much as he loved them.

In 1920 he had begun an affair that would become the grand passion of his life, with Helen Hessel.

Helen was the wife of his old and dear friend Franz Hessel. And just as he had found a particular excitement and satisfaction, not to say a piquant new aspect of friendship, in sharing a mistress with Marcel, so in 1920 he felt no qualms about beginning a delirious love affair with Franz's wife. With Marcel, Louise Norton, and Yvonne Chastel, the sharing arrangement had been entirely unproblematic, but with Helen and Franz it proved more difficult, not least because Franz loved Helen in a way that Marcel had never, before Maria, loved his sexual partners.

Pierre, too, had changed with the years. Hitherto horrified by the idea of paternity, he was now, as he approached his fiftieth year, desperate to have a child. With this in mind, in 1921 Helen divorced Franz so that she could marry Pierre and legitimate the hoped-for child. And in 1925, along with Stéphane, one of her sons by Franz, she moved from Berlin to Paris. However, she neither married Pierre nor conceived. And to cap her disappointment, in 1927 Pierre finally agreed to make the long-suffering Germaine his wife. "I regret in a way [Helen] is not there to see us" he told his diary on his wedding day. It is unlikely either Helen or Germaine shared his feeling.

Since Pierre did not change his habits ("Short visit to [Germaine], my wife, my *légitime*," he noted next day), but continued to divide his time three ways, between his mother, who was now very ill, Germaine, and Helen, this marriage seems on the face of it mysterious. It was in fact prompted partly by Germaine's shocked discovery of his diaries, with their sexual history, and partly by Pierre's desire for a child. Since he could not succeed with Helen, perhaps he should turn to Germaine, who had twice become pregnant by him. Each of those times his mother had insisted she undergo an abortion, but perhaps now she would consent to try for one more pregnancy. This, however, Germaine refused to do. There had been too many betrayals and in any case it was too late.

In 1929 Pierre's mother died, and that same year he met a new love. He set out the circumstances in *Jules et Jim*: "One day Jim was introduced—unwillingly, for he had no desire to meet new people—to a young girl. She was silent, calm, and translucent, though with child-bearing hips . . . She was called Michèle. He saw her again. When he was with her, he forgot the two warring others. He was at peace."

Her name was in fact not Michèle but Denise, and she was not a young girl, but thirty-four years old. Denise did get pregnant, and in May 1931 their son Claude was born. She moved into the Boulevard Arago apartment, set about reorganizing it, and took her place as chief wife, in fact if not in law. Two years later Germaine, now doubly displaced, left Paris to live in the Corrèze, in a holiday house Pierre had bought with his mother and of which he now gave her the use. She never saw him again, though they continued to correspond, but refused to grant a divorce. When she died in 1948, Pierre immediately married Denise.

The year of Germaine's departure for the Corrèze, 1933, also saw the end of Pierre's affair with Helen. Following Claude's birth he had been spending less time with her, though without telling her why. But finally, on Bastille Day, he confessed to the existence of Denise and their little boy, now two years old.

Helen exploded in rage. She threatened Pierre with a revolver, told him to lie down and prepare to die, then hit him with a cane. He did not die, however, but hit her back. In *Jules et Jim* the story ends with her inviting him for a drive and drowning them both in a river. In real life

the rupture was formalized with a financial settlement. Helen at first claimed the Brâncuşis as damages ("Mes Brâncuşis!"), but in the end it was agreed that Pierre would finance the studies of her son Stéphane until 1938, when Stéphane would turn twenty—a duty he punctiliously carried out.* She also stipulated that Pierre cease all contact with Franz, who had been his dear friend since 1906. But now that her hopes of having a child by Pierre were dashed, she insisted that the friendship follow suit. Pierre and Franz never met again. Helen and Franz remarried, but Franz, who was Jewish, died in 1941, his life made impossible by the Nazis.

Pierre began writing *Jules et Jim* in 1943, but it was not published until 1953. It achieved a certain critical success, but did not sell and would have been forgotten had François Truffaut, in 1956, not picked it up from a second-hand bookstall—"I liked the title, I found it very musical," he told film critic Michel Polac. Truffaut, enchanted by the contrast between the novel's dramatic emotions and its stripped-down style, sought out its author, and they became friends. But Pierre never saw Truffaut's film, for he died in 1959, and it did not appear until 1962. By then he had become a harmless old gossipmonger who rarely left his suburban home; had it not been for his novels and diaries, no one would have guessed at his previous life of improbable sexual adventure.

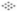

In 1957, Beatrice and Pierre met for the last time. They had remained sporadically in touch, and in 1939 she tried to persuade him to bring his new family to California, where there was no war, living was cheap, and the weather was wonderful. He declined, however, and sat out the war years in the Drôme. When he returned to Paris, she sent parcels of food and other supplies, along with news of her current amorous fantasies, hopeless as always—she was, or fancied herself, in love with "my doctor,

* Stéphane Hessel, after joining the Resistance and narrowly escaping death in Buchenwald, became a diplomat, ambassador, and leading advocate of human rights. In 2010, when he was ninety-three, his book *Indignez-vous!* (*Time for Outrage!*) became a world best-seller.

who is old, who is busy, my pottery teacher, who is homosexual, who is busy. Wish they would hug me. Both at the same time." Pierre's response was mostly about being an art dealer, which was how he now made his living, and Marcel. Some early Duchamps had been discovered at Jacques Villon's house—perhaps Walter might buy them? Should he tell Marcel, whom he saw whenever Marcel was in Paris, to drop a hint that Walter should also buy some of Beatrice's pottery? Marcel was "thin and always delightful . . . is sure of your success and admires you. It is through him that I have known you!"*

In 1957 Beatrice, who had finally begun to make good money, had been intending to visit Peru. But hearing that Pierre was unwell, she changed her plans and flew to Paris instead.

The Rochés were living in a large house in suburban Sèvres filled with Picassos and the Brâncuşis that Helen had tried to take from him. The onetime heartbreaker had become "a dear old dodo," Beatrice noted: the one she fancied was his son Claude, now a strapping youth in his mid-twenties. (Since she was now over sixty, nothing came of this.) The once-gregarious Pierre rarely left the house, but gathered gossip via the phone, on which he spent hours every day. He was busy transmuting his succession of triangular loves into fiction. When *Jules et Jim* was published, many people, including Beatrice, mistakenly thought it was about herself, Pierre, and Marcel, though "the characters bare [sic] only passing resemblances to us in real life!" They would, however, appear in *Victor*, his love letter to Marcel, in which Patricia, the Beatrice character, is so cruelly and self-servingly belittled. But that was not yet written and would never be finished. Perhaps it was this 1957 visit, and the memories it awakened, that inspired Pierre to begin writing it; he was working on *Victor* when he died in 1959.

Beatrice stayed with the Rochés for several weeks, until they left for the south of France. She then went on to Spain, where she received a remarkable (but characteristic!) letter from Pierre. His wife, he said, was a jealous woman, but liked Beatrice so much that she wanted her to

* Wood, *I Shock Myself*, 137–38.

come and join the Rochés in their hotel on the Riviera. She would even give up her bed to Beatrice and sleep on the spare bed in the other room so that Beatrice and Pierre could enjoy early morning chats. Beatrice, however, declined this strange invitation. She said she had made a rule never again to flirt with a married man, and besides, "together again—in the same bedroom—I couldn't take a chance!"*

* Wood, 141.

Marcel Duchamp, *Nude Descending a Staircase, No. 2*, 1912. Oil on canvas, 57 ⅞ x 35 ⅛ in. Philadelphia Museum of Art, public domain.

ABOVE: Interior, Arensberg apartment, New York. Photo by Charles Sheeler. Philadelphia Museum of Art: The Louise and Walter Arensberg Collection, 1950, 1950-134-989. BELOW: Lou Arensberg, circa 1917. Beatrice Wood Center for the Arts/Happy Valley Foundation.

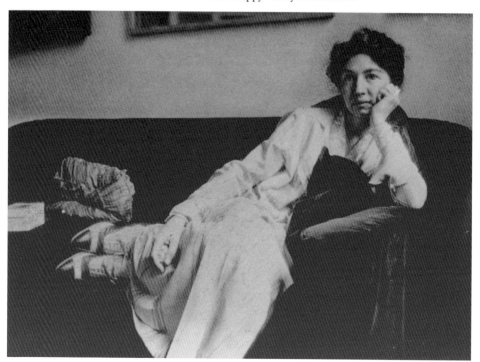

Aileen Dresser, Painter

Clara Tice: New York's Modern Girls. *Cartoons* Magazine, 1917. Arensberg Archives, Philadelphia Museum of Art, Library and Archives.

Lou Arensberg

Louise Norton, Writer

Mina Loy, Painter-Poet

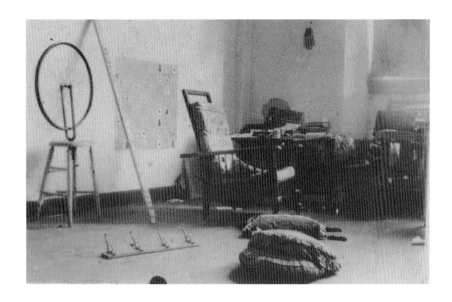

ABOVE: Marcel Duchamp's studio, 1917, 33 West 67th Street. Philadelphia Museum of Art, "Marcel Duchamp," 1973, Marcel Duchamp Exhibition Records, Philadelphia Museum of Art, Library and Archives. BELOW: Marcel Duchamp and Henri-Pierre Roché, multiple pictures, 1917. Public domain.

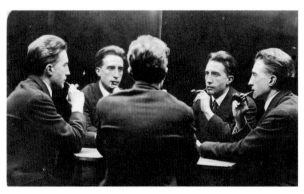

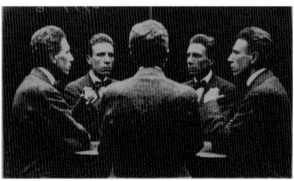

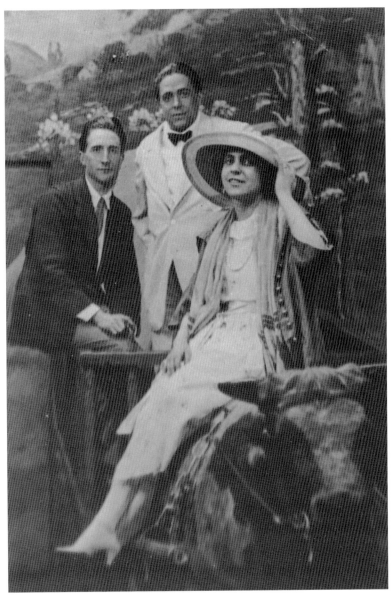

Beatrice Wood, Marcel Duchamp, and Francis Picabia, Coney Island, 1917. Public domain.

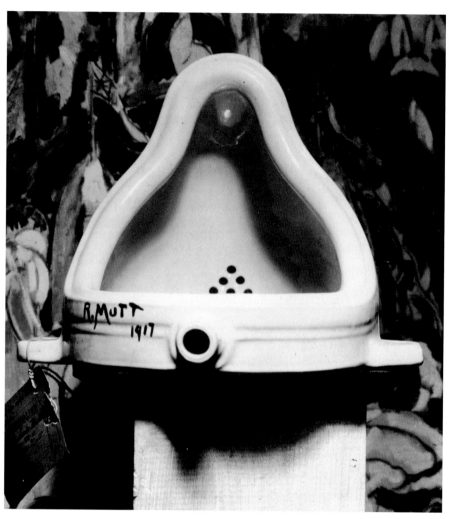

Marcel Duchamp, 1917, *Fountain*, photograph by Alfred Stieglitz at the 291 (Art Gallery) following the 1917 Society of Independent Artists exhibit, with entry tag visible. The backdrop is *The Warriors* by Marsden Hartley. Wikipedia Commons, public domain.

The Large Glass, repaired, in Katherine Dreier's library. Yale University, Beinecke Rare Books Library, Katherine Dreier papers.

Marcel Duchamp, New York, 1918. Yale University, Beinecke Rare Books Library, Katherine Dreier papers.

Yvonne Chastel. Provenance: Centre Pompidou. Public domain.

Beatrice's stick-man poster for the Blindman's Ball, 1917. Philadelphia Museum of Art: Gift of the artist, 1973, 1973-191-1

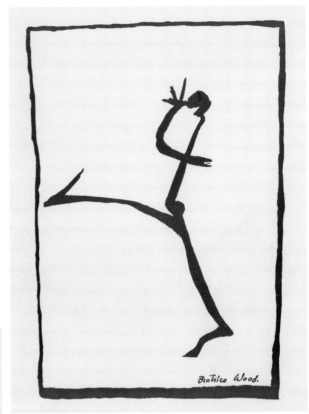

THE

BLINDMAN'S
BALL

For the BLINDMAN
A Magazine of *Vers Art*

Friday May 25th

at Ultra Bohemian, Pre-
Historic, Post Alcoholic

WEBSTER HALL 119 East 11th Street

DANCING EIGHT-THIRTY

Tickets $1.50 each in advance—$2.00 at the gate. Boxes not
requiring Costume, but requiring Admission tickets $10.00

Everything sold by the BLINDMAN

7 East 39th Street Telephone Vanderbilt 3280

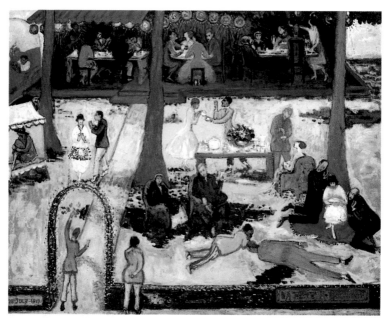

Florine Stettheimer's painting of Marcel's birthday party. Open source media.

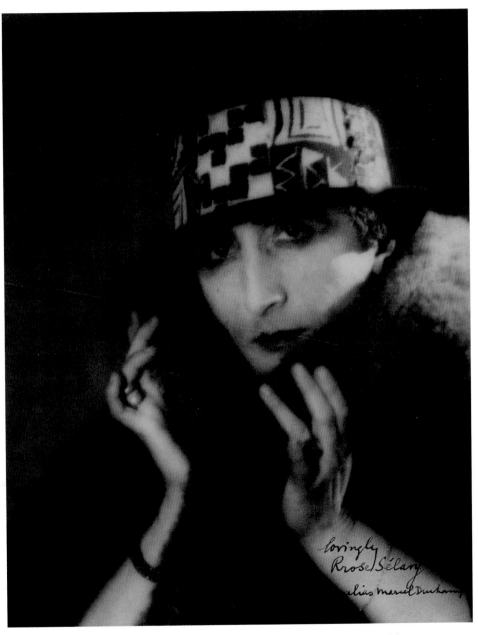

Man Ray: *Marcel Duchamp as Rrose Selavy*. Philadelphia Museum of Art:
The Samuel S. White, 3rd, and Vera White Collection, 1957, 1957-49-1, Wikimedia Commons.

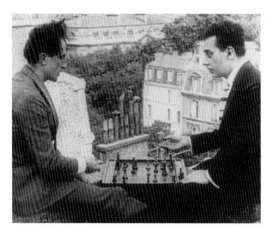

Marcel Duchamp and Man Ray play chess on the roof of the Théâtre des Champs-Élysées, from René Clair, Entr'Acte, 1924.

Old friends: Louise and Edgard Varèse, Suzanne Duchamp, Jean Crotti, Mary Reynolds, Paris, 1923/4 (the photographer was Marcel). Provenance: Wiki commons.

Maria with one of her sculptures. Wiki commons.

Maria (second from the right, back row) and Marcel with friends, Provincetown. Back row: Yves Tanguy, Kay Sage, Maria Martins, Enrico Donati; front row: Marcel Duchamp, Frederick Kiesler. Woodbury, Connecticut 1947.

Marcel and Lydie at the church door. Yale University, Beinecke
Rare Books Library, Katherine Dreier papers.

Marcel and Teeny Duchamp. Provenance: Philadelphia Museum of Art.

ABOVE: Walter and Louise Arensberg with Marcel, California. Beatrice Wood Center for the Arts/ Happy Valley Foundation. BELOW: Old friends. Marcel Duchamp and Man Ray in Paris, 1968. Henri Cartier-Bresson/Magnum.

Beatrice in old age. Beatrice Wood Center for the Arts/Happy Valley Foundation.

3

MARCEL

For many years it seemed as though Marcel Duchamp would be one of those artists who are modish for a day then recede into the collective unconscious. In 1924 William Carlos Williams, one of the first and most ardent of his modernizing American admirers, mourned this disappearance. "The amusing controversy between Arensberg and Duchamp, on one side, and the rest of the hanging committee on the other as to whether the porcelain urinal was to be admitted to the Palace Exhibition of 1917 as a representative piece of American sculpture, should not be allowed to slide into oblivion," he wrote.* But it had so slid, and as the decades passed showed no sign of resurrection.

Marcel was unperturbed. He was perfectly content with his low-key, peripatetic lifestyle. Did he ever regret not being known? Pierre Cabanne asked him in 1967. He replied, "No, not at all. Absolutely no regret. There are people who are born unlucky, and who simply never 'make it.' They're not talked about. That was a little the case with me."**

Following the fiasco with Lydie, Marcel—like Pierre—kept himself financially afloat by dealing. As a dealer, he insisted that his readymades were not attempts to make art available to the masses, but consisted of strictly limited editions of eight signed pieces:*** you could not simply

* Williams, prologue to *Kora in Hell*.

** Cabanne, *Dialogues with Marcel Duchamp*, 86.

*** Gough-Cooper and Caumont, "Ephemerides."

wander into a hardware store, find a bottle rack, and consider yourself possessed of a Duchamp.* Unlike Pierre, however, he kept his profits to the necessary minimum. (When Marcel wanted to buy back, at Teeny's request, a small study on glass he had given Pierre in 1917, Pierre shamelessly, and to Marcel's amusement, insisted on charging the same high price he would have demanded from any other customer.) And although, as he always said, he had no new ideas for artworks, and (until Maria Martins reawakened him) no desire to make any, he made the most of the old ones, constructing elaborate boxes that contained painstakingly miniaturized versions of his most important works, along with facsimile editions of his *Notes* for the *Large Glass*.

Bored with the *Glass*, he had declared it definitively unfinished. It had been bought in 1918 by Walter Arensberg, and sold on to Katherine Dreier when the Arensbergs moved to California in 1921. In 1927, on a journey back to her house from the Brooklyn Museum, where it had been exhibited, it broke, but Miss Dreier, seemingly in no hurry to reinstall it in her library, did not discover this misfortune until 1931, when the traveling case was finally opened. Another two years passed before she could bring herself to reveal the catastrophe; in 1936 Marcel laboriously reconstructed it, securing the fragile original between two sheets of clear glass clamped together in a steel frame. He liked the symmetric lacework of cracks, and declared the mended *Glass* much improved. Chance had already been incorporated into it in the form of the *3 Standard Stoppages* (where lengths of cord were glued in place where they fell), and now that it had intervened once more he welcomed it, even though the process of reconstruction was numbingly tedious.

Mostly, though, he played chess. He played every day, took part in tournaments, sat on the board of the French chess federation, and co-wrote a book, *Opposition and Sister Squares are Reconciled*, "about blocked pawns," he explained, "when your only means of winning is by moves

* Later, his friend Max Ernst learned that Marcel had allowed Arturo Schwarz, his Milanese devotee, "to multiply his Readymades [and] use them to make commercial 'multiples.' I asked myself if it was not simply another gesture to irritate public opinion, to trouble minds, to baffle his admirers, etc. When I asked Marcel he replied laughing, 'Yes, it's a little of all that.'" (In d'Harnoncourt and McShine, *Marcel Duchamp*.) *New Yorker*, April 6, 1957.

of kings, something that only happens once in a thousand times."* He compared beauty in chess to beauty in poetry. "The chess pieces are the block alphabet which shapes thoughts; and these thoughts, although making a visual design on the chessboard, express their beauty abstractly, like a poem. From my close contacts with artists and chess players, I have come to the personal conclusion that while all artists are not chess players, all chess players are artists."**

In April 1957, Marcel gave an interview to the *New Yorker.* The occasion was an exhibition at the Guggenheim of works by the three Duchamp brothers, an exhibition suggested by Marcel and for which he had designed the catalog. But although this event argued a certain renewed importance in the artistic world, the *New Yorker* clearly knew nothing of him, for the article was built around the surprising fact that Marcel had once been extremely famous, but forty years later was virtually unknown. "How many successful creative artists have at their peak summarily abandoned the pursuits that made them famous, to pass their remaining decades in relative obscurity, fortified by their memories? This solemn question has often been on our lips, and our lips have answered, Damn few!"

The interview took place at Teeny and Marcel's apartment, which had previously been occupied by Max Ernst.

> After pressing the button under a remarkable nameplate that read "Matisse, Duchamp, Ernst," we climbed a pitch-black four-flight staircase on East Fifty-Eighth Street ("Watch your step," a man in pajamas said on the first landing, "the electricity's out of order,") rang a bell which didn't ring (the electricity again), knocked, and were admitted to a top-floor apartment by Mr. Duchamp, a tall, lean man with a high forehead, a great shock of brown hair, cavernous eyes and a winning smile. We sat down in a room that contained a chessboard; a Polynesian ceremonial carving, several feet

* *New Yorker*, April 6, 1957.

** August 1952 speech at a banquet during the New York State Chess Association annual meeting in Cazenova.

high; a large Miró and a small and a medium-sized Matisse; and a replica, by Duchamp, of a section of his "Bride Stripped Bare By Her Bachelors."

We asked Mr. Duchamp, who is sixty-nine, if he would mind telling us what he had used for money all his life.

"It's perfectly proper to ask an artist how he gets along," he said, offering us a vermouth. "It's *not* proper to ask a businessman, because he doesn't get along, he borrows from other businessmen. But I can't tell you how an artist gets along. You live and you don't know how you live. You just don't die. I've never had more than two or three hundred dollars ahead of me. I've never gone without a meal. People always ask artists how they live. They don't have to live. They just breathe."

At the end of the interview, Marcel showed the journalist through the rest of the apartment. It contained several more Mirós, a couple of Balthuses, a Tanguy, a small Picasso gouache, and a chess table designed by Marcel himself, with inlaid squares and two inlaid clocks that could be stopped and started by a switch. He didn't think much of the current art scene, he confessed. Painting had got altogether too commercialized, dealers had become too powerful. "Painting shouldn't be a fashionable thing. And money, money, money comes into it. It becomes a Wall Street affair."

How he must have chuckled to himself, as he poured the vermouth amid artworks that were now, thanks to Wall Street, worth a small fortune. But that wasn't the real joke. What Marcel knew, and the journalists didn't—what no one except Teeny knew—was that his creative career was not over at all. Only after he died would the delightful secret of the diorama with its Maria doll be revealed.

In the meantime, however, although the news had not yet reached the *New Yorker*, the wheel of chance that had shot him to fame in 1913, then dumped him back into obscurity, had caught him up once more and was lifting him into a second bout of fame, as unlooked-for as the first—and much more substantial.

·:⣿:·

In 1950 Marcel's work, for the first time, became permanently available to the public. After many negotiations, most of which foundered on Walter Arensberg's insistence (eventually abandoned) that the receiving institution also guarantee the continuance of the Francis Bacon Foundation, the Arensbergs presented their collection to the Philadelphia Museum of Art, where in 1953, on Katherine Dreier's death, it was joined by the reconstructed *Glass*. Meanwhile, a young Swede, Pontus Hulten, who would soon become the world's most influential and imaginative curator of modern art, had become very excited by Marcel's method of using notes to supplement his images. "The beauty of the total process is very stimulating," he wrote.[*]

Ah, the *Notes*! Between 1913 and 1934 Marcel had made a (literal) pile of them, handwritten on various ends and scraps of paper, allusive, whimsical, and pseudo-technical, setting out the theory and mechanics of the *Bride and Her Bachelors*. Pierre, comparing the 1917 Marcel to "a young prophet," observed that he didn't write down his teachings.[**] He could not have been more wrong. Marcel's alternative machine world was not only visual but also equipped with a full theoretical explication. Although his body always enjoyed whatever carnal pleasures were available, this imagined world, along with the similarly discarnate world of chess, was where he preferred to spend his time, and perhaps it was this sense that he was both present and ungraspably elsewhere that constituted what Pierre called his "halo."

With their mix of elegance, double entendre, nonsense physics, sex, gaiety, and crazy originality, the *Notes*, which form a thirty-six-page booklet, encapsulate the wit, charm, and brilliance that captivated Marcel's fans and followers, and that were the essence of the fascination he exercised over all who met him.

The first note set out the work's title:

[*] In a catalog essay for his Duchamp exhibition at the Pompidou in 1973.

[**] "Souvenirs sur Marcel Duchamp," in Lebel, *Sur Marcel Duchamp*.

THE Bride stripped bare by her bachelors
—Agricultural machine—even

. . .

Kind of Sub-Title

Delay in Glass

. . .

The Bride. skeleton
The Bride, at her base, is a reservoir of
love gasoline. (or timid-power). This
timid-power, distributed to the motor with II
quite feeble cylinders, in contact with the sparks
of her constant life (desire-magneto) explodes
and makes this virgin blossom who has
attained her desire.
Besides the sparks of the desire-magneto, the
artificial sparks which are produced by the
electrical stripping should supply
explosions in the motor with quite feeble
cylinders.

. . .

The Bride accepts this stripping
by the bachelors, since she supplies
the love gasoline to the sparks of this
electrical stripping; moreover, she
furthers her complete nudity by adding to
the 1st focus, of sparks (electrical stripping)
the 2nd focus of sparks to the desire-magneto

Blossoming.

. . .

In 1934 Marcel made facsimiles of these *Notes*, which were included in his Green Boxes, and in 1960 the British artist Richard Hamilton, explaining that "intimacy with all the texts and diagrams of the Green Box is the best, indeed the only, way to achieve true understanding and enjoyment of the *Glass*,"* published, in a Green Book to go with the Green Boxes, a typographic translation of them (from which my quotes are taken). Marcel carried Hamilton's translation everywhere, and placed it beside his bed at night.

The art world, unsurprisingly, had always been predicated on visual objects that could be exhibited and traded. However, as his famous scorn for the "retinal" acknowledged, Marcel dealt in ideas. Since ideas can't be traded and are singularly hard to exhibit, this was an unusual priority for a visual artist. But as the 1960s approached, ideas were what the art world craved. Surrealism had run its course, a course Marcel found rather disappointing. It had begun very promisingly, he thought, had "tried to break away from the sensual and superficial, but in the end came back to it."** Abstraction, too, was becoming outworn. And who could imagine a greater contrast to Jackson Pollock's drip paintings than Marcel Duchamp's meticulous intellectualism? "Art is anything you can get away with," wrote Marshall McLuhan, the voice of 1960s media theory.*** And few had got away with more than Marcel. Forty years old but as good as new, his iconoclasm and anti-commercialism was wonderfully in tune with the new era. Mr. Mutt's *Fountain*, so shocking in 1917, perfectly expressed the mood of the 1960s.

Marcel tremendously enjoyed his new burst of fame. Showered with invitations to speak or be interviewed, he accepted them all. His old charisma and charm continued undimmed—Joan Bakewell, interviewing him for the BBC, declared him the most intelligent man she had ever met. The Beatles had the Maharishi; the antiwar movement had Dr. Spock. And now the art world, too, had its guru: Marcel Duchamp.

* Hamilton, "Marcel Duchamp," in *Marcel Duchamp*, ed. d'Harnoncourt and McShine, 60. This essay contains a detailed explication of *The Large Glass*.

** Interview with Richard Hamilton, BBC *Monitor*, September, 1961.

*** McLuhan, *Understanding Media*.

Unlike most artists, Marcel was ideally suited to the role of guru. Although his body of work was small, the apparatus surrounding it was immense. Everyone could construct their own Duchamp, and everyone was correct. By the time he died, aged eighty, in 1968, he was world famous. His last decade was probably the happiest of his life. Happily married, comfortably looked after, revered, adulated—and aware, as his followers were not, of the piece on which he was still secretly working, and that, unveiled after his death, would provide a final feast of controversy for his admirers! What more could a man want?

It is so surprising that any artist could become famous twice, each time seemingly by pure chance, with decades of chess-playing obscurity in between, that the temptation to impute some sort of secret plan is almost irresistible. Rather than mere happenstance, was this not the culmination of some grand strategy toward which Marcel had secretly been working all along? The critic and historian Roger Shattuck thought this was exactly what it was.

> In one segment of his life, Duchamp was an amused non-participant in the politics, therapies, and binges of self-expression that have importuned artists from the Twenties on. He claimed to have taken early retirement. In another segment, he trained himself unflaggingly to be a victorious commander in a warlike contest requiring vigilance and planning.
>
> Did he ever unite these two sides of his temperament and his life? I believe he did, quite evidently, in the overall strategy of his low-keyed, occasionally scandalous, and stunningly successful career. At some juncture between the unexpected fate of *Nude Descending a Staircase* (first rejected in 1912 by his own family circle of Cubists, then singled out the following year to become the most publicized work in the Armory Show) and the *Fountain* episode in 1917, Duchamp decided to make a wager with himself about the artistic and intellectual culture he belonged to. He wagered that he could beat the game by doing

virtually nothing, by just sitting around. His minimal, carefully planned tactic required that he sign only a few carefully selected objects. Deftly used, that tactic would bring him the one thing he wanted—fame. And the move coincided with his already-formed scheme to abandon painting in the traditional sense. Draped in arcane *Notes* and irreparably cracked in transit, *The Large Glass* fit easily into this lifelong mystification. Duchamp, a canny deadpan operative beneath these antics, never gave himself away. The strategy worked perfectly. Yes, he put us all in his pocket.*

It's a seductive theory, but whether you think it works depends on whether you believe it possible for fame to be decoupled from ambition.

Marcel repeatedly said that his guiding principle was indifference: "Nothing was intentional. The most I had decided was not to make a living by painting."** Shattuck thought this indifference was feigned, a monumental cover-up for an ambition that, since it was always denied, was never suspected. But why disbelieve what every action demonstrated? In the years between 1912, when his painting was rejected by the Cubists and his love rebuffed by Gaby Picabia, and 1946, when he met Maria Martins, Marcel refused, with the disastrous exception of his first marriage, to try and shape his life. Rather, in life as in art, he followed where chance led with total detachment. In 1915, combined with his brilliance and gaiety, this made him both irresistible to a New York then as now in love with fame, and a focus for profile-boosting disapproval. And then darkness redescended.

As for his second coming, it surely had no more to do with any plan than had his Armory Show fame. Rather, they were both functions of the zeitgeist, which as all yesterday's imagined futures so vividly demonstrate, is wholly unpredictable. Who could have guessed that in 1913 *Nude Descending a Staircase* would, for a few months, represent the dreaded and reviled "modern" in the eyes of American conservatives, become a totem for liberals, and provide a subject for every cartoonist in the land? Or

* "The Confidence Man," *New York Review of Books*, March 27, 1997.

** Interview with Otto Hahn, July 1, 1966.

that as the *Nude*'s moment faded and controversy found other focuses, a war would remove its creator from an indifferent Paris and take him to New York, unanticipated adulation, and eventually, *Fountain*? Or that the 1960s might seem specifically designed to suit Marcel Duchamp?

Marcel died on October 2, 1968, from a prostate cancer he never suspected, after a last happy evening spent with Teeny and some old friends, and with his death, the scene was set for the last and biggest joke of all.

Control had always been one of his obsessions. It was part of the attraction of chess, which, unlike life, is specifically a battle for control—and also unlike life, has no lasting consequences: "To play, it's the thing to live for. You play chess and you kill, but you don't kill much. People live like that, after being killed, in chess, but not in normal wars. It's a peaceful thing, a peaceful way of understanding life. You play with life anywhere—chess is more alive than people are."* Fear of losing control had loomed between him and love; it had directed his creativity into the anti-chaotic world of geometry and machines.

Did he plan, with his usual meticulousness, that he would continue to exercise this control even in death, when his strange diorama would finally, posthumously, be revealed? Of course the main reason he made it was that he terrifically enjoyed everything about it—designing its rules, playing with its parameters, feeling the connection to Maria and feeling, too, that it was their secret, shared now with Teeny. But he had become so famous that he must have known the secret would never be kept. And it was not.

There had been a hint of what was to come in 1966, when London's Tate Gallery staged a Duchamp retrospective organized by Richard Hamilton. It included a loan from Maria Martins, which Hamilton found puzzling: a work in pencil on vellum over gesso, and velvet on cardboard, showing a small female torso with legs stretched apart, and inscribed in French, on the back, "This Lady belongs to Maria Martins with all my affection, Marcel Duchamp, 1948–49." And on his death, *Étant donnés*, the teasing recapitulation of themes familiar from forty years earlier, was finally revealed.

On the face of it, and although they shared so many of the same preoccupations, the *Large Glass* and *Étant donnés* could not have seemed

* Filmed interview with Marcel Duchamp, 1960s, Cadaqués.

more different. The *Glass* was more or less two-dimensional, abstract, and intellectual—its suggestive title, *The Bride Stripped Bare by Her Bachelors, Even*—both enigmatic and intriguingly at odds with the crazy yet severe reality. Both its originality—nothing like it had ever before been seen in an art gallery—and the existence of a complex intellectual apparatus behind it, in the form of the *Notes*, were immediately apparent. It required, indeed invited, exploration of its intricate web of puzzles, puns, allusions, and geometries. In contrast, *Étant donnés*, even to the most clued-up observer, was—as viewed via the obligatory eyeholes—nothing more than a crude and rather obscene peepshow, its seediness emphasised by the fact that you could only see it, like some sort of guilty secret, through two holes in a wooden wall. The extremely clued-up Roger Shattuck couldn't believe it was serious, declaring it an "indecent peekaboo panorama . . . the ultimate and most daring art-history hoax."* And where one of the *Glass*'s intriguing paradoxes was that it was at once sexual and impersonal, *Étant donnés* could hardly have been more personal, given that the woman was modeled on Maria, with whom Marcel was sexually obsessed.

It was not, however, simple. It is arranged, with minute accuracy, on a squared grid; the doll, which when viewed from the enforced viewpoint that is one of the peepholes' functions seems so porno-graphically lifelike, is in fact an anamorphic distortion, lying not on the ground but on an invisible table that raises her to the required height and is camouflaged by, among other items, a heap of twigs. Another function of the peepholes is to restrict viewing to one person at a time—for Duchamp hated the idea of art as mass entertainment, as exemplified by the constant crowds gathered in front of the *Mona Lisa*, whose goateed and mustachioed image had been one of his most celebrated early jokes. She was everywhere in the new work. The doll is set against the landscape and waterfall that form the background to Leonardo's painting, but reversed so that the section on the left of Mona Lisa's head in the original painting appears in *Étant donnés* on the right-hand side, and vice versa, while the dolly, in the fore-ground, can perhaps be seen as representing the fallen state of Mona

* "The Confidence Man," *New York Review of Books*, March 27, 1997.

Lisa herself, both physically, from the balcony on which she stood or sat to be painted, and sexually.* And so the arguments go on.

In 2004 Marcel Duchamp was acknowledged as the twentieth century's most influential artist. He had become art history. And perhaps the greatest joke of all was that his influence stemmed not from either of his complex set pieces—but from Mr. Mutt's *Fountain*.

* These thoughts on *Étant données* from Haralambidou, *Marcel Duchamp and the Architecture of Desire*.

4

SURVIVING MARCEL

As the Duchamp cult gathered momentum, the group of friends from the days of the Arensberg salon found themselves caught up once more in Marcel's slipstream. Now that he had become a legend, people wanted to know everything about him. What had really happened? How had it felt to be in on the making of history?

The survivors, it turned out, were all women. Stieglitz had died in 1946, Walter Pach in 1953, Walter Arensberg in 1954, Picabia in 1956, Pierre in 1959, Marcel in 1968. The women, however, were made of more durable stuff. Gaby Picabia would live to be 104, Louise (Norton) Varèse to 99, Beatrice to 105.

In the years immediately following Marcel's death, it was Gaby who was most in demand. Not only had she been married to Marcel's twin soul, Picabia, she had published a number of memoirs of her adventures in New York and the people she had met there. Interviewed for the catalog of Hulten's 1973 exhibition, she fluently recalled the Arensbergs' salon and the sensitive youth who had been so enchanted by Picabia, and who had made fruitless love to her sixty years before. When Beatrice, to whom in those days she had been a sort of mother figure, met Gaby again in the 1970s, she found her old friend's ancient face lit up by the same bright dark eyes remembered from half a century before. They took up their friendship as though they had last met only the previous day.

Louise, nine years younger than Gaby, was also sought out by the historians. Her affair with Marcel was not public knowledge, however, (we only know of it through Pierre's diaries), and she had not been

involved in the Independents Exhibition, though her characteristically batty piece "The Buddha of the Bathroom" in *The Blind Man* was parsed by art historians with the usual minuteness, prompting various learned speculations about its gender implications. Was Louise, scholars wondered, the mysterious friend who (so Marcel once claimed) had sent him the urinal for exhibition?

Following the turbulent few months of threesomes and foursomes with Marcel and Pierre and her divorce from Allen Norton, Louise had married the French composer Edgard Varèse, bought a house in Greenwich Village, and become a faithful and supportive wife. Varèse was not an easy husband. Although he enjoyed a certain success in New York in the 1920s, that soon faded, and as he dropped out of fashion he became prone to bouts of depression. It cannot have helped that his cousin Alfred Cortot, whom he despised and whose character was distinctly unpleasant, was acknowledged as one of the world's great pianists and correspondingly feted.

Louise, however, did not repine, but since she now lived in a bilingual world and enjoyed writing, took up translation. It was a job that ideally suited her, making the most of her fascination with words while releasing her from the task, never mastered in her own writing, of stringing those words together coherently. She became America's foremost translator from the French and was made a Chevalier of the Légion d'honneur. Her version of Rimbaud's poetry was particularly celebrated, and she became a close friend of Georges Simenon, whose novels she also translated. Translation does not pay well, and Varèse never earned much, but luckily Louise's Pittsburgh money was there to supplement their earnings. He died in 1965, and she spent much of her life thereafter writing his biography. She planned two volumes, but only completed the first. Her account of the Duchamp/New York years was brief, hardly mentioned Marcel, and did not mention Pierre at all.

Neither Gaby nor Louise, though both talented, had made the same splash as their brilliant husbands. Beatrice, in contrast, had become not just financially independent but famous in her own right. At long last she was free, and the dream of her twenties—to become a self-supporting artist, to affront Marcel's world on equal terms—was fulfilled.

Eighty years on, she remained improbably pretty. Though her hair, which she wore elegantly knotted, had become snow white, her smile was still mischievous. At more than a hundred years old she still, in every sense, worked. In her nineties she'd developed a slightly distressed luster-ware that sold better than anything she'd done previously. And pottery needs physical strength: moving the bags of clay, controlling the lump on the wheel. How did she do it? they asked. "Young men and chocolate," she replied, no doubt thinking of Marcel, whose studio at West 67th Street was always littered with half-eaten chocolate bars.

Marcel, Marcel. She could still, at this distance, recall every embrace—his arm holding her tight on the Coney Island roller coaster, his cool chest pressed against her back the night five of them shared a bed after the Blind Man's Ball, the kiss when he'd handed her the envelope of cash and made her promise not to open it until she was back in her room . . .

In one particular, however, Beatrice's memory betrayed her. Those events occupied, she said, two years, between 1916 and 1918. The truth was that they extended to barely one. She met Marcel in September 1916, and by August the next year it was all over—the excitement, the joy, everything. As for Pierre, their affair had lasted barely two months from the first kiss to the tearful parting.

Artistic truth knew otherwise. Those months were an epoch.

ACKNOWLEDGMENTS

Grateful thanks to Celia Crowther, Claiborne Hancock, Toby Mundy, Phil Steadman, Phil Tabor, and Randall Wright. Also to Elizabeth L. Garver at the Harry Ransom Center, Jonathan Hoppé, Margaret Huang, and Richard Sieber at the Philadelphia Museum of Art, and Kevin Wallace at the Beatrice Wood Center for the Arts. I couldn't have done this without you.

SELECT BIBLIOGRAPHY

Manuscripts

Duchamp correspondence. http://www.dada-companion.com/duchamp/correspondence
.php.

Marcel Duchamp's Letters to Maria Martins, 1946–1967/68. http://www.golob-gm
.si/32-Marcel-Duchamp-s-letters-to-Maria-Martins.htm.

Roché, Henri-Pierre. *Carnets 1916–1918*. Harry Ransom Center, University of Texas
at Austin.

Roché, Henri-Pierre. "How New York Did Strike Me." Unpublished manuscript, Harry
Ransom Center, University of Texas at Austin, 1930.

Wood, Beatrice. *Diaries, 1915–1919*. Archives of American Art, https://www.aaa.si.edu
/collections/items/detail/beatrice-wood-diary-13121.

Wood, Beatrice. *Pour Toi*. June 2, 1917. Philadelphia Museum of Art

Wood, Beatrice. *Pour Toi–psychologie*. July 16, 1917. Philadelphia Museum of Art

Wood, Beatrice, and Henri-Pierre Roché. Correspondence. Harry Ransom Center,
University of Texas at Austin.

Articles

Godlewski, Susan Glover. "Warm Ashes: The Life and Career of Mary Reynolds." Art
Institute of Chicago, 2001. http://archive.artic.edu/reynolds/essays/godlewski4
.php.

Gould, Stephen Jay, and Rhonda Shearer. "Drawing the Maxim from the Minim: The
Unrecognised Source of Niceron's Influence upon Duchamp." *Tout-Fait: The Marcel
Duchamp Studies Online Journal* 1, no. 3 (2000).

Lepore, Jill. "What Next for Planned Parenthood?" *New Yorker*, November 14, 2011.

McBride, Henry. "The Walter Arensbergs." *Dial*, July 1920.

Naumann, Francis. "Walter Conrad Arensberg: Poet, Patron and Participant in the New
York Avant-Garde 1915–20." *Philadelphia Museum of Art Bulletin* 76 (Spring 1980).

Ray, Man. "Bilingual Biography." *View* 5, no. 1 (March 1945).

Shattuck, Roger. "Confidence Man." *New York Review of Books*, March 27, 1997.

Books

Berest, Anne, and Claire Berest. *Gabriële*. Paris, 2017.

Brandon, Ruth. *Surreal Lives: The Surrealists 1917–1945*. London, 1999.

Breton, André. *Les Pas perdus*. Paris, 1969.

Buffet-Picabia, Gabriële. *Rencontres*. Paris, 1977.

Buffet-Picabia, Gabriële. *Aires abstraites*. Geneva, 1957.

Buttel, Robert. *The Making of Harmonium*. Princeton, NJ, 1967.

Cabanne, Pierre. *Dialogues with Marcel Duchamp*. New York, 1967.

Camfield, William. *Marcel Duchamp: Fountain*. Houston, 1989.

Drutman, Irving, ed. *Janet Flanner's World*. London, 1980.

Everling, Germaine. *l'Anneau de Saturne*. Paris, 1970.

Fischer Sarazin-Levassor, Lydie. *Un échec matrimonial*. Dijon, 2004.

Haralambidou, Penelope. *Marcel Duchamp and the Architecture of Desire*. Farnham, UK, 2013.

d'Harnoncourt, Anne, and Kynaston McShine, eds. *Marcel Duchamp*. New York, 1973.

Hulten, Pontus, ed. *Paris-New York*. Paris, 1977.

Gough-Cooper, Jennifer, and Jacques Caumont. "Ephemerides." In *Marcel Duchamp*, ed. Pontus Hulten, 1993.

Kuenzli, Rudolf, and Francis M. Naumann, eds. *Marcel Duchamp: Artist of the Century*. Cambridge, MA, 1991.

Kuhn, Walt. *The Story of the Armory Show*. New York, 1938.

Lebel, Robert. *Sur Marcel Duchamp*. New York, 1959.

Marquis, Alice Goldfarb. *Eros, c'est la vie: A Biography of Marcel Duchamp*. Troy, NY, 1981.

McLuhan, Marshall. *Understanding Media, the Extensions of Man*. London, 1964.

Motherwell, Robert, ed. *The Dada Painters and Poets*. New York, 1951.

Reliquet, Scarlette, and Philippe. *Henri-Pierre Roché, l'enchanteur collectionneur*. Paris, 1999.

Ray, Man. *Self-Portrait*. London, 1963.

Roché, Henri-Pierre. *Carnets, Les années Jules et Jim, avant-propos de François Truffaut*. Marseille, 1990.

Roché, Henri-Pierre. *Victor*. In *Three New York Dadas and The Blind Man*, edited by Ades and Brotchie, translated by Chris Allen. London, 2013.

Seigel, Jerrold. *The Private Worlds of Marcel Duchamp: Desire, Liberation, and the Self*. Berkeley, CA, 1995.

Stein, Gertrude. *The Autobiography of Alice B. Toklas*. London, 1933.

Stein, Gertrude. *Geography and Plays*. Boston, 1922.

Tomkins, Calvin. *Duchamp*. New York, 1997.

Varèse, Louise. *A Looking-Glass Diary*. New York, 1972.

Williams, William Carlos. *Autobiography*. New York, 1967.

Williams, William Carlos. *Kora in Hell, Improvisations*. San Francisco, 1957.

Wood, Beatrice. *I Shock Myself*. San Francisco, 1985.

INDEX